P9-DOC-779

Selected Works

The Minneapolis Institute of Arts

Selected Works

The Minneapolis Institute of Arts

Sandra LaWall Lipshultz

THE
MINNEAPOLIS
INSTITUTE
OF ARTS

Cover:
Edgar Degas
Mademoiselle Hortense Valpinçon, 1871
Oil on canvas
The John R. Van Derlip Fund 48.1

Edited by Elisabeth Sövik
Designed by Ruth Dean
Photographs by Gary Mortensen and Petronella Ytsma
Typeset by Patrick Atherton
Production coordinated by Donald Leurquin

Photo credits: *Pepper No. 30*, by Edward Weston,
© 1981 Arizona Board of Regents, Center for
Creative Photography; *Highway Corner, Reedsville,
West Virginia*, by Walker Evans, courtesy of the
Walker Evans Estate; *Mount Rushmore, South Dakota*,
by Lee Friedlander, courtesy of Lee Friedlander.

© 1988 by The Minneapolis Institute of Arts
2400 Third Avenue South
Minneapolis, Minnesota 55404
All rights reserved
Third printing 2001

Library of Congress Catalog Card Number 87-61465
ISBN 0-912964-32-4

The publication of this book was made possible
by a generous gift of funds from the Friends
of the Institute, Bruce B. Dayton, the John
Cowles Family Fund, and the Andrew W.
Mellon Foundation.

Printed in Japan

Contents

Preface

In 1883 fourteen men and eleven women incorporated The Minneapolis Society of Fine Arts "to advance the knowledge and love of art." Their dream of establishing a public museum for Minnesota was realized three decades later, when The Minneapolis Institute of Arts opened its doors in 1915. Under the direction of Joseph H. Breck, the Institute began to amass a permanent collection to "illustrate by carefully selected pieces the history of art."

Today that collection has grown to one hundred thousand objects and includes representative masterpieces from every continent and age. Among the treasures of Western painting are Dutch and Italian pictures of the seventeenth and eighteenth centuries, French canvases of the mid-nineteenth century, and Cubist and German Expressionist works of the twentieth century. The Institute also has acquired over fifty thousand prints and drawings, and a collection of photographs that is particularly strong in contemporary images. Significant holdings in the decorative arts include English and American silver, eighteenth-century French and Italian furniture, and nineteenth-century French sculpture. The Minneapolis *Doryphoros*, a first-century B.C. marble version of a lost bronze by the Classical Greek sculptor Polykleitos, adds new strength to the antiquities collection, and the departments of textiles and ethnographic art feature such distinguished objects as European tapestries and African works of unusual age and importance. The Asian department also has numerous specialized collections of international renown, including ancient Chinese bronzes and jades, classical Chinese furniture and ceramics, and Japanese Ukiyo-e paintings and prints.

As part of the Institute's continuing commitment to education, this handbook introduces the visitor to key objects in our collection and provides basic information about the cultures that made them. Choosing from the thousands of works available was a difficult task. Our aim was to present the very best objects in the collection and also to demonstrate the wide range and diversity of our holdings.

This book is not intended as a gallery-by-gallery guide to the museum. It is arranged chronologically by broad historical periods and includes sections devoted to Asian, ethnographic, and American art. We hope it will prove informative and enjoyable, but we know that nothing can equal the delight of seeing the works themselves.

We would like to thank the Friends of the Institute, Bruce B. Dayton, the John Cowles Family Fund, and the Andrew W. Mellon Foundation. Without their generous support, this publication would not have been possible.

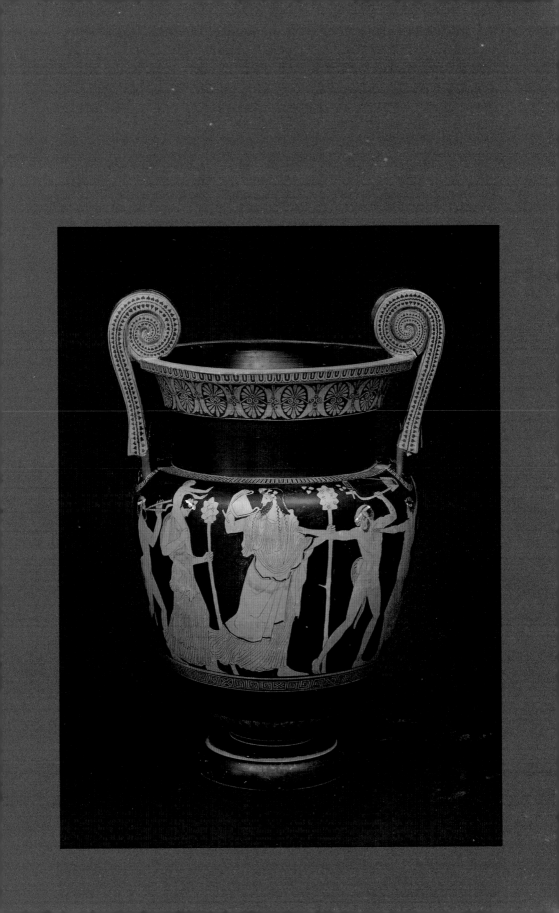

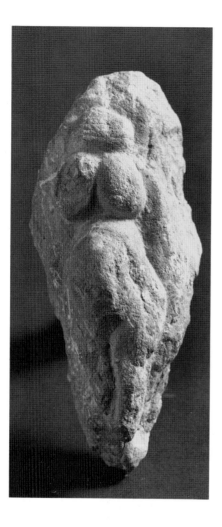

Paleolithic (probably La Mouthe,
France)
Venus Figure
About 20,000 B.C.
Sandstone
5¼ in. high
The William Hood Dunwoody Fund
72.10

The earliest known paintings and
sculptures are magical-religious images
that were probably meant to ensure
a successful hunt and abundant game.
They were made by the nomadic
hunters of the Paleolithic Age, who
lived in caves or pit dwellings, used
fire, and fashioned tools and weapons
of stone, wood, bone, and antler. This
carving from the caves of La Mouthe,
in southern France, represents a nude
woman with large breasts, wide hips,
and an extended abdomen—a type
archaeologists call a Venus figure.
Although little is known about the
purpose of such figurines, their exag-
gerated sexual characteristics suggest
that they reflect a concern with
fertility and increase.

Mesopotamian (Sumer)
Peg Figurine
25th century B.C.
Copper
10½ in. high
The Katherine Kittredge McMillan
Memorial Fund 74.23

In southern Mesopotamia, between
the Tigris and Euphrates rivers
(in modern Iraq), the Sumerians
developed the earliest and most
influential civilization in the ancient
Near East. They invented writing and
devised the syllabic cuneiform script.
And they discovered the rudiments of
mathematics, astronomy, and medi-
cine, and established fundamental
principles of law. Although the
Sumerians evolved a complex urban
society, agriculture remained central
to their religion. To please the gods,
on whose favor the harvest depended,
they built monumental mud-brick
temples—stepped pyramidal struc-
tures called ziggurats—and buried
small sculptures of their gods in the
foundations. The museum's peg figu-
rine, smiling faintly, arms bent in an
attitude of prayer, was made for that
purpose. It represents Shulutula, the
personal god of the Sumerian kings
Enannatum I and Entemena. Shulutula
acted as an intermediary for the royal
household, interceding on their behalf
with more powerful divinities.

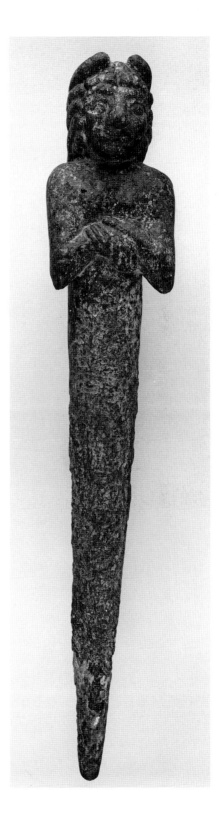

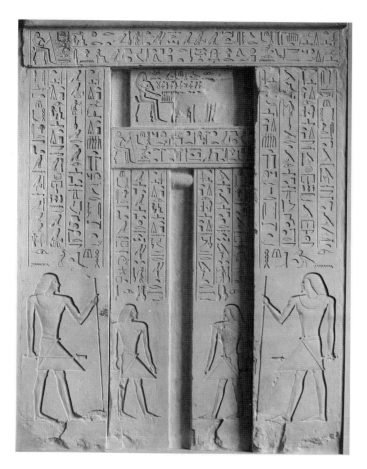

Egyptian (early 6th Dynasty)
*False Door from the Tomb of
Iry-en-Akhet at Giza*
About 2400 B.C.
Limestone
61 × 45¾ in.
The Christina N. and Swan J. Turnblad
Memorial Fund 52.22

The civilization of ancient Egypt flour-
ished in the Nile valley, nine hundred
miles to the west of Mesopotamia.
The Egyptians had a more optimistic
outlook than the Sumerians; they
believed in an afterlife that offered
enjoyments much like the pleasures of
earthly existence. The Minneapolis

false door came from the tomb of an
Egyptian priest buried at Giza, the site
of the Great Pyramids and the Sphinx.
Its limestone panels, lavishly carved
with hieroglyphs and conventionalized
pictures of the deceased, were origi-
nally painted, and traces of color can
still be seen in the cuts. The numerous
inscriptions ask that the king make an
offering in honor of the priest Iry to
aid the dead man's journey to the next
life. The relief served as a place for
offerings of food and drink, and the
door itself—the central, unadorned
niche—was a passageway through
which the soul could leave the tomb
and partake of these gifts.

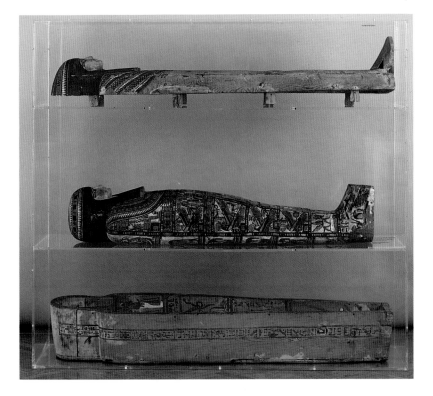

Egyptian (21st–24th Dynasty)
Mummy Case and Coffin of Lady Teshat
1085–710 B.C.
Painted and varnished cartonnage,
polychromed pine coffin
67 in. long
The William Hood Dunwoody Fund
16.414; 16.417

The Egyptians thought that every person possessed a *ka*, a spirit which survived the body's death so long as the corpse remained more or less intact. To preserve the dead, they developed embalming, or mummification, to a high art and built stone tombs, which they supplied with food, furniture, and clothing so that nothing would be lacking in death that had been needed or treasured in life. The Institute's mummy is about three thousand years old. It is the body of a fifteen-year-old woman identified as "Teshat, Lady of the House," a title indicating that she was married and a member of a harem. Because of her father's close association with the pharaoh, as treasurer of the temple of Amon, she was entitled to an elaborate burial. Her prepared body was fully enclosed in a cartonnage—a casing of plastered, painted, and varnished linen—that was in turn placed in a shaped pine coffin. Both the cartonnage and the coffin bear stylized representations of Teshat's face and inscriptions praising the gods and asking their help in gaining immortality. X rays show that an extra adult skull was placed in Teshat's wrappings between her legs—perhaps the embalmers' attempt to conceal a previous mistake.

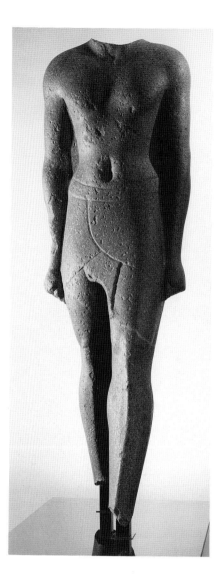

Egyptian (Ptolemaic period)
Striding Figure
300–30 B.C.
Red granite
57 in. high

Anonymous gift 58.14

Ancient Egyptian civilization was remarkably stable and conservative throughout its three thousand years of recorded history—from the rise of Menes, the first pharaoh, about 3100 B.C. until the country fell to the armies of Alexander the Great in 332 B.C. During all those centuries Egyptian art changed very little stylistically, keeping to certain standardized forms, proportions, and poses. Egyptian sculpture was primarily funerary, giving the *ka* an alternative place to reside should the mummy be destroyed. Like many Egyptian statues, this life-sized figure of a nobleman is rigid and artificial in pose. The arms are held stiffly at the sides, and motion is expressed only by the advancement of one leg. However, a subtle softness to the torso's musculature reflects the influence of Greek naturalism on Egyptian forms during the Ptolemaic era, when Egypt was under Greek rule. In the second century A.D., the Roman emperor Commodus claimed this sculpture as a portrait of himself and had his own name and titles carved into the granite support behind the left knee.

Egyptian (Roman period)
Statuette of Isis
1st century A.D.
Bronze
9 in. high
The Morse Foundation 68.9.5

According to Egyptian mythology, Isis
was the wife-sister of Osiris, the son
of Nut (the sky goddess) and Geb (the
earth god). Osiris was murdered by
his evil brother Set, who dismembered
the corpse and scattered it throughout
Egypt. The faithful Isis searched for
the parts of her husband's body,
reassembled them, and with magical
incantations brought him back to life.
Thus, the resurrected Osiris became
the god of the dead and of immortality,
and Isis was regarded as the personifi-
cation of female creative power. In
this small bronze, Isis wears the
double crown of Upper and Lower
Egypt and holds two of her attributes—
a serpent and a libation jug. Although
her stiff-legged stance is typical of
Egyptian works, her gently flowing
garments and individualized face show
Roman influence.

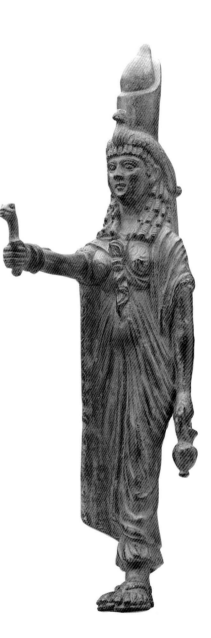

Mesopotamian (Assyria)
Winged Genius
9th century B.C.
Alabaster
90 × 41 in.
The Ethel Morrison Van Derlip Fund
41.9

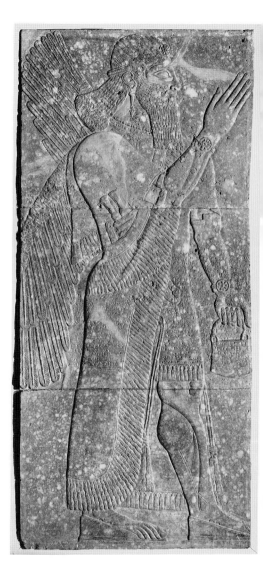

The fierce and hardy Assyrians, who
inhabited northern Mesopotamia,
were the major power in the Near East
from the ninth through the seventh
century B.C. Infamous for their ruth-
lessness and brutality, they made
conquest their chief occupation and
warfare their principal passion. One of
their greatest early rulers was Ashur-
nasirpal II (883–859 B.C.), a man both
cultivated and cruel. In his capital at
Calah (Nimrud), he built a magnificent
palace surrounded by gardens and
orchards that were stocked with
elephants, lions, panthers, and gazelles.
The structure was of brick, with cedar,
juniper, and pistachio timbers, and
many of the rooms had eight-foot-high
stone wainscoting carved with low-
relief scenes of Ashurnasirpal's
exploits as a hunter and warrior. The
Institute's panel is from this palace and
was excavated in the mid-nineteenth
century by Sir Henry Layard, the
British archaeologist who discovered
the ruins at Nimrud. It depicts a per-
sonage often represented in these
bas-reliefs — a winged genius, or spirit,
who guarded the monarch and per-
formed fertility rites associated with
the date palm, a tree held sacred by
the Assyrians because it provided food,
drink, wood, and shelter. Like other
reliefs found at the site, the panel has
a cuneiform inscription across the
center section and was once painted
in bright colors.

Iranian (Marlik)
Repoussé Beaker
About 800 B.C.
Silver
6½ in. high
The Katherine Kittredge McMillan
Memorial Fund 65.36.2

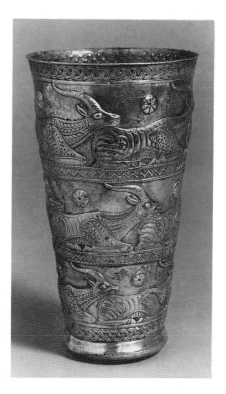

The people of Marlik were a nomadic
Indo-European tribe who once
inhabited northwestern Iran. Unlike
Egypt, which was protected by natural
barriers, the high plateau of Iran was
subject to successive waves of invasion
and foreign domination. Migrating
tribes from the Asiatic steppes and
India crossed this region en route to
Mesopotamia, Asia Minor, and south-
ern Russia. Since they left no monu-
ments or written records, little is
known about those early people except
by way of the small portable objects
they buried with their dead — weapons,
bridles, jewelry, and utensils. The
museum's silver beaker is decorated
with stylized ibexes (wild mountain
goats) worked in repoussé, a technique
in which the metal is hammered from
the back to create raised designs on the
surface. Narrow bands of braided and
zigzag patterns separate the three
rows of reclining animals, and a six-
petaled rosette adorns the bottom
of the cup.

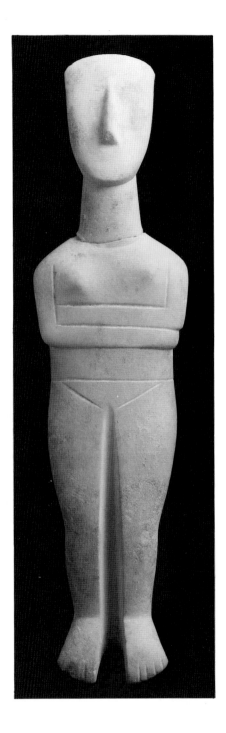

Greek (Cycladic)
Female Figurine
About 2200 B.C.
Marble
16½ in. high
The William Hood Dunwoody Fund
62.52

During the third and second millennia
B.C., three distinct cultures emerged in
the Aegean: the Minoan on Crete, the
Helladic on the mainland of Greece,
and the Cycladic on the small islands
east of the Peloponnesus. Archaeo-
logical excavation of sites on Crete and
the mainland has yielded abundant
information about those Early Bronze
Age civilizations, but our knowledge
of Cycladic culture remains scant.
The few artifacts that have been
found come from modest stone tombs
and include small marble statues, most
of them nude females like this
figurine. Ranging from a few inches to
four feet high, they are schematized
and streamlined, with smooth,
rounded surfaces and simple, abstract
features. The purpose of the Cycladic
"idols" is much debated. Some scholars
think they were meant to be used in
the owner's lifetime, but others
see them as objects made exclusively
for the grave.

Greek (Cyprus)
Head of a Votary
About 500 B.C.
Limestone
12¾ in. high

The William Hood Dunwoody Fund
28.22

Because their land was poor and
mountainous, the early Greeks took to
the sea and established trading and
agricultural communities throughout
the Mediterranean. Borrowing from
the older traditions of the Middle East
and the Aegean, they developed a
culture that became the basis of
Western civilization. During the
Archaic period (about 700–480 B.C.),
they adopted the Phoenician alphabet,
founded city-states such as Athens and
Sparta, and codified laws guaranteeing
the rights of citizens. The architecture
of temples and civic structures became
monumental in scale, with increas-
ingly complex decoration, and vase
painting and sculpture flourished.
Archaic Greek sculpture has the rigid
blockiness and frontal pose of its
Egyptian prototypes. Freestanding
statues usually portray nude males
(*kouroi*) or draped females (*korai*),
representing either divinities or
worshipers (votaries). Votary figures
were placed in temples as untiring
substitutes for mortal worshipers.
This life-sized head from the temple
at Golgoi, on the island of Cyprus, is a
mixture of Greek and Syrian styles.
The large eyes and distinctive smile
are characteristic of Archaic sculpture.
But Cyprus was outside the main-
stream of Greek political and artistic
development and was strongly
influenced by its eastern neighbors.
The cylindrical shape of this head and
its stylized hair and beard are features
typical of Syrian carvings.

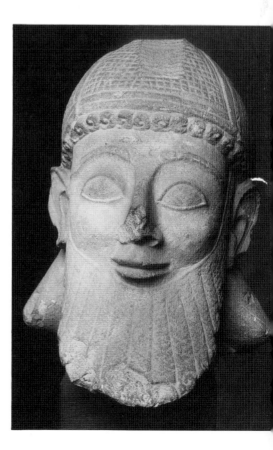

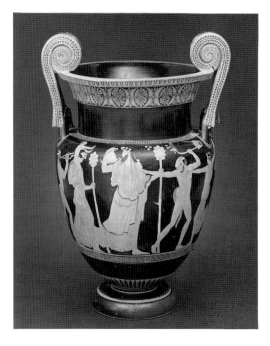

Greek, Methyse Painter
Volute Krater
460–450 B.C.
Terra-cotta
23½ in. high

Gift of Mr. and Mrs. Donald C.
Dayton 83.80

Greek, Antimenes Painter
Hydria
530–500 B.C.
Terra-cotta
20⅛ in. high

The John R. Van Derlip Fund 61.59

Pottery making was the first major
industry to develop in Athens during
the Archaic period, with utilitarian
and luxury wares for both the local
market and export being manufactured
in a variety of shapes and sizes.
Generally, the vessels were made on
a potter's wheel, smaller pots in one
piece, larger ones in sections. The style

of decoration called black-figure, which
came into use around 625 B.C., can be
seen in the museum's *hydria* (three-
handled water jar) by the Antimenes
Painter. The red clay of the pot itself
was left untouched, and silhouettes of
figures were painted on it in black.
This *hydria* shows Athena, the goddess
of war, preparing to jump into her
chariot. About 530 B.C., Athenian
artists began using a new type of
ornamentation, known as red-figure.
With this technique the background,
rather than the figures, was painted
with a lustrous black glaze, and the
unpainted areas of red clay formed
the design. Additional details were
brushed on, not simply scratched into
the surface as with black-figure
decoration. The Institute's volute
krater by the Methyse Painter is an
example of red-figure work. *Kraters*
were fashioned for mixing water and
wine, and this one pictures dancing
satyrs and maenads, the attendants
of Dionysus, the god of wine.

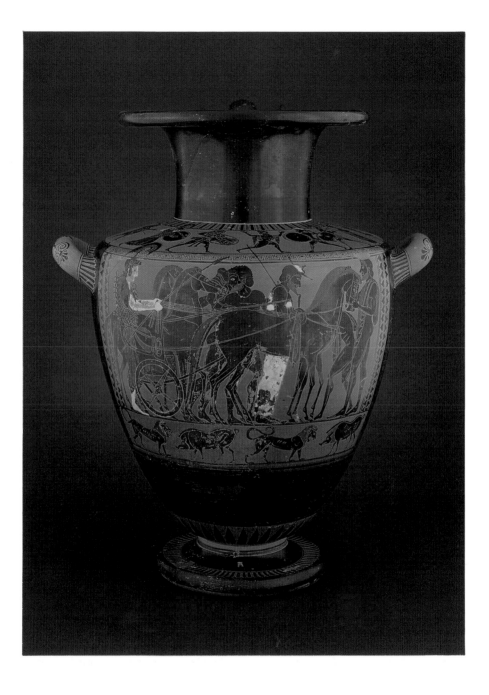

Roman, after a 5th-century B.C. Greek original

Doryphoros (Spear Bearer)
Probably 1st century B.C.
Pentelic marble
78 in. high

The John R. Van Derlip Fund and gift of Bruce B. Dayton, an anonymous donor, Mr. and Mrs. Kenneth Dayton, Mr. and Mrs. W. John Driscoll, Mr. and Mrs. Alfred Harrison, Mr. and Mrs. John Andrus, Mr. and Mrs. Judson Dayton, Mr. and Mrs. Stephen Keating, Mr. and Mrs. Pierce McNally, Mr. and Mrs. Donald Dayton, Mr. and Mrs. Wayne MacFarlane, and many other generous friends of the Institute 86.8

This statue is the finest surviving version of a famous sculpture of antiquity, the *Doryphoros* of Polykleitos. The bronze original (long since lost) was made between 450 and 440 B.C., during the Classical period of Greek history, when Athens was the political, cultural, and commercial center of the Western world. During this golden age, the Parthenon was built on the Acropolis, Aeschylus staged the first tragic dramas, Herodotus wrote his history of the Persian Wars, and democracy was established as a form of government. The most renowned artists of the time were Pheidias, who designed the sculptures for the Parthenon, and Polykleitos, whose statues of young athletes exemplified the naturalistic ideal of Classical Greek art. The *Doryphoros* embodies Polykleitos's theories of rhythm and proportion, which he set forth in a treatise called the *Canon*. In this nude figure he created visual harmony by means of a compositional device called the *chiastic* pose. The tension of the weight-bearing right leg is balanced by that of the spear-bearing left arm; the relaxed, bent left leg is countered by the relaxed, but straight, right arm. The position of the legs—the relaxed leg behind the supporting leg—suggests motion, yet the figure is at rest. Movement and stasis, action and repose, are in perfect equipoise, and the body itself is carefully proportioned. Three other Roman copies of the *Doryphoros* are extant: one in the Vatican, another at the Uffizi, and the third at the Museo Nazionale in Naples.

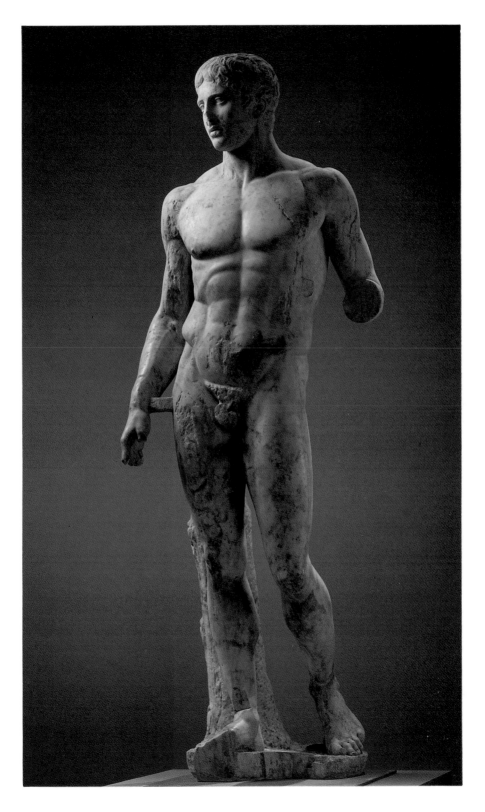

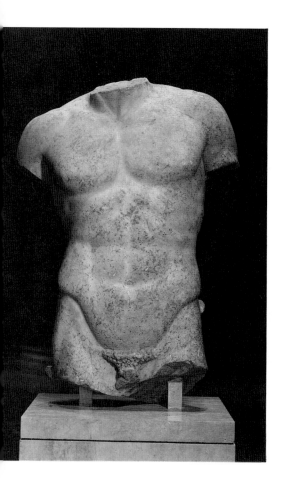

Roman, after a 5th-century B.C.
Greek original
Male Torso
2nd century A.D.
Marble
34¾ in. high

The Sweatt Foundation, in memory
of William R. Sweatt II and Lucian S.
Strong, Jr. 57.40

The ancient Romans admired Greek
sculpture of every period and style,
importing works by the thousands and
copying them in even greater numbers.
This torso is a fragment of a Roman
version of a lost Greek original from
the fifth century B.C. During the Clas-
sical age (about 475–325 B.C.), Greek
thought was dominated by the philos-
ophy of humanism, which taught that
man was the measure of all things and
emphasized the importance of an
educated mind and a healthy body.
These attitudes, coupled with the
Greeks' curiosity about the world
around them, led to the beginnings of
the scientific method and to greater
knowledge of human and animal
anatomy. That the sculptor of the
Institute's torso had studied the male
form closely is obvious from the
naturalistic, though still idealized,
modeling. Despite the lack of head and
limbs, this fragment remains a good
example of the Greeks' use of *con-
trapposto*, showing the asymmetrical
yet balanced posture of a standing
figure with most of its weight sup-
ported on one leg.

Greek (Athens)
Crouching Lion
About 330 B.C.
Marble
48 in. long
The Ethel Morrison Van Derlip
Fund 25.25

The ancient Greeks put stone markers on graves as a way of commemorating their dead. Many extant grave monuments belong to the fourth century B.C., when both stelae (upright slabs) and sculptures in the round were mass-produced for sale. The Institute's lion originally stood in an Athenian cemetery. Although bulls, mastiffs, leopards, and griffins were all placed on tombs as guard animals, the lion was by far the most popular. The muscular body of this beast, with its tense, protruding tendons and veins, shows the anatomical accuracy prized by Athenian artists of the Classical period, whereas the wrinkled brow and chaotic mane display the expressive qualities found in Hellenistic sculpture.

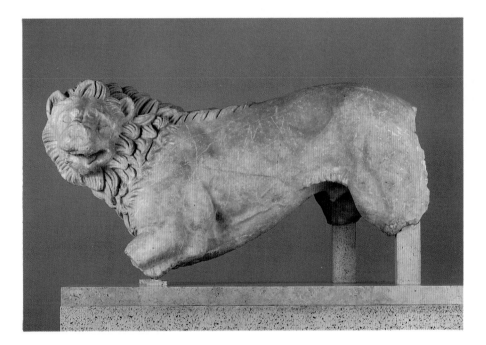

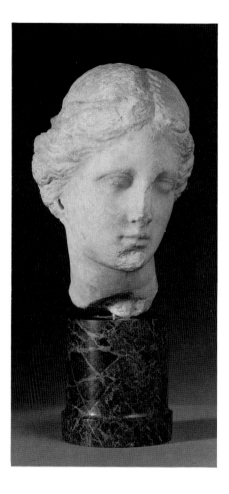

Greek
Head of Aphrodite
3rd century B.C.
Marble
9¾ in. high
The Ethel Morrison Van Derlip Fund
32.15

The defeat of Athens by Sparta in the Peloponnesian War (431–404 B.C.) was followed by a period of chronic political and social unrest. Disunited, discouraged, and vulnerable, Greece was attacked and conquered by Philip of Macedon in 338 B.C., an event that signaled the end of the Classical period of Greek culture and the beginning of the Hellenistic age. Throughout the fourth century B.C. and later, the austere, idealized forms that had dominated the previous century gave way to more individualized renderings, to graceful, almost sensual figures with dreamy or highly emotional expressions. This smaller-than-life-sized head of Aphrodite (goddess of love and beauty) is stylistically similar to copies of Praxiteles' Knidian Aphrodite. The sensitive treatment emphasizes the womanly, rather than the divine, qualities of the goddess, and despite extensive damage to the nose and chin, the face retains a delicacy and pensiveness often seen in Hellenistic sculpture.

Greek
Tiber Muse
Late 2nd century B.C.
Marble
47 in. high
The John R. Van Derlip Fund 56.12

Hellenistic sculpture, exemplified by
the *Winged Nike of Samothrace* in the
Louvre, is known for its energetic real-
ism and a variety of subject matter
ranging from the heroic to the banal.
Tiber Muse is thoroughly Hellenistic
in style and pose. The figure (missing
its head and arms) leans forward casu-
ally, the left foot raised and propped
against a rock. The deeply cut folds,
creases, and gathers of her drapery
lend textural and dramatic interest
while disclosing the voluptuous young
body underneath. The statue was
found in Rome in 1885, and scholars
suggest that it represents a muse
or a nymph or perhaps Aphrodite
(goddess of love) or Hygieia (goddess
of health).

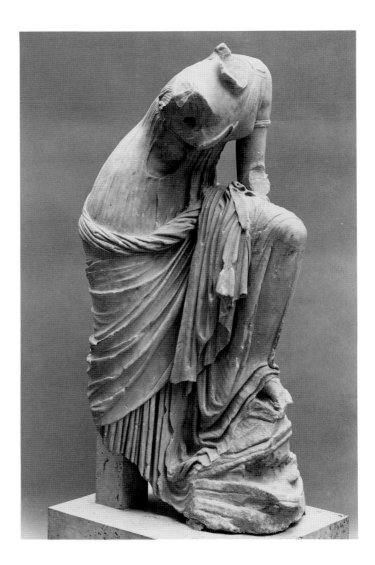

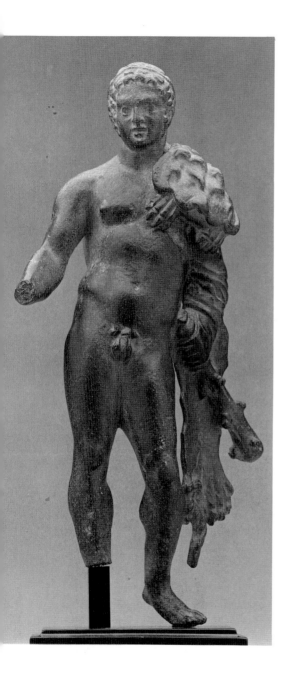

Greek (Ptolemaic)
*Ptolemaic Ruler in
the Guise of Herakles*
3rd century B.C.
Bronze
9 in. high
The Christina N. and Swan J. Turnblad
Memorial Fund 68.81

The mythological Herakles (the
Roman Hercules), renowned for his
tremendous strength and courage, is
often depicted wearing a lion pelt as
a cloak and carrying a club. The
museum's bronze figure includes both
of these attributes, but the highly
individualized face and the headband
or fillet (a traditional symbol of
monarchy) indicate that it is a portrait
of a temporal ruler, probably
Ptolemy III Evergetes, king of Egypt
from 246 to 221 B.C. Although cast in
Egypt, this statuette is wholly Greek in
origin and Hellenistic in character.
When Alexander the Great succeeded
his father, Philip of Macedon, in
336 B.C., he established an empire that
stretched from northwestern India to
the Mediterranean and included Asia
Minor, Persia, Mesopotamia, Egypt,
and the whole of Greece. He made
Greek the official language and
founded at least half-a-dozen new
cities named Alexandria. In Alex-
andria, Egypt, he built a magnificent
library and museum that housed Greek
books and works of art. Greek culture,
which had once been limited to the
Aegean, spread throughout the Middle
East and was the dominant influence
there for centuries.

Roman (Pompeii)
Floor Mosaic with Crab Motif
1st century B.C.
Marble
33⅞ × 65¾ in.
Gift of James F. and Louise H. Bell
72.55

The Romans were excellent architects and engineers. They were the first to extensively use the rounded arch, barrel vault, and dome, and the remarkable substance called concrete. In domestic architecture, they adapted Greek and Etruscan elements, building houses that were both comfortable and luxurious. The dwellings of the well-to-do were designed around an atrium, a central court with a large rectangular opening in the roof to admit light and fresh air and also rainwater, which was collected in a pool (*impluvium*) sunk into the floor. The entryways, dining rooms, bedrooms, and service areas constructed around the atrium were often decorated with lavish wall paintings and colored floor tiles. This mosaic from Pompeii comes from the floor of such a house. The large salt-water crab in the center is surrounded by red, green, black, and white pieces of stone (tesserae) arranged in geometric and floral patterns. Since the crab is the traditional symbol of Cancer, the fourth sign of the zodiac, it may be that the panel was one of twelve set into the same marble pavement to illustrate the months of the year.

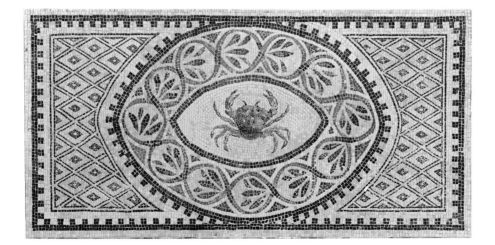

Roman (Pompeii)
Standing Deity
1st century A.D.
Paint on plaster (fresco)
33¾ × 18¼ in.

Gift of Mr. and Mrs. Lawrence Rubin
79.21

The eruption of Mount Vesuvius on
24 August A.D. 79 buried the southern
Italian cities of Pompeii, Herculaneum,
and Stabiae in volcanic mud, pumice,
and ash. In the middle of the eigh-
teenth century, these forgotten cities
were discovered and their excavation
was begun. Almost all the Roman
murals and many of the floor mosaics
known today come from these three
sites. The Institute's painting,
uncovered in Pompeii in the late nine-
teenth century, is a fragment of a
domestic shrine. It was executed in the
fresco technique, in which water-based
pigments are applied directly to moist
plaster. The subject is a Lar, a Roman
household deity, wearing a red tunic
and a green pallium, or cloak. He
carries a drinking horn and a wine
bucket, the attributes of the Lares. The
ancient Romans honored the Lares as
guardians of the family's prosperity
and well-being and worshiped them,
along with other household spirits,
at the door, cupboard, and hearth.

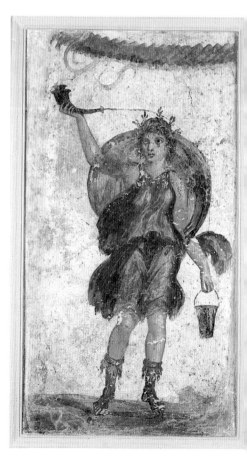

Roman
Portrait of a Matron
About A.D. 60–70
Marble
50½ in. high
The William Hood Dunwoody Fund
32.16

The realistic portrait in stone and the
historical relief emerged as distinc-
tively Roman sculptural forms. The
portrait was intended to preserve a
person's likeness, the historical relief
to commemorate a political event or
honor a public figure. Unlike Classical
Greek art, which was an attempt to
embody the ideal, Roman sculpture
was factual and particular, reproducing
the subject's flaws and idiosyncracies.
In this marble statue, probably made
during Nero's reign (54–68), obviously
Roman qualities are combined with
characteristics of late Greek (Helle-
nistic) sculpture. The elaborate, deeply
cut drapery accentuating the firm-
breasted body reflects Hellenistic taste,
but the realistic rendering of the face
is typically Roman. Beneath the stiff,
curled rows of a fashionable Neronian
coiffure, we see the tired, bony
countenance of a middle-aged woman
whose lined face and slack skin betray
her age. Yet she possesses an aura of
stern dignity that reveals the Roman
artist's ability to depict personality
as well as appearance.

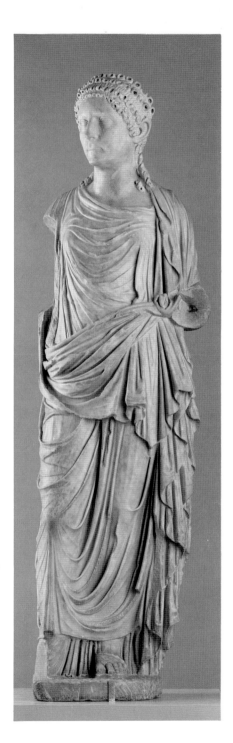

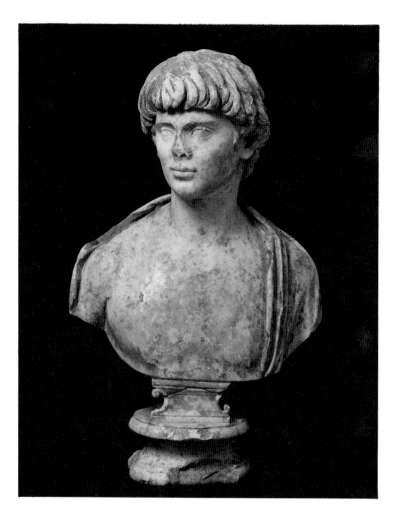

Roman
Bust of a Young Nobleman
2nd century A.D.
Marble
28 in. high
Gift of the Morse Foundation 68.9.2

Portrait sculpture had a long history with the Romans, beginning with the terra-cotta heads of the Etruscans and including the wax effigies and death masks of the early Republic. During the Imperial era (about 27 B.C.– A.D. 395), the relentless realism that had characterized Republican statuary was often tempered with idealism, as in this bust from the second century A.D. The incised pupils and large size suggest that the piece was made during Hadrian's rule (117–38), but the sparing use of the drill and the unruly mass of hair typify sculpture from the reigns of Antonius Pius (138–61) and Marcus Aurelius (161–80). This handsome youth may have belonged to the intellectual circle of Herodes Atticus, an Athenian rhetorician and Roman senator who kept a salon frequented by young aristocrats.

Roman (Early Christian)
Head of a Young Man
A.D. 325–425
Sandstone
10 in. high

The Putnam Dana McMillan Fund
70.68

Late Roman art reflected the severe economic and political problems of the deteriorating empire. Rome was sacked by Alaric the Goth in A.D. 410, and by 476 the empire had come to an end in the West, although it survived in the East until the fall of Constantinople (Istanbul) in 1453. The uncompromising realism that had been the hallmark of Hellenistic and Roman sculpture increasingly gave way to simpler and technically cruder work, such as this head of a young man. The frontal gaze, large incised eyes, and flamelike hair are typical of imperial portraits after the time of Constantine the Great (died 337). For the next thousand years, portraiture in the Greco-Roman sense was extinct, replaced by the highly stylized images of the Middle Ages.

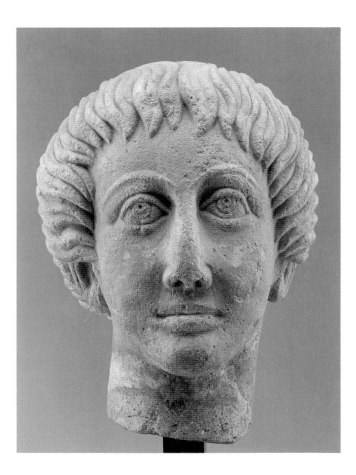

The Middle Ages

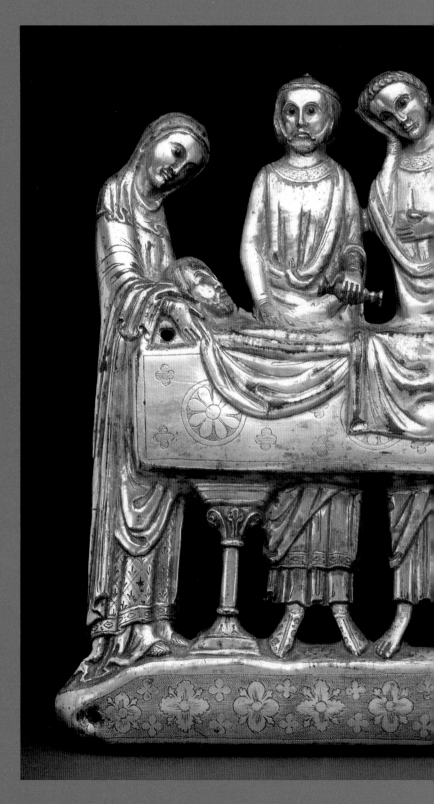

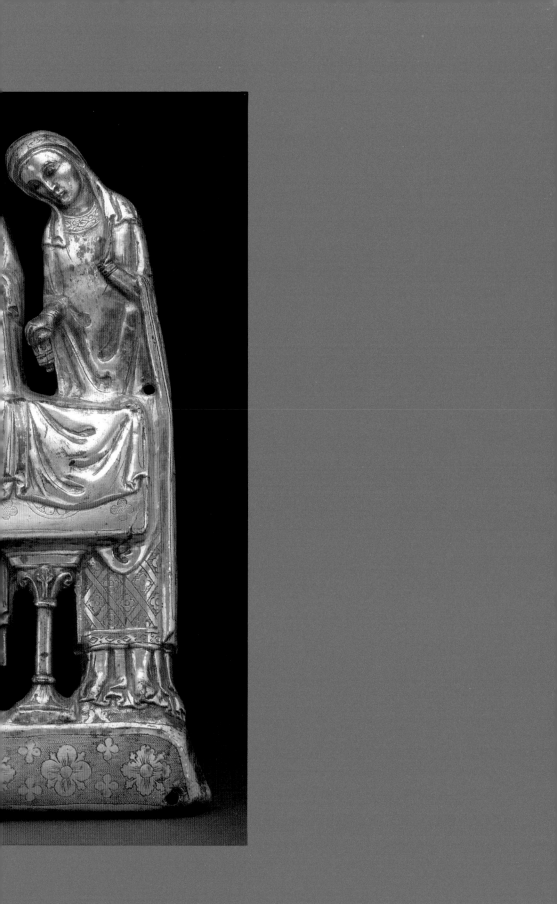

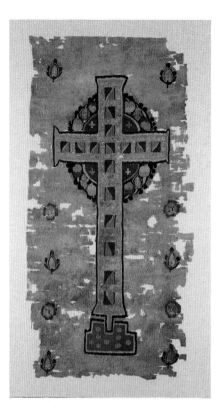

Egyptian (Coptic)
Hanging with a Latin Cross
5th–7th century
Tapestry weave, linen and wool
54½ × 27½ in.

Gift of the Aimee Mott Butler
Charitable Trust, Mr. and Mrs. John F.
Donovan, the estate of Margaret B.
Hawks, and Eleanor Weld Reid 83.126

During the Middle Ages (roughly 500–
1500), the Christian church influenced
nearly every sphere of life—politics,
economics, agriculture, education, and
the arts, as well as religion. Christian-
ity flourished in the Middle East until
the Muslim conquests of the seventh
century, and Christian monasticism,
which became so important in
medieval Europe, had its beginnings
in Egypt, among the Copts. The first
monks lived as hermits in the desert,
but in the fourth century a monastic
community was established on an
island in the Nile. The Institute's
Coptic tapestry was probably woven
in a monastery as a sanctuary curtain
and then used later as a burial pall. Its
brilliant colors and large Latin-style
cross are unusual. The designs of most
extant Coptic textiles are not overtly
religious, and when crosses are
depicted, they are generally small
ones of the Greek (equal-armed) type.
Here, the combination of the wreath
(a classical emblem of victory) with
the cross symbolizes Christ's triumph
over death. Shown with fruit and
flowers the cross and wreath signify
renewed life. The green-and-orange
squares represent jewels, and the
border along the sides of the fabric con-
sists of alternating leaves and rosettes.

French
Madonna and Child
Late 12th century
Marble
29 in. high
The Christina N. and Swan J. Turnblad
Memorial Fund 66.24

In the political, economic, and social disruption of the early Middle Ages, painting, sculpture, and architecture were neglected. By about the year 1000, however, a new style—the Romanesque—was developing. An important aspect of Romanesque art was the revival of monumental stone sculpture, which had long been out of favor because of its association with idolatry. This *Madonna and Child* is stylistically similar to a number of schematized and coarsely executed sculptures from the central region of the French Pyrenees. Posed as the throne of wisdom (*sedes sapientiae*), the Madonna holds the Christ Child on her right knee, and in her left hand displays a lily with an enlarged flower, symbolizing her virginity and fertility. The Child's right hand is raised in the traditional gesture of blessing. The back of the image is not carved, suggesting that this statue was originally placed against a wall.

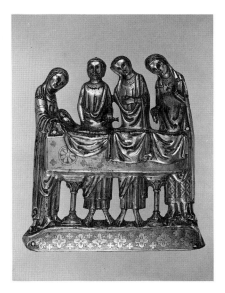

heads and dark blue enamel eyes. The evenly worked surfaces of their simple garments and of the coffin are decorated with stamped geometric and floral designs. Both Joseph and Mary Magdalene have movable arms, suggesting that the ointments were "poured" from their tiny vessels in reenactments of the Passion during Holy Week.

French (Limoges)
The Anointing of the Body
About 1220–40
Gilt copper with enamel
11½ × 11 × 1½ in.
The William Hood Dunwoody Fund
58.8

During the twelfth, thirteenth, and fourteenth centuries, the city of Limoges in south central France was a thriving center for the fabrication of objects in gold, silver, and enamel. This plaque, along with similar reliefs now in Cluny, Baltimore, and Boston, was once part of an altarpiece depicting the life of Christ. It illustrates one of the final events of the Passion: the preparation of Jesus' body for burial. The Virgin tenderly supports the head of her dead son, while Joseph of Arimathea and Mary Magdalene anoint the body with preserving balms. Between Joseph and Mary Magdalene stands Saint John the Evangelist, clasping his head in grief. All the figures are stylized, columnar, and stiff, with small

Swedish (Gotland?)
The Coronation of the Virgin
About 1250
Stained glass
37 × 18¾ in.
The William Hood Dunwoody Fund
32.11

Stained-glass windows were a special achievement of the Gothic age—jewel-like walls of color and light that flickered and changed with every passing hour and season. In this small window attributed to the Gotland school of craftsmen, pieces of red, blue, green, and yellow glass have been fitted together with strips of lead to depict the Coronation of the Virgin. The details of the faces, hands, and drapery were drawn directly on the glass with black paint (a technique typical of this medium), and the whole panel was reinforced with a metal armature. Generally the final scene in narratives of the life of Mary, the Coronation follows the Death and Assumption of the Virgin, showing her welcome into Paradise. Here, inside an almond-shaped frame (mandorla) partially bordered by acanthus leaves, Mary and Christ share a throne while he crowns her Queen of Heaven.

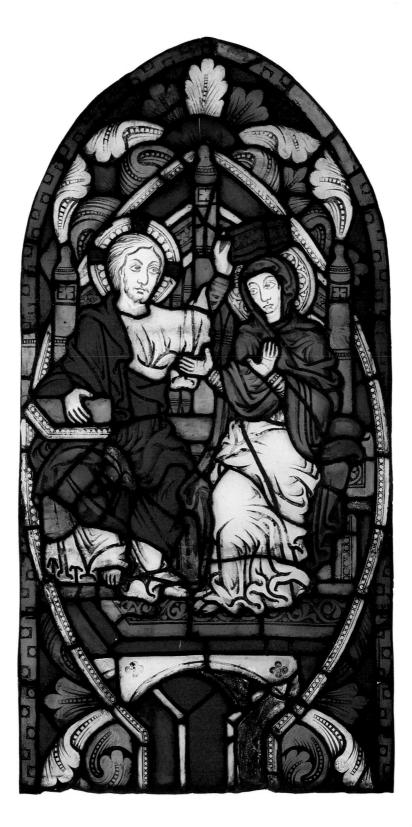

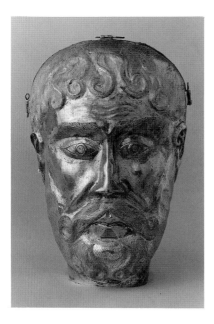

Italian
Reliquary Head of Saint Theobald
About 1300
Silver, silver gilt, and copper
14 in. high

Gift of Bruce B. Dayton 83.73

The custom of placing the relics
(bones or other remains) of saints and
martyrs in finely wrought containers,
for veneration by the faithful, began in
the fourth century and continued into
the sixteenth. Early reliquaries took
the form of caskets, or boxes; later
ones were often shaped like buildings
or like their contents. This life-size
silver head may have held the cranial
relics of Teobaldo Roggeri, a pious
twelfth-century cobbler who lived in
the town of Alba, in northwestern
Italy. A fitted leather case made for it
in the early nineteenth century bears
the inscription HIC LATET CAPUT S.
THEOBALDI (Herein is concealed the
head of Saint Theobald). Reliquary
heads such as this are rare. They were
often melted down for their metal, and
most of those extant remain in monas-
teries. Dating this one accurately is
difficult, because the stylized hair and
beard suggest late Gothic workman-
ship, whereas the shallow skull and
hieratic frontality of the face are
Romanesque characteristics.

French (Ile-de-France)
Standing Madonna and Child
14th century
Polychromed limestone
24 in. high

Gift of Mrs. Harry A. Bullis in
memory of her husband 63.59

The Gothic style first appeared around
1150 in central France. It reached its
peak there and throughout Europe by
1300 and remained strong in the north
until the late fifteenth century. Gothic
cathedrals, with their pointed arches,
ribbed vaults, and flying buttresses,
soared heavenward. And Gothic sculp-
ture, too, rejected the heavy, earth-
bound proportions of the Romanesque
in favor of the graceful, the attenuated,
and the naturalistic. These qualities
can be seen in this relatively small
French sculpture of the Madonna
and Child. The rosy-cheeked Virgin,
dressed in traditional red and blue
robes, is all comeliness and humility.
She looks demurely away from the
infant balanced on her left hip, her
body curving gently in a rhythmical S
shape. The bouquet of barbless roses
in her right hand signifies that she is
the sinless "rose without thorns."
Looking up at his mother, the Child
makes the sign of blessing with the
open palm of his right hand; in his left
hand, he holds an orb symbolizing his
sovereignty over the world.

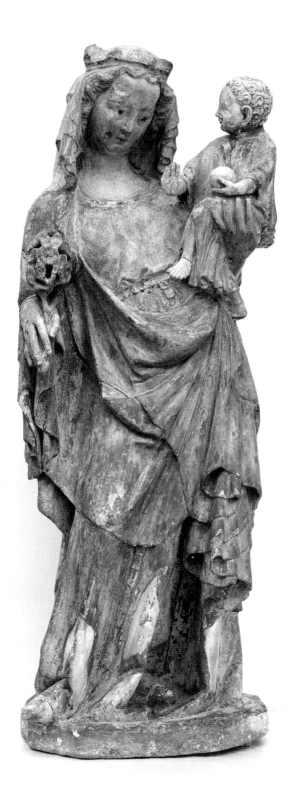

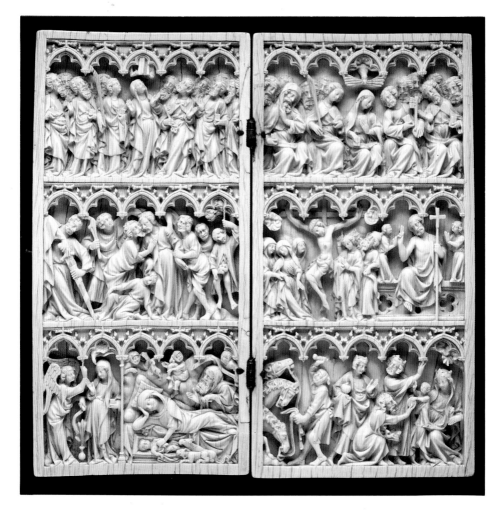

French

Diptych with Scenes from the Life of Christ
About 1375
Carved ivory with traces of paint
8³/₁₆ × 8¾ in.

Gift of Mr. and Mrs. John E. Andrus III, Atherton and Winifred W. Bean, and an anonymous donor 83.72

Ivory—the hard, creamy-colored tusks of elephants, narwhals, walruses, and hippopotamuses—has been used for sculpture since Paleolithic times. In the Middle Ages, particularly in France, ivory carvers produced exquisite reliefs and statuettes, representing both religious and secular subjects. This fourteenth-century diptych (two-paneled work) portrays scenes from the life of Christ, beginning in the bottom left-hand corner with the Annunciation and moving to the right with images of the Nativity and the Adoration of the Magi. The middle tier contains events of Christ's Passion: the Betrayal (with Judas hanged, at the right), the Crucifixion, and the Resurrection. Along the top are the Ascension of Christ and, finally, Pentecost, when the Holy Spirit (shown here as a dove bringing rays of light) descended to the apostles. The attitudes of the figures in these intricate vignettes, the style and arrangement of the drapery, and certain features of the Gothic arches relate this piece to several small diptychs attributed to the workshop of the Master of the Passion Diptych. The Minneapolis ivory, too, may have been made there.

German

Rider Aquamanile
15th century
Bronze
13 in. high
Miscellaneous purchase funds 56.40

As its Latin names indicates, an aquamanile is a container made to hold water for washing the hands. The form is an ancient one, based on Islamic prototypes. In Europe, from the twelfth to the sixteenth century, aquamanilia in both animal and human shapes were made for the nobility, who used them at table, and for the church, where they were used in the ritual cleansing of the priest's hands before celebration of the Mass. This one, in the form of a mounted knight (the protector of life and property in feudal society), is filled through a hole behind the horse's ears and emptied through the spout protruding from the animal's breast. It would have been placed on the dining table for use between the courses of a meal.

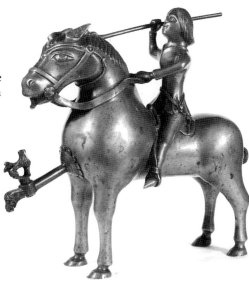

Austrian (Salzburg)
Saint Catherine of Alexandria
About 1450–60
Polychromed and gilded linden wood
63 in. high

Gift of Ethel Morrison Van Derlip in
memory of her mother, Julia Kellogg
Morrison 20.11

After the Virgin Mary and Mary
Magdalene, Catherine of Alexandria
was one of the female saints most
often depicted in medieval art. Accord-
ing to legend, she was a beautiful
virgin of royal descent, queen of Alex-
andria in the fourth century and a
devout and learned convert to Chris-
tianity. When she refused to deny her
faith and marry the Roman emperor
Maxentius, she was first imprisoned
and later tortured on four wheels
studded with iron spikes and knives.
When those measures failed to hurt
her or break her will, Maxentius had
her beheaded with a sword. The Min-
neapolis Saint Catherine is carved in
a late Gothic manner sometimes called
the "hard style," characterized by stocky
figures and angular treatment of
drapery. The wooden form was
covered with linen and then painted to
show Catherine as a handsome young
woman with long blonde hair. She
treads upon the back of the crouched
Maxentius, whose pained expression
and coarse features contrast sharply
with her own serenity and fairness—
an allusion to Christianity's superiority
to and triumph over paganism.

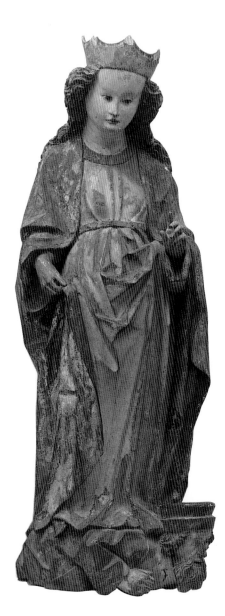

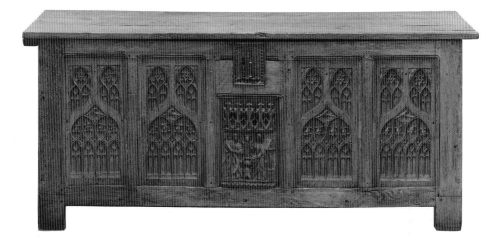

French
Chest
15th century
Oak
28¾ × 67½ × 24¾ in.
Bequest of John R. Van Derlip in
memory of Ethel Morrison Van Derlip
35.7.40

Gothic architecture was the glory of
medieval Europe and dictated the
form that the other fine and applied
arts took during the later Middle Ages,
from painting and sculpture to furni-
ture, textiles, silverware, and
armaments. Gothic furniture, which
came into its own during the early
thirteenth century, included stools,
benches, chairs, trestle tables, box
beds, cupboards, and writing desks.

But the most prevalent article of
medieval furniture was the chest, or
coffer. Although used primarily to
store clothing and linens, it also served
as a seat, table, or bed, if it had a flat
top. Unlike Romanesque examples,
which were often gaily painted to hide
their crude construction, most Gothic
chests were skillfully crafted and
carved. The museum's French Gothic
chest is made of oak, a building
material favored in northern Europe
and England because of its durability
and abundance. The front and sides
are decorated with elaborate tracery of
the type found in Gothic cathedrals,
except for the front center panel,
which shows the Annunciation (the
Archangel Gabriel telling the Virgin
she will be the mother of Christ).

Spanish (Toledo?)
Antiphonary Page
Late 15th century
Gouache and gilding on parchment
27½ × 18½ in.

The John R. Van Derlip Fund 44.1

Since ancient times, handwritten books have been illuminated, or "lighted up," with ornamental lettering, borders, and pictures. During the Middle Ages, manuscript pages were made of vellum or parchment (prepared animal skins), the text was written in ink, and the decoration was done with egg-based paints and precious metals. This leaf is from an antiphonary, or choral book, commissioned by a high-ranking churchman of the Mendoza family, whose coat of arms appears at the bottom of the page. It contains several lines of verse to be sung during the office of matins (the morning prayers of the clergy) on the feast of Corpus Christi. Celebrated on the ninth Thursday following Easter Sunday, the feast of Corpus Christi honors the sacrament of the Eucharist (the ceremonial eating and drinking of

bread and wine), which was instituted at the Last Supper, illustrated here in the miniature painting.

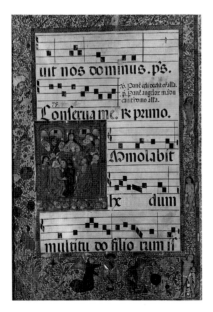

Flemish (Arras) or French (Tournai)
Hunting Party with Falcons
About 1440–50
Tapestry weave, wool warp and weft
135 × 128 in.

Gift of Mrs. C. J. Martin for the Charles Jairus Martin Memorial Collection 15.34

Many of the furnishings of medieval castles and churches were textiles— window curtains, bed hangings, wall tapestries, and chair cushions all served both for comfort and as decoration. *Hunting Party with Falcons* originally formed part of the right-hand side of a larger wall hanging. It is similar in style to the famous Devonshire Hunting Tapestries from Hardwick Hall, which now hang in the Victoria and Albert Museum in London, and probably came from the same workshop as those tapestries. The elegantly dressed lords and ladies in the Minneapolis tapestry are engaged in falconry—the sport of hunting game with trained birds of prey—a favorite pastime of the nobility in the Middle Ages. Against a forested background, they are shown hawking in a flowery meadow near a castle, accompanied by their dogs. The scene includes various aspects of the exercise and discipline of the birds. Several falcons remain on their leads, perched on the heavy leather gloves that protect their owners' fists. One bird is being unhooded, another untied, and yet another is already returning to its master's upraised arm. At the top center, two hawks circle a heron, about to bring it down, and to the right a waving lure beckons them back.

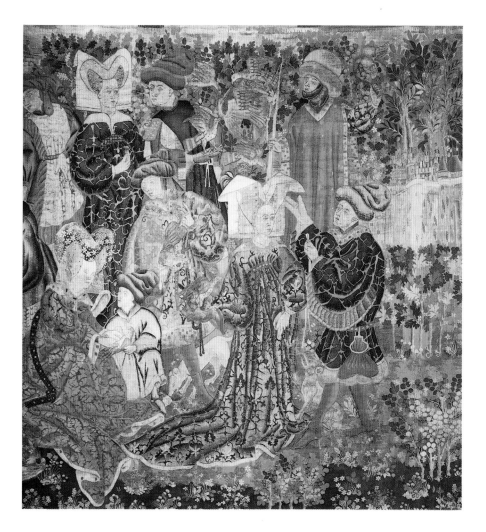

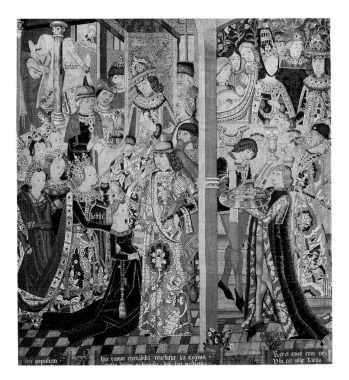

Flemish (Tournai)
Esther and Ahasuerus
About 1470–80
Tapestry weave, wool warp, wool and
silk weft
133½ × 128 in.

Gift of Mrs. C. J. Martin for the
Charles Jairus Martin Memorial
Collection 16.721

From the days of Charlemagne on,
Europe's aristocracy, particularly the
powerful rulers of Burgundy, Berry,
and Anjou, were generous patrons of
the arts. Philip the Good, duke of
Burgundy, is known to have bought
a set of six tapestries representing the
life of Esther from Pasquier Grenier
of Tournai in 1462. The Institute's
tapestry, made about twenty years
later, probably was woven in Grenier's
workshop too, perhaps from the same
cartoon (design) used for the duke's

set. The Old Testament story of Esther
was a popular subject of medieval art.
A beautiful Jewish orphan, Esther was
chosen as the wife of King Ahasuerus
(Xerxes) of Persia. After her marriage,
she learned of a plot to murder all the
Jews in the kingdom, and by pleading
with Ahasuerus, who did not know she
was Jewish, she saved her people. The
event is still commemorated at the
feast of Purim. In the tapestry's upper
left-hand corner, Esther's cousin
Mordecai tells her of Haman's evil
scheme to massacre the Jews, and
Esther prays for God's help to prevent
the disaster. Below this scene, she
kneels before the king in his private
chambers, asking that he and Haman,
his chief advisor, attend a banquet she
has prepared in their honor. Finally,
to the right, Esther and Ahasuerus
preside over a meal of game birds and
wild rabbit while Haman, his treachery
revealed, slinks away.

Flemish (Brussels)
The Prodigal Son
About 1515
Tapestry weave, wool warp, wool and silk weft
156 × 252 in.
The John R. Van Derlip Fund 37.17

This excellent example of late Gothic weaving was made in Brussels at a time when that city was Europe's leading supplier of tapestries. It illustrates the parable of the prodigal son (Luke 15:11–32), the story of a youth who squandered his inheritance in riotous living and then returned, poor and repentant, to his father's house. After receiving his portion from his aging father (upper left corner), the Prodigal spends his wealth on Pleasure (center), succumbs to Gluttony (lower right center), and gives himself to Lust (lower left center). But the women who personify these vices all spurn him later when he becomes a pauper (lower right corner), and at last, stripped of his finery, bareheaded, and penniless, he is abandoned by his sole remaining companion (upper right corner). In his desolation, however, Repentance, Humility, and Mercy (top center) are at hand to save him.

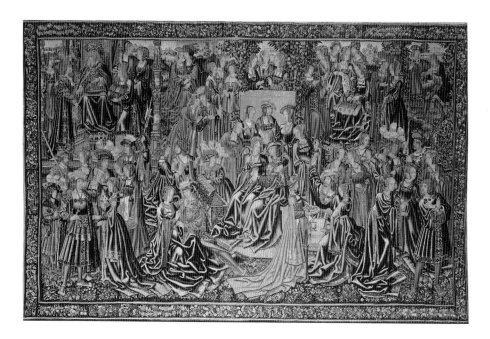

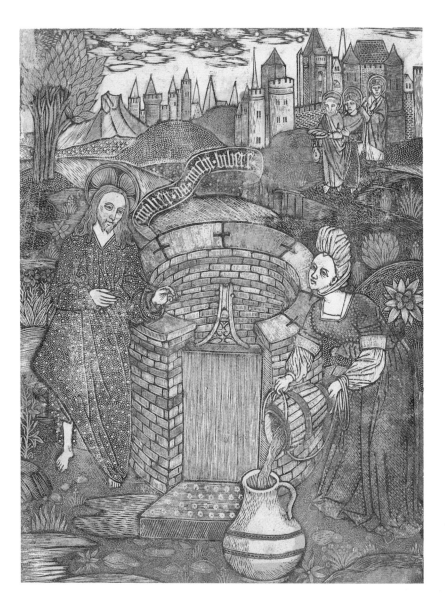

Master of Jesus in Bethany
Netherlandish, 15th century
Christ and the Woman of Samaria
About 1470
Hand-colored dotted print (metalcut)
9³⁄₁₆ × 6¾ in.

Bequest of Herschel V. Jones
P.68.90

Dotted prints were made primarily in Germany and the Netherlands, during the 1470s and 1480s. They were printed from copper, brass, or pewter plates (actually easier to carve than wood blocks), on which the artist had created intricate designs by means of cutting, stamping with punches, and drilling. (The drilling formed the characteristic dots.) In printing, the raised surfaces of these relief plates transferred ink to the paper, while the depressions left white areas. *Christ and the Woman of Samaria* is a rare dotted print, the only surviving impression of this image. It depicts an episode from the life of Christ (John 4:5–42) that can be interpreted as an allusion to baptism. While traveling through Samaria with his disciples, Jesus stopped at a well. A woman came to draw water, and he asked her for a drink (his words are shown on a scroll). This surprised her, since Jews had no dealings with Samaritans, but he said to her, "If you knew the gift of God, and who it is that is saying to you, 'Give me a drink,' you would have asked him, and he would have given you living water."

Master E. S.
German, 15th century
Saint Mark the Evangelist
About 1460–65
Engraving
Diameter 4⅝ in.

Gift of Paul J. Sachs P.12,516

Most early European printmakers remain anonymous, but some of them initialed their works and are known today by their monograms. Master E. S., who marked twenty-six engravings *e, E, S,* or *ES,* seems to have been active in the region of the Upper Rhine from 1450 until the late 1460s. He was a pioneer in the art of engraving, which grew out of the goldsmith's technique of decorating metal surfaces with incised lines. This roundel of Saint Mark, the patron saint of Venice, shows the precise draftsmanship of Master E. S. and his method of shading with short parallel lines and cross-hatching. The saint carries his gospel and is attended by a winged lion, his traditional attribute. The swirling folds of his tunic and cloak recall treatments of drapery in late Gothic German paintings. Costlier to produce than woodcuts and printed in limited editions, early engravings were usually sold to the well-to-do at fairs and church festivals.

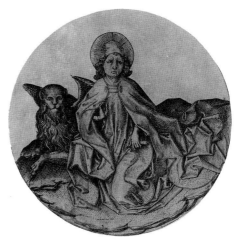

Firabet of Rapperswil
Swiss, active 1465–80

Christ on a Goldsmith's Cross
About 1465
Hand-colored woodcut
15 7/16 × 9¾ in.

Bequest of Herschel V. Jones
P.68.164

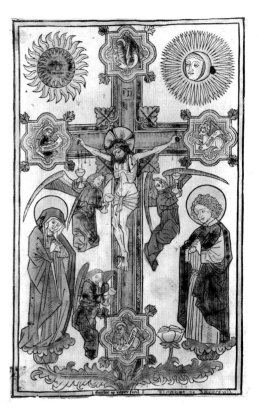

Although the oldest known European woodcuts date to the late fourteenth century, the earliest prints to survive in any quantity are from the fifteenth century and include devotional images and playing cards. This print, one of only two known impressions of Firabet's woodcut, is among the first to document both the name and the city of its cutter in an inscription—*firabet ze raperswil.* The dying Christ is shown entrusting his mother to the care of Saint John. Incorporated into the arms of the cross are the signs of the four Evangelists: the winged man of Matthew, the lion of Mark, the ox of Luke, and the eagle of John. The blood from Christ's wounds, caught in chalices held by three angels, symbolizes the Eucharist. The depiction of the sun and moon together is found in portrayals of Greek and Persian sun-gods and on Roman coins. Adapted to Christian art, it became a common motif in representations of various themes, including the Crucifixion. Here, the sun and moon signify the darkness that fell over the earth when Christ died, the sadness of all creation at his death, and the idea that the Old Testament is to be understood in the light of the New.

Martin Schongauer
German, 1450?–91
A Bishop's Crosier
About 1475–80
Engraving
10¾ × 4⅜ in.

Bequest of Herschel V. Jones
P.68.259

Gothic art had reached its zenith by about 1300, but the Gothic style prevailed in northern Europe throughout the fourteenth and fifteenth centuries. Martin Schongauer's prints combine the austerity of the northern Gothic style with the richness of Italian Renaissance art. The son of a German silversmith, Schongauer settled in Colmar, on the Upper Rhine, and became an accomplished printmaker as well as a painter. Following the example of E. S., with whom he may have studied, Schongauer monogrammed all 115 of his plates with his initials, a cross, and a crescent, but he never dated them. He was the first virtuoso engraver in medieval Europe, and some of the methods he developed for working the copper plate are still in use today. This engraving of a crosier (bishop's staff) shows the delicacy and clarity of Schongauer's mature manner in every detail, from the architectonic qualities of the staff, with its Gothic flourishes, to the enthroned Madonna and Child in the volute.

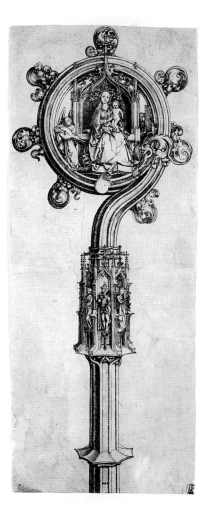

The Renaissance

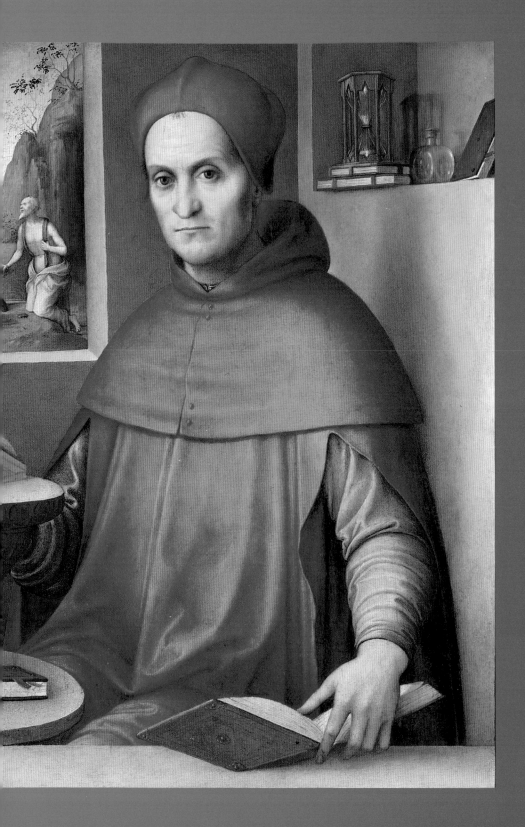

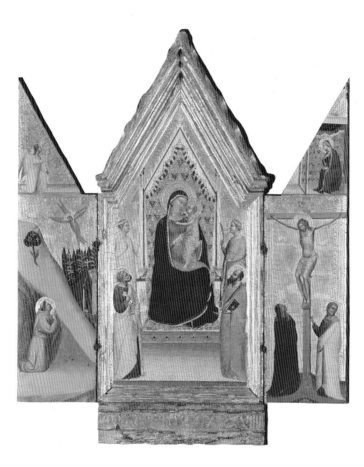

Bernardo Daddi
Italian (Florence), active 1312–48
Madonna and Child with Saints
1339
Tempera on panels
23½ × 19¾ in.
The Ethel Morrison Van Derlip
Fund 34.20

The Italian Renaissance, which
flowered in the fifteenth and sixteenth
centuries, began in the early thirteen
hundreds with the humanistic writings
of Petrarch and the frescoes of Giotto.
Like the paintings of other fourteenth-
century Florentine artists who
followed Giotto's example, Bernardo
Daddi's works contain both medieval
and proto-Renaissance elements. They
are shaped and gilded in the Gothic
manner, but the spatial depth and

the solidity of the forms anticipate
Renaissance art. This small triptych
(three-paneled painting), made for
a domestic altar, illustrates several
events from the life of Christ. In the
central panel, an enthroned Madonna
gazes sweetly at the Child, who stands
in her lap, while Saints Helena,
Catherine, Peter, and Paul look on in
adoration. In the right wing, Mary and
Saint John sadly witness the Cruci-
fixion, and in the left, Saint Francis
kneels to receive the stigmata (the
marks of Christ's wounds). In the left
pinnacle the Archangel Gabriel
announces the Incarnation to a demure
Virgin who sits opposite. The painting
was obviously meant to be portable:
the hinged side panels can be folded
over to protect the central scene when
the triptych is in transit.

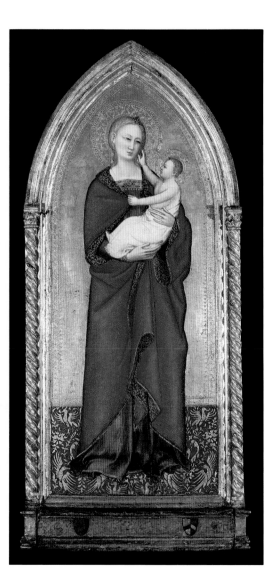

Nardo di Cione
Italian (Florence), active 1343–66
Standing Madonna with Child
Mid-14th century
Tempera on panel
38½ × 17⅛ in.

Bequest of Miss Tessie Jones in memory of Herschel V. Jones 68.41.7

During the fourteenth and fifteenth centuries, most paintings were executed either in fresco on a wall or in tempera on a wooden panel. In tempera painting, ground pigments mixed with egg yolk and water were carefully applied to a hardwood panel already coated with layers of size (glue), linen, and gesso (plaster). That was the technique Nardo di Cione used in this painting of the Madonna and Child, one of only ten panels attributed to him. The monumental, humane tradition of Florentine art is here combined with the decorative manner of the Sienese to produce an image in which the volume of the figures counterbalances the flatness of the gold background. When this work was cleaned in 1983, the background proved to be in excellent condition, but the original blue of the Madonna's robe had largely disappeared. Azurite, the mineral often used by Italian artists of the trecento (fourteenth century) and quattrocento (fifteenth century) for the color blue, tends to disintegrate or turn black in the course of time. Following the incised lines with which Nardo had delineated the drapery folds, a conservator applied blue paint to the area of the robe, reconstructing Nardo's design as far as possible. The blue pigment in the cloth of gold at the Virgin's feet is lapis lazuli rather than azurite, and it is still perfectly preserved.

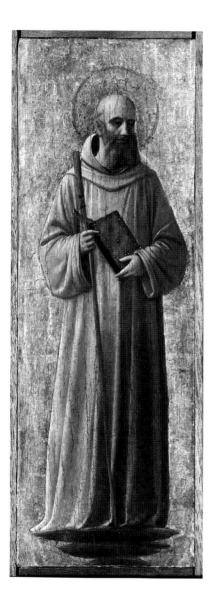

Fra Angelico
Italian (Florence), 1387–1455
Saint Benedict
About 1440
Tempera on panel
15⅜ × 5¼ in.

The Putnam Dana McMillan Fund
62.9

Sculptors and painters of the Middle Ages rarely signed their works and were regarded simply as craftsmen, but during the Renaissance artists began to be exalted as men of genius, the intellectual peers of philosophers, writers, and statesmen. One of the most renowned Italian artists of the fifteenth century was a Dominican monk called Fra Giovanni da Fiesole, a painter of religious scenes who in his own lifetime was known as Fra Angelico, "the angelic friar." The museum's small panel of Saint Benedict, one of the few works by Fra Angelico on this side of the Atlantic, was once part of the high altarpiece of San Marco in Florence, the artist's own monastery church. Its clarity and simplicity of style are typical of Fra Angelico's images. The meditative saint, surrounded by the golden light of heaven, stands upon a cloud of lapis lazuli blue. His staff symbolizes his role as abbot of Monte Cassino, and the book refers to the rule that he established as a guide for monastic life.

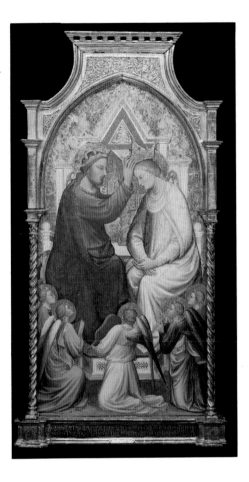

Mariotto di Nardo
Italian (Florence), active 1394–1431
The Coronation of the Virgin
1408
Tempera on panel
51⅞ × 27 in.

The Putnam Dana McMillan Fund
65.37

It was the style, not the content, of
early Italian Renaissance art that
was revolutionary. Religious themes
continued to predominate, as they had
in the Middle Ages, but with a new
emphasis on the realistic depiction of
the human figure in various physical,
psychological, and emotional states.
Unlike the flat, insubstantial figures
of medieval paintings, Mariotto di
Nardo's Virgin and Christ look three-
dimensional: their bodies seem to fill
out the robes that clothe them. The
gabled throne on which they sit and
the angelic musicians kneeling at their
feet have the same tangible quality.
These simple, massive forms were
inspired by Giotto, while the graceful-
ness and dazzling color of the angels
show the influence of Lorenzo Monaco.
This painting was the central section
of a large altarpiece that originally
stood in the Florentine church of Santo
Stefano in Pane. Two smaller images
from the same polyptych—Saints
Bartholomew and Anthony Abbot—
are also in the Institute's collection,
and the two large side panels now
belong to the J. Paul Getty Museum
in Malibu, California.

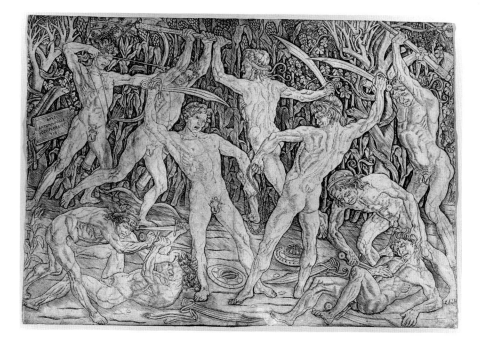

Antonio Pollaiuolo
Italian (Florence), 1432–98
Battle of the Naked Men
About 1470
Engraving
15$^{11}/_{16}$ × 22$^{1}/_{16}$ in.
Bequest of Herschel V. Jones P.68.246

This famous engraving has the dramatic intensity and energetic movement that characterized most fifteenth-century Florentine art, beginning with the work of Masaccio and Donatello. In order to imitate nature more faithfully, Renaissance artists pioneered the study of anatomy and mathematical perspective. Antonio Pollaiuolo may well have been the first Italian artist to dissect corpses to gain a firsthand knowledge of human anatomy. Trained as a goldsmith, sculptor, and painter, Pollaiuolo was regarded by Lorenzo de' Medici as the leading master in Florence in 1489. His understanding of the body is apparent in the peculiar flayed appearance of these ten nudes, who look as if their skin has been stripped off to reveal the muscles and tendons underneath. The violent battle in which the figures are engaged shows the human "machine" in action—stretching, twisting, and kicking. This is the only print known to have been made by Pollaiuolo, and only forty-five impressions of it are extant.

Nicola di Maestro Antonio d'Ancona
Italian (Padua), active 1460–1500
Madonna and Child Enthroned
About 1490
Tempera and oil on panel
55¾ × 21¼ in.
The John R. Van Derlip Fund 75.53

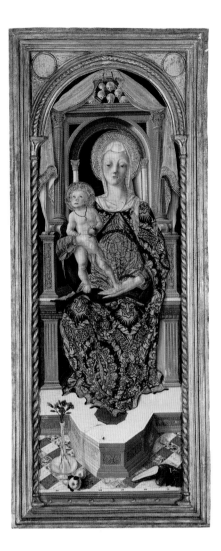

Renaissance Italy was a land of fiercely independent city-states, each with its own alliances, its own system of government, and its own cultural climate. Although Padua is near Venice, Paduan painting was influenced by certain Florentine artists who worked in the city during the 1430s and 1440s. As a result, the Paduan style that emerged around mid-century combined noticeably Florentine qualities with incisive linearity and hard, angular forms. Nicola's carefully planned and meticulously painted *Madonna and Child* reveals his Paduan training; every detail, from the sumptuous brocade of the Virgin's gown to the veining in the marble floor, has been rendered with *trompe l'oeil* (fool-the-eye) accuracy. The apples at the base of the throne and the fly (a carrier of pestilence) represent sin and death; the gourds symbolize the Resurrection; the pinks (small carnations) stand for the marriage of Christ and the Church; and the apple in the Christ Child's hand signifies that he is the New Adam, who will redeem creation. It is thought that this panel was commissioned by the citizens of Ancona to celebrate their survival of an earthquake that occurred in 1474.

Italian (Deruta)
Majolica Plate with Saint Barbara
16th century
Glazed earthenware
Diameter 14½ in.
The Washburn Fund 23.63

Italian (Urbino), workshop of Orazio
Fontana
Majolica Plate with Battling Men
16th century
Glazed earthenware
Diameter 17¼ in.
Miscellaneous purchase funds 61.5

During the Renaissance, numerous
cities in central and northern Italy—
Orvieto, Siena, Pisa, Faenza, and
Padua, to name only a few—became
centers for the manufacture of
majolica, a tin-glazed earthenware

that had been made since the eleventh
century. Deruta ware, represented by
this show dish picturing Saint Barbara
with the tower of her imprisonment,
was notable for its vigorous ornamen-
tation and high luster. The decoration
typically consisted of a central image
(usually a single large figure or a reli-
gious scene) encircled by a wide border
of foliate designs and overlapping
scale patterns. Ceramics from Urbino
were much more refined and delicate
in appearance than those from Deruta.
In this example, a central boss depicts
the struggle of Hercules and Cacus.
The rest of the plate has a white
ground enlivened with frolicking
grotesques, whimsical and airy motifs
derived from the Raphaelesque
designs that adorn some of the rooms
of the Vatican.

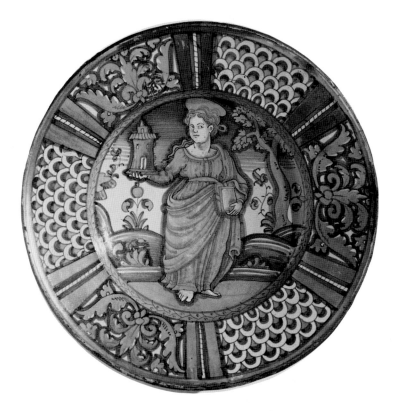

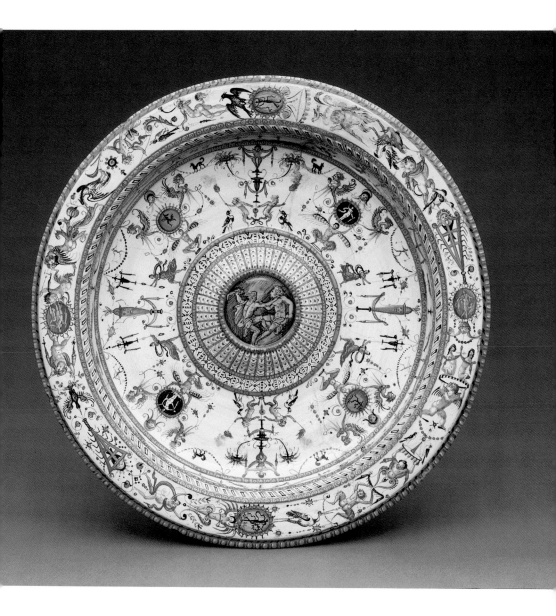

Giovanni dal Cavino
Italian (Padua), 1500–1570
Portrait of Luca Salvioni
About 1536
Bronze
28¾ in. high
The William Hood Dunwoody Fund
33.3

The Renaissance emphasis on the individual led to a revival of portraiture and biography, forms of art and literature that had virtually disappeared with the fall of ancient Rome. Like Roman sculptors, Renaissance artists sought to capture not only the physical likeness but also the character and temperament of their subject. Luca Salvioni, a Paduan jurist and antiquarian, is portrayed by Cavino as an aging man with close-cropped hair and a wrinkled forehead. His square jaw and firm mouth show

him to be decisive and purposeful, and his large eyes and arched brows reveal a lively and skeptical intelligence. Busts such as this were first modeled in clay and then cast in bronze.

Giovanni Battista Cima da Conegliano
Italian (Venice), 1459–1517
Madonna and Child
Late 15th or early 16th century
Oil on panel
9 × 7⅜ in.

Gift in memory of Mr. and Mrs. Frederic W. Clifford by their children
55.4

Oil painting, though not unknown in medieval times, was first extensively practiced in Flanders in the early fifteenth century and was gradually introduced into Italy by the Venetians. This new method of painting differed from the tempera technique in that oil (usually linseed oil) instead of egg yolk was used as the binding agent. Besides being easier to handle and slower drying, oil-based colors could be blended to achieve rich, lustrous hues that had been unobtainable with fast-drying tempera paints. Most early oil paintings were executed not on canvas but on gessoed wooden panels. In this small *Madonna and Child*, Cima da Conegliano has skillfully employed the medium to create massive, weighty figures—a big-boned, full-faced Madonna and a plump Christ Child. Like most quattrocento artists, he aimed at producing solidly modeled, realistic forms; and like most Venetians, he delighted in fresh, light-filled colors.

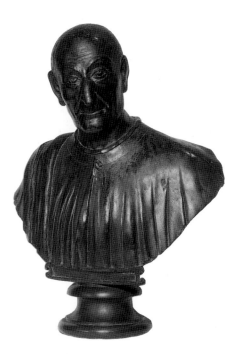

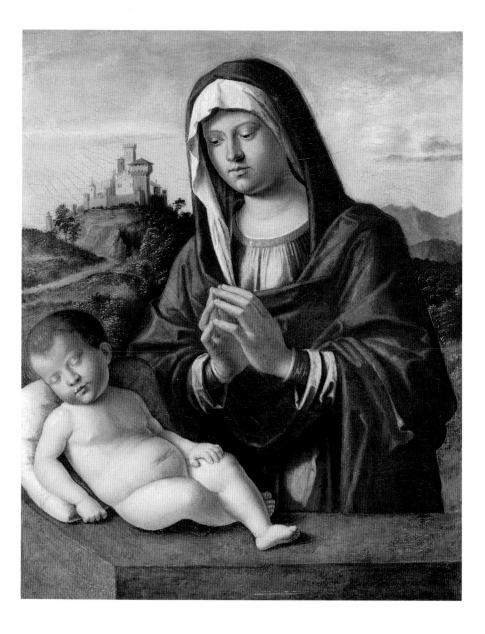

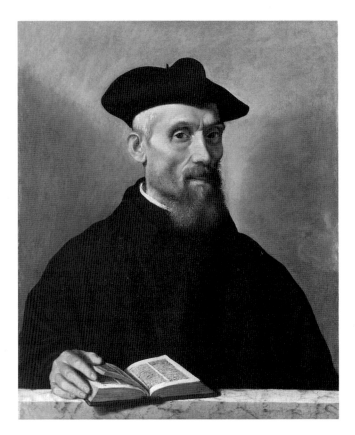

Giovanni Battista Moroni
Italian (Brescia), 1520/25–78
Portrait of an Ecclesiastic
Mid-16th century
Oil on canvas
28½ × 23¾ in.
The William Hood Dunwoody Fund
16.22

The Renaissance was an age of optimism and opportunity. National monarchies began to replace the feudalism of medieval times; commerce and banking prospered; new lands were discovered and explored; and a humanistic attitude arose that focused attention on mankind and the here and now. During the late Renaissance, the many portraits commissioned by aristocrats and prelates tended to emphasize the subject's dignity and intellectual powers. We can see this in Moroni's clergyman, posed sedately behind a marble ledge that distances him somewhat from the viewer. His penetrating gaze and the open book before him indicate a keen mind and scholarly interests. The simple yet skillful composition, careful modeling, and subdued colors all contribute to the impression of thoughtfulness and quiet authority. Moroni's portraits are considered his best work, and in his own day they rated the admiration of Titian. After studying with Il Moretto in Brescia, Moroni went to Bergamo, where he spent the rest of his life.

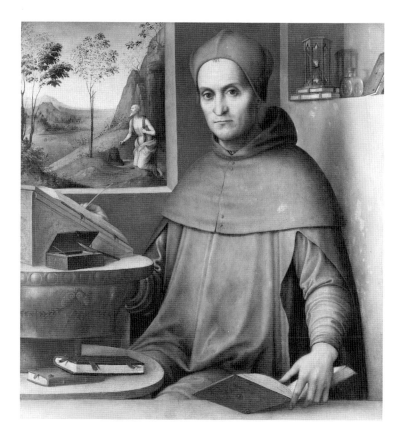

Attributed to Lorenzo Costa
Italian, 1460–1535
Portrait of a Cardinal in His Study
Early 16th century
Oil and tempera on panel
32¼ × 30 in.

The John R. Van Derlip Fund and the
William Hood Dunwoody Fund 70.17

The fifteenth-century Italian philos-
opher Marsilio Ficino said that man
was free to soar with the angels or
consort with the brutes. That the
unknown sitter in this portrait
considered himself nearer to the angels
is evident, for he chose to be pictured
with the attributes of Saint Jerome, the
fourth-century biblical scholar who
translated the Old Testament from
Hebrew into Latin (the Vulgate).
Wearing the brilliant red robes of a
cardinal, he sits at a lectern in his
study, surrounded by his books — a
traditional pose for Saint Jerome.
Through the open window we see
another common representation of
Jerome, the penitent kneeling in the
wilderness, about to beat himself with
the stone clenched in his right fist.
Beside him are his usual attributes:
a copy of the Vulgate, the lion that
legend says he befriended, and a
cardinal's hat. But this image of
the ascetic hermit is dominated by
the figure in the foreground — the
cultured man of letters so admired
during the Renaissance.

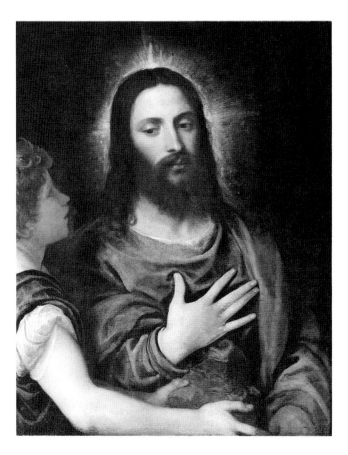

Titian (Tiziano Vecellio)
Italian (Venice), 1488?–1576
The Temptation of Christ
About 1530
Oil on panel
35⅜ × 27⁷⁄₁₆ in.
The William Hood Dunwoody Fund
25.30

With Leonardo, Raphael, and Michel-
angelo, Titian was one of the great
masters of the Italian High Renais-
sance. His style is marked by heroic
simplicity, harmonious design, and
dramatic chiaroscuro. He was trained
by the Venetian colorists Giovanni
Bellini and Giorgione, and like them
he used a rich and sensuous palette,

underpainting his brilliant colors with
warming reds and veiling them with
layer upon layer of thin glazes. *The
Temptation of Christ* depicts an
episode from Christ's life recounted in
the Gospels of Matthew (4:1–11),
Mark (1:12–13), and Luke (4:1–13).
After fasting forty days in the wilder-
ness following his baptism, Christ
was tempted three times by the Devil.
To each taunt he answered simply,
quoting passages from the Scriptures.
In this painting a serene, idealized
Christ, boldly placed against an
impenetrable black background lit
only by the glow of his own radiance,
is challenged by Satan in the guise
of an angelic youth.

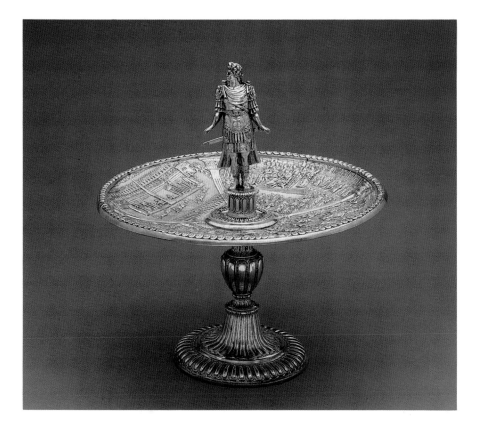

Probably Italian
Tazza
About 1570–80
Silver gilt
15 in. high, diameter 15½ in.
The James Ford Bell Family Foundation Fund, the M. R. Schweitzer Fund, and the Christina N. and Swan J. Turnblad Memorial Fund 75.54

The Italian humanists looked to the ancients for inspiration and instruction—to the poetry of Homer and Vergil, the histories of Thucydides and Tacitus, and the political writings of Plato and Cicero. During the fifteenth century, the *Lives of the Caesars* by Suetonius, a Roman of the second century A.D., became an indispensable volume in every Renaissance library. It is a biography of the first twelve

Roman emperors, from Julius Caesar to Domitian. The museum's silver-gilt tazza belonged to a set of twelve ornamental cups inspired by this book. Each one represented a different emperor, with important events of his reign depicted in low relief on the inside of the large, shallow bowl and a fully modeled figure of the ruler himself rising from the center. The set once belonged to Cardinal Ippolito Aldobrandini, who became Pope Clement VIII in 1592. Sometime during the nineteenth century, the service was dismantled for resale and then reassembled—incorrectly. As a result, the Institute's tazza combines the finely detailed image of Augustus with scenes from the life of Caligula, the simplest showing a chariot race at the Circus Maximus.

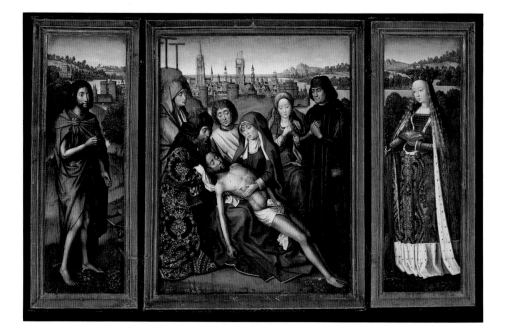

Master of the Saint Lucy Legend
Netherlandish, active 1470–1500
Pietà with Saints John the Baptist and Catherine of Alexandria
Late 15th century
Oil on panel
39¼ × 62¼ in. overall

Bequest of John R. Van Derlip
35.7.87

North of the Alps, in the Netherlands (modern Holland and Belgium)— notably in the cities of Tournai, Ghent, and Bruges—a style of painting developed that was very different from that of Renaissance Italy. The work of fifteenth-century Flemish (southern Netherlandish) painters like Robert Campin, Jan van Eyck, and Rogier van der Weyden was distinguished by the unflinching realism and meticulously

executed detail that characterize the museum's *Pietà* by the Master of the Saint Lucy Legend. In the central panel, a weeping Madonna holds the body of Christ on her lap while the richly clad Joseph of Arimathea supports his head. Behind them are Mary Magdalene, Saint John the Evangelist, and the two donors of the triptych. In the left wing stands John the Baptist, and in the right, Catherine of Alexandria. Resplendent in her royal robes, Saint Catherine holds a book (a symbol of her learning) and a sword (the instrument of her martyrdom). All of the details are carefully rendered, from the sheen and texture of fabrics, fur, gems, and hair to the dead face and bleeding wounds of Christ. Even the bluish landscape in the distance is an accurate depiction of Bruges in the 1490s, the years when the painter of this altarpiece worked there.

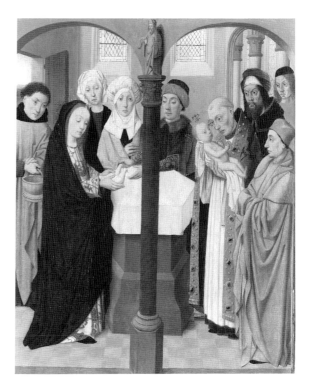

Master of the Brunswick Diptych
Netherlandish, possibly Jacob Jansz.,
active 1483–1509

Presentation in the Temple
About 1490
Oil on panel
17³/₁₆ × 14⅛ in.

Bequest of Miss Tessie Jones in
memory of Herschel V. Jones 68.41.1

During the fifteenth century, the
realistic Flemish style spread to the
northern Netherlands, France, and
Germany. This panel painting was
once credited to the famous northern
Netherlandish artist Geertgen tot Sint
Jans but is now ascribed to the Master
of the Brunswick Diptych, whom some
art historians identify with Jacob Jansz.
The work of both Geertgen and the
Brunswick Diptych master owes much
to the intense coloring and hard-edged
forms of Flemish art. The museum's

panel, along with a Nativity in the
Rijksmuseum and an Annunciation in
the Glasgow Art Gallery, once
belonged to an altarpiece of the life of
the Virgin. According to Jewish law,
the firstborn of each living thing was
to be sacrificed to the Lord, but chil-
dren were to be redeemed by the
payment of five shekels. Forty days
after the birth of a male child, mothers
were purified by an offering of two
turtledoves or pigeons. As reported in
the Gospel of Luke, the Purification of
the Virgin and the Presentation of
Christ took place in the Temple at the
same time. The dour and somewhat
wooden figures in this painting enact
these rites in a Romanesque interior
with leaded glass windows. The high
priest Simeon holds the infant Jesus in
his arms while Mary gives the birds to
be sacrificed—an allusion to Christ's
death, which will cleanse mankind
of original sin.

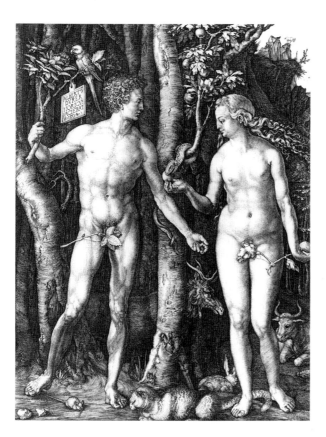

Albrecht Dürer
German, 1471–1528
Adam and Eve
1504
Engraving
9^{13}/$_{16}$ × 7^{9}/$_{16}$ in.
The Christina N. and Swan J. Turnblad
Memorial Fund P.12,613

Before the sixteenth century, the monumental forms and unified compositions of Italian Renaissance painting had little influence in northern Europe, where the precise realism and warm colors of Flemish art prevailed. But late in 1494, the great German printmaker Albrecht Dürer journeyed to Venice, and soon afterward he brought the "modern" style of the south to his homeland. Northern artists had seldom depicted nudes. In this engraving of 1504, however, Dürer combined the robust, idealized figures of Italian art with the intricate detail typical of northern work. His Adam and Eve, muscular and well formed, are set against a luxuriant forest inhabited by a variety of creatures. To people of Dürer's time, many of these plants and animals were symbolic. For instance, the elk, the ox, the cat, and the rabbit represent the four humors—melancholy, phlegm, choler, and blood—fluids whose balance, or temperament, within the body was thought to determine a person's character. The mountain ash that Adam holds signifies the tree of life, and the fig branch, around which the snake coils, stands for death.

Lucas Cranach the Elder
German (Saxony), 1472–1553

*Portraits of Moritz and
Anna Buchner*
1518
Oil on panel
16⅛ × 10¾ in.
The William Hood Dunwoody Fund
57.11; 57.10

During the Renaissance, the growth of capitalism, along with an increasingly materialistic outlook on life, led to the rise of a self-made middle class who strove for money, position, and plea-sure rather than the medieval virtues of poverty, humility, and self-denial. The confidence and pride of this new bourgeoisie can be read in the face of Moritz Buchner, a Leipzig merchant and alderman, whose family had grown rich from their mining inter-ests. Buchner hired Lucas Cranach, court artist to Frederick III of Saxony, to paint likenesses of him and his wife. The portrait of Moritz shows us a shrewd and strong-willed man. Anna, on the other hand, appears stolid and reserved; adorned with jeweled finger rings and heavy gold chains, she seems little more than a symbol of her husband's wealth and status.

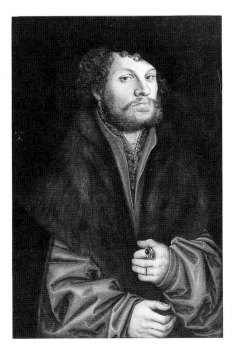
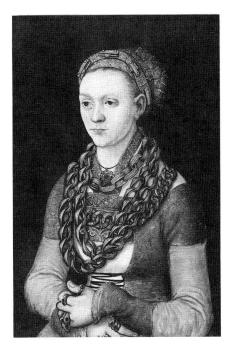

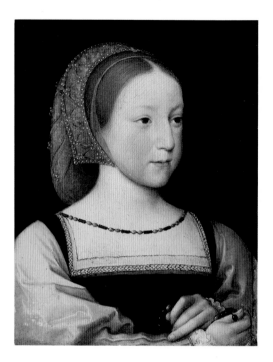

Jean Clouet the Younger
French, 1475-1541
Princess Charlotte of France
About 1522
Oil on panel
7 × 5½ in.

Bequest of John R. Van Derlip in
memory of Ethel Morrison
Van Derlip 35.7.98

Renaissance Europe witnessed the
growth of strong national states in
England, France, and Spain, monar-
chies that were ruled by despots of
Machiavellian character. Francis I,
a contemporary of Charles I of Spain
and Henry VIII of England, governed
France from 1515 until 1547 and made
his court an international center for
humanistic studies and the arts.
Leonardo da Vinci, Andrea del Sarto,
and Benvenuto Cellini worked there,
as did French artists like Jean Clouet,
who painted this likeness of Francis's
daughter Charlotte. One of seven
children by her father's first marriage,

Charlotte was born in 1516 and died
at the age of eight. Employing the
incisive manner and jewellike coloring
of the Flemish school, Clouet depicts
a girl of gentle bearing and sweet
disposition, holding a rosary while she
quietly sits for her portrait.

Design attributed to
Bernard van Orley
Flemish, 1492?-1542?

The Month of September
About 1525-28
Tapestry weave, wool warp, wool and
silk weft
174 × 163 in.

The William Hood Dunwoody Fund
38.40

During the early sixteenth century,
tapestries were transformed into cloth
"pictures" with woven "frames." In
contrast to the flat decoration of
Gothic wall hangings, the new designs

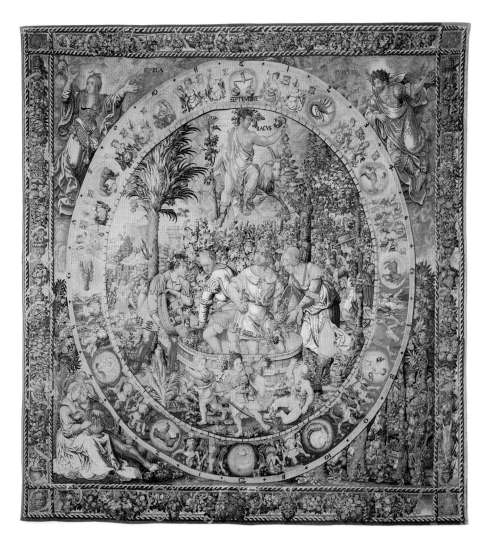

created the illusion of rounded figures and receding space. Bernard van Orley, court painter to Margaret of Austria and Mary of Hungary, spent his later years designing textiles and stained glass. This tapestry—from a set illustrating the twelve labors of the year—presents the month of September in all its glorious bounty. The central medallion shows grapes being gathered from the vineyards and dumped into a wooden vat where two stocky peasants crush them underfoot. Bacchus, the Roman god of wine and merrymaking, oversees the harvest from above, seated on a goat. The main scene is enclosed by signs of the zodiac alternating with twelve pairs of women holding hourglasses, who represent the twenty-four hours of the day. The upper spandrels are occupied by Jupiter and Semele (Bacchus's father and mother), and the lower ones by a pair of lovers and a man cutting grapes. Similar tapestries, some from the same set as the Institute's *September*, are in the Chicago Art Institute, the Metropolitan Museum of Art in New York, the Rijksmuseum in Amsterdam, and the Doria Palace in Rome.

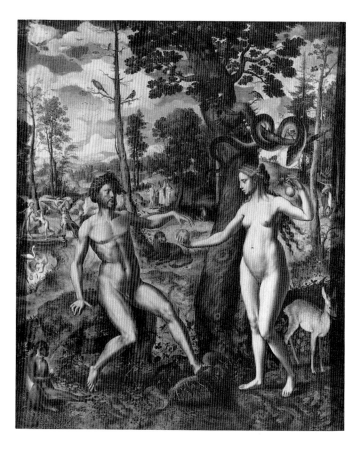

Jan Swart van Groningen
Netherlandish, 1500?–1553?
The Fall of Man
Early to mid-16th century
Oil on panel
78 × 65⅜ in.

The William Hood Dunwoody Fund
76.30

Netherlandish artists of the fifteenth and sixteenth centuries took endless delight in depicting the world around them, down to the smallest particular. This penchant for minutiae is evident in Jan Swart's large, radiantly colored *Fall of Man*, in which a luxuriant landscape teems with birds and beasts. The monumental figures of Adam and Eve in the central foreground dominate the painting, while in the background, near the swan, the fox, and the unicorn, three other episodes from Genesis are represented: the Expulsion from the Garden of Eden, God forbidding Adam and Eve to eat from the Tree of Knowledge, and the creation of Eve from Adam's rib. Swart executed this picture late in life, after he had settled in Gouda as a successful painter and printmaker. Its linear style shows the influence of his work as a wood engraver.

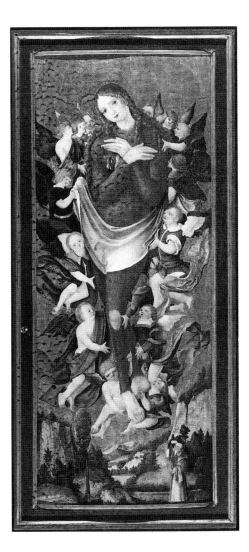

Peter Strüb the Younger
(Master of Messkirch)
German, active 1530–43
The Elevation of the Magdalen
Second quarter of the 16th century
Tempera on panel
60½ × 24¾ in.

The Bergmann Richards Memorial
Fund and the Fiduciary Fund 82.83

In Christian iconography from the
Middle Ages on, Mary Magdalene
exemplifies the repentant sinner. The
Bible mentions her as the woman
from whom Jesus cast out seven devils;
she was present at the Crucifixion and
was the first to see the risen Christ.
Later tradition identified her with the
harlot who anointed Christ's feet after
washing them with her tears and
drying them with her hair, and also
with Mary the sister of Martha and
Lazarus. The *Golden Legend*,
a medieval collection of lives of the
saints, says that after the Crucifixion
she was cast adrift with some com-
panions in a rudderless ship. They
landed at Marseilles, where the
Magdalen converted thousands with
her preaching. Then she went into the
countryside near Aix and lived as
a hermit for the rest of her life. In her
solitude, angels visited her seven times
a day, lifting her up to heaven so she
might see the bliss she would one day
enjoy. Peter Strüb's altarpiece shows
her borne skyward by a host of cherubs.
She is clothed in her own hair, which
grew miraculously to cover her whole
body. Below her, in a landscape which
is not that of Provence but a northern
scene of cliffs and pines, an astonished
monk witnesses her elevation.

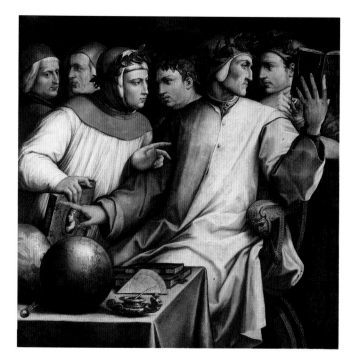

Giorgio Vasari
Italian (Florence), 1511–74
Portrait of Six Tuscan Poets
1544
Oil on panel
52 × 51⅝ in.
The William Hood Dunwoody Fund
71.24

The Italian term *maniera* (manner) is
often applied to artists of the sixteenth
century who worked in the style of
Leonardo, Raphael, Michelangelo, or
Titian, converting the images of those
masters into formulas that could be
easily and quickly reproduced. Giorgio
Vasari and Giulio Romano were
mannerists in this sense, copying not
from the world of nature but from the
art of other artists. Following the
example of Raphael and Michelangelo,
Vasari covered acres of wall space in
Florence and Rome with his highly
finished, decorative compositions. In

this painting of 1544, he accurately
depicted several famous Tuscan poets
and philosophers of the thirteenth and
fourteenth centuries by referring to
earlier portraits of them. The principal
figure, dressed in pink and violet and
seated in a chair, is Dante Alighieri,
author of the *Divine Comedy.* To his
right stands Petrarch, the father of
Italian humanism, and between them
appears the head of Boccaccio, the
author of the *Decameron.* Facing
Dante and pointing to the volume of
Vergil in Dante's hand is Guido Caval-
canti, and at the far left are Cino
da Pistoia and Guittone d'Arezzo. The
objects on the table in front of the
poets symbolize the seven liberal arts.
Although well known as a painter in
his own time, Vasari is now admired
most as the architect of the Palazzo
degli Uffizi (the present-day Uffizi
Gallery) and as the writer of *The Lives
of the Most Eminent Painters, Sculp-
tors, and Architects*, the first art-
historical treatise of the modern age.

Tintoretto (Jacopo Robusti)
Italian (Venice), 1518–94
The Raising of Lazarus
About 1558–59
Oil on canvas
70⅞ × 108¼ in.

Gift of an anonymous donor
83.74

Jacopo Robusti, known as Tintoretto because his father was a dyer by trade, displayed a sign outside his studio proclaiming that he combined "the drawing of Michelangelo" with "the color of Titian." But these were false claims, for Tintoretto's art had little to do with the simplicity and harmony of the Italian High Renaissance. Instead, his was a style of virtuoso foreshortenings and dramatic attenuations, of crowded compositions and passionate emotions. These Mannerist qualities are evident in *The Raising of Lazarus*, as is the artist's vigorous *alla prima* technique. *Alla prima* (Italian, at once) means that, instead of being built up in layers, the paint is put on in one application. Tintoretto first primed his canvas with flat earth tones (dark grays, greens, and browns) and then quickly laid in his composition with broad, sweeping brushstrokes. The focus of this dramatic scene is the relationship of the calm figure of Christ to the tense form of the revivified Lazarus. Unlike most of Tintoretto's work, which he executed *in situ* as part of architectural settings, this picture was conceived as an easel painting. The Venetian Republic presented it to the marquis de Goddes, a Frenchman who was their ambassador in Constantinople.

Luis de Morales
Spanish, 1509?–86
Man of Sorrows
About 1560–70
Oil on panel
25⅜ × 18¼ in.
The Ethel Morrison Van Derlip Fund
62.24

The subjectivity, emotionalism, and theatricality of Mannerism appealed to sixteenth-century Spanish artists like El Greco and Luis de Morales. Morales, from the region of Estremadura, was an eclectic painter who combined the figural attenuations, dramatic lighting, and anguished expressions of the Mannerists with the meticulous brushwork and attention to detail of Netherlandish artists. He painted only religious scenes, particularly the Virgin and Child and episodes from the Passion, and for this reason his contemporaries called him El Divino, "the divine one." *Man of Sorrows* illustrates one of his favorite themes, Christ wearing the crown of thorns and meditating on his own suffering and death. In this work, Christ's form is partially obscured by dark shadows, but the cross, the scourge, and the instruments of his torture (and his trade) — auger, hammer, and nails — are fully revealed in a bright, clear light. Most paintings by Morales are still in Spain, and this one belonged to the collection of the Spanish crown until 1829.

El Greco (Doménikos
Theotokópoulos)
Spanish (born Greece), 1541–1614
*Christ Driving the Money
Changers from the Temple*
About 1570
Oil on canvas
46⅝ × 59⅜ in.
The William Hood Dunwoody Fund
24.1

The sixteenth century was a time of widespread political turmoil and religious unrest. Spain fought to expand its empire in Europe, the Protestant Reformation brought about permanent division in the church, and the Roman Catholic church instituted the Counter-Reformation in an attempt to regain its former power. These disruptions are reflected in the figural distortions, spatial exaggerations, and harsh coloring of Mannerist art. El Greco, a Greek who studied in Italy and settled in Spain, is one of the best-known Mannerists. The museum's painting, one of several that he made of the same subject, depicts Christ's anger at finding the Temple used as a marketplace and stable. In this version, Christ is shown at the height of his anger, lashing out with a whip at the surprised merchants, who draw back in terror and try to flee. In the lower right corner, El Greco has included portraits of the four artists who most influenced him—Titian, Michelangelo, Giulio Clovio, and Raphael. His signature, in Greek letters, appears in the lower center.

The Baroque Period

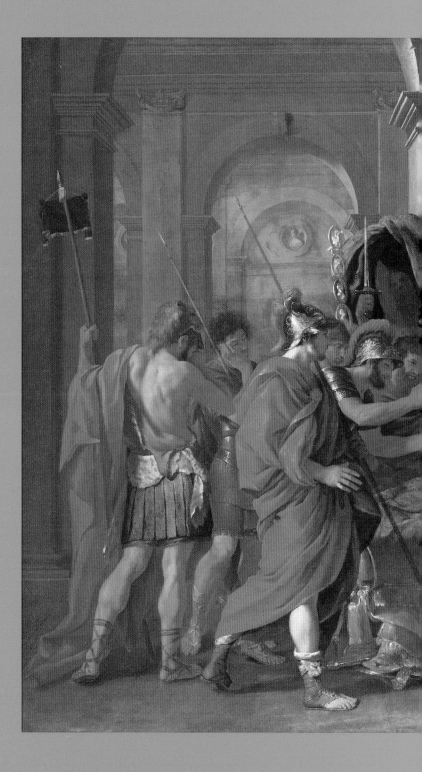

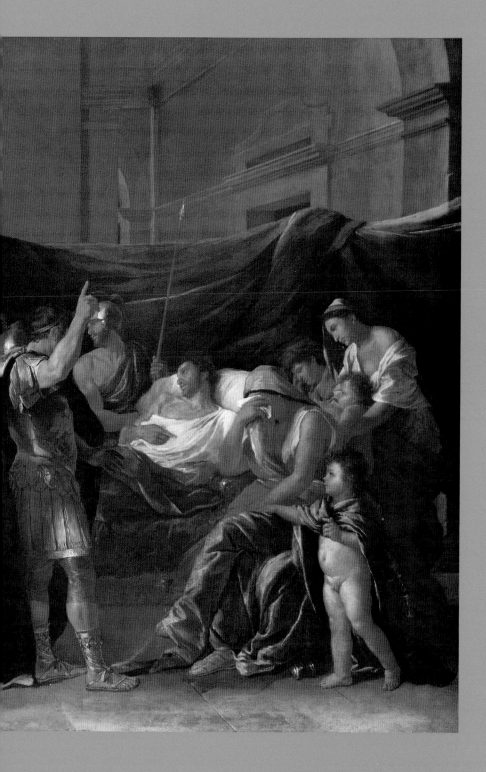

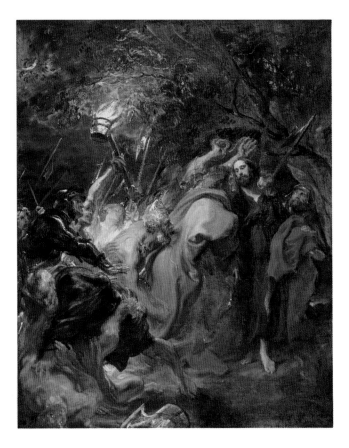

Anthony van Dyck
Flemish, 1599–1641
The Betrayal of Christ
About 1621
Oil on canvas
55⅞ × 44½ in.
The William Hood Dunwoody Fund,
the Ethel Morrison Van Derlip Fund,
and the John R. Van Derlip Fund
57.45

The Baroque style developed in Italy shortly before 1600 and was soon adopted elsewhere, particularly in Flanders, Spain, Germany, and central Europe. A reaction against both the simplicity of High Renaissance art and the distortions of Mannerism, Baroque art was dramatic, dynamic, and often sensual, appealing to the emotions by means of heightened chiaroscuro, rich coloring, and exuberant brushwork. Anthony van Dyck used all of these techniques in this painting of the Betrayal of Christ in the Garden of Gethsemane. The fluid brushstrokes and intense hues create a vortex of torchlight and ghoulish faces that surges toward Christ, who quietly awaits the kiss from Judas Iscariot that will lead to his arrest and crucifixion. Meanwhile, in the lower left corner, another disciple, Simon Peter, cuts off the ear of Malchus, the slave of one of the high priests who conspired against Christ. This work was a preparatory study for a larger version now in the Prado in Madrid. Van Dyck painted it early in his career, shortly after leaving the studio of Peter Paul Rubens.

Peter Paul Rubens
Flemish, 1577–1640
*The Union of England
and Scotland*
1630
Oil on panel
33¼ × 27⅞ in.
The William Hood Dunwoody
Fund 26.2

Peter Paul Rubens was the first north-
ern European artist to work in the
Baroque manner. One of the greatest
painters of the seventeenth century, he
was also a gifted linguist, a diplomat,
an art collector, and a successful busi-
nessman. He maintained a studio full
of apprentices who enlarged his ideas
into finished pictures for an inter-
national clientele. Consequently, most
of the paintings done solely by Rubens
are the preliminary studies that he
made for new commissions, such as

this oil sketch. While in London in
1629 negotiating a peace settlement
between England, France, and Spain,
Rubens was knighted by King Charles I
and asked to design ceiling decorations
honoring the reign of James I,
Charles's father, for the Banqueting
House in Whitehall. James's dual
sovereignty, as king of both Scotland
and England, is celebrated by the
coronation depicted here. Aided by
Athena, the Greek goddess of war and
wisdom, female personifications of
England and Scotland crown the young
prince, while two cherubs bearing the
royal coat of arms fly overhead and
a third sets fire to a pile of weapons
and armor in the lower foreground.
Because the scene was meant to be
viewed from below, the figures have
all been severely foreshortened. The
energetic brushwork is characteristic
of Rubens's mature style.

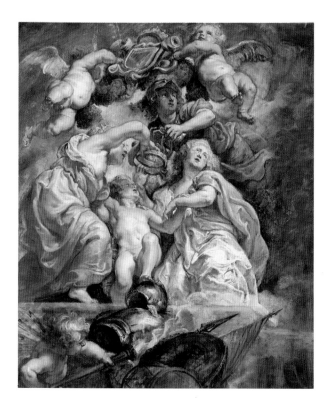

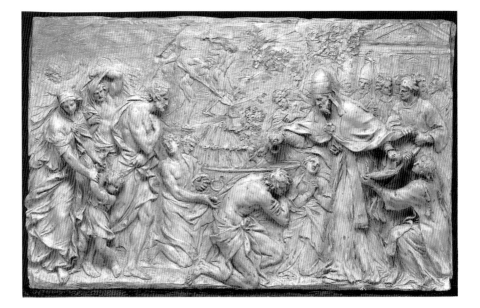

Alessandro Algardi
Italian (Bologna), 1602–54
*Pope Liberius Baptizing
the Neophytes*
1647–49
Terra-cotta
21½ × 36 in.

Miscellaneous purchase funds 59.17

After Bernini, Alessandro Algardi was
the most important Italian sculptor of
the seventeenth century. Compared to
the intensely dramatic works of his
more successful rival, Algardi's com-
positions seem restrained and classical.
This terra-cotta relief is a study for the
decoration of a marble fountain com-
missioned by Pope Innocent x as part
of a project to restore the Vatican's
aqueducts, which had been built in the
fourth century by Pope Damasus. The

fountain still stands in the Cortile di
San Damaso. The event depicted on
the relief occurred shortly before the
aqueducts were constructed, when
Pope Liberius (Damasus's predecessor)
had been exiled from Rome by the
emperor. So that Liberius could baptize
large numbers of people at Pentecost,
as was customary, Damasus (then
a presbyter) had a font built near
St. Peter's, which at that time lay
outside the city gates. Algardi's model
shows Liberius bending forward to
purify a kneeling convert, while
Damasus raises the pope's mantle
so he can turn the pages of the Bible.
In the background, men are excavat-
ing the Vatican Hill to obtain water
for the font. The terra-cotta model
retains more detail than the finished
marble, which is weathered from
standing outdoors.

Giovanni Benedetto Castiglione
Italian (Genoa), 1611?–65

*The Immaculate Conception
with Saints Francis and
Anthony of Padua*
1649–50
Oil on canvas
144 × 104¾ in.

The Putnam Dana McMillan Fund
66.39

In Italy, the extravagance and splendor of Baroque art often served the purposes of the Counter-Reformation by strengthening people's attachment to Roman Catholicism. Giovanni Castiglione's *Immaculate Conception* is typical of many paintings of the time—large-scale propaganda pieces that illustrate Roman Catholic doctrine in grandiose, epic terms. On this huge canvas, life-sized figures of Saints Francis of Assisi and Anthony of Padua kneel to the Virgin, worshiping her as Queen of Heaven. She is the woman without sin described in Revelation 12:1 as "clothed with the sun, with the moon under her feet, and on her head a crown of twelve stars." The image is intended to stir religious feeling and also to remind the viewer of the danger of sin (the thistle) and the impermanence of earthly life (the skull).

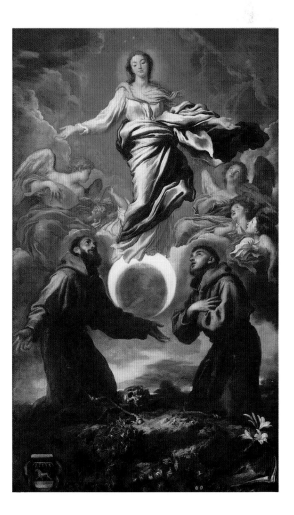

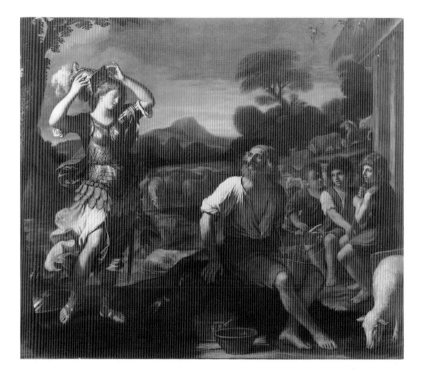

Guercino (Giovanni Francesco
Barbieri)
Italian (Bologna), 1591–1666
Erminia and the Shepherds
1649
Oil on canvas
94 × 113 in.
The William Hood Dunwoody Fund
62.12

Throughout the Middle Ages and
much of the Renaissance, subjects for
works of art were generally drawn
from the Bible and other Christian
writings. By the seventeenth century,
however, themes from secular litera-
ture were gaining favor. This large can-
vas illustrates a scene from Torquato
Tasso's poem *Jerusalem Delivered*,
a sixteenth-century Italian epic about
the siege and capture of the Holy City
by the Crusader Godfrey of Boulogne.
(Tasso was a favorite of Italian and
French artists for over two centuries;
Annibale Carracci, Poussin, Fragonard,
and Delacroix all made paintings based
on his verse.) Guercino's subject is
from the episode in which the dis-
traught and lovesick Syrian princess
Erminia disguises herself as a warrior
and leaves Jerusalem in search of
Tancred, a Christian knight who is
infatuated with another woman. Lost
in a forest, Erminia hears singing and
follows the music to a clearing where
she finds an aged shepherd and his
three sons. "They at the shining of her
arms / were seized at once with
wonder and despair; / But sweet
Erminia soothed their vain alarms; /
Discovering her dove's eyes and
golden hair." Guercino shows this
encounter, with Erminia taking off her
helmet to reveal her true identity to
the astonished shepherds. The ideal-
ized figures, classical restraint, and
warm colors are typical of his late
manner. This painting was commis-
sioned by an important Sicilian collec-
tor, Don Antonio Ruffo of Messina.

Salvator Rosa
Italian (Naples), 1615–73
Saint Humphrey
About 1660
Oil on canvas
78 × 46½ in.
The John R. Van Derlip Fund
64.2

Though best known as a painter of
landscapes and battle scenes, Salvator
Rosa was also an etcher, a poet,
a satirist, a musician, and an actor.
A restless man of nonconforming
spirit, he worked chiefly in Florence
and Rome but remained largely outside
the influential artistic circles of those
cities. Unhappy being classified as a
bamboccianto (maker of genre scenes),
Rosa aspired to be a history painter
and in the late 1650s began producing
large-scale works based on biblical and
mythological subjects. In the Institute's
painting, Saint Humphrey (Onu-
phrius)—a hermit who spent sixty years
in the Egyptian desert—is portrayed
in a meditative pose. The backdrop of
turbulent clouds and wind-tossed trees
suggests the spiritual energy of this
brooding figure.

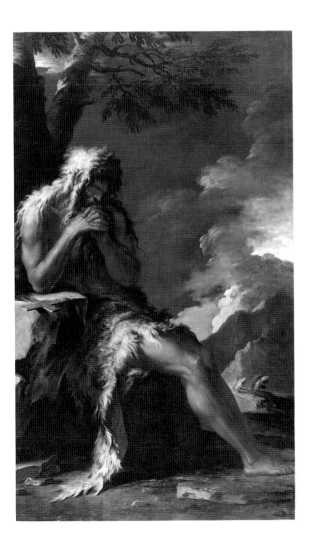

Italian (Rome), style of Giovanni
Paolo Schor, 1615–74
Console Table
Late 17th century
Gilt wood and marble
37 × 62 × 31 in.

The Ethel Morrison Van Derlip
Fund 64.71

During the Baroque period, archi-
tecture became more sculptural, sculp-
ture more pictorial, and painting
more illusionistic. Furniture took on
a decidedly sculptural appearance,
displaying the Baroque tendency to
fuse the various arts into one compli-
cated whole. This console table has the
intricately inlaid top and boldly carved
gilt supports typical of seventeenth-
century Italian designs. Its legs and
stretchers are formed from scrolling
acanthus leaves and flowers, which
cascade from the crown of a goddess,
perhaps Flora. A *putto* climbing in the
foliage glances playfully out of the
shadows. Furniture like this would
have been placed in the state apart-
ments of the wealthy—rooms meant
for show rather than habitation. Often
a wall mirror was hung above such a
table, and a vase or a small piece of
sculpture was set on the tabletop.

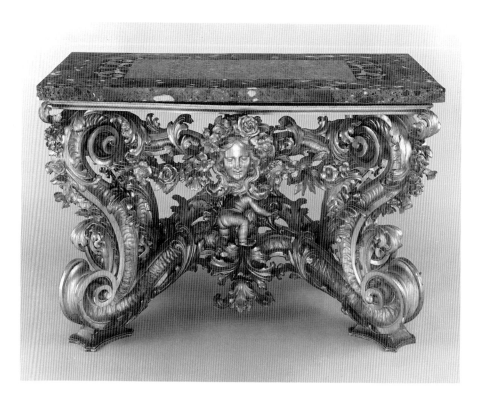

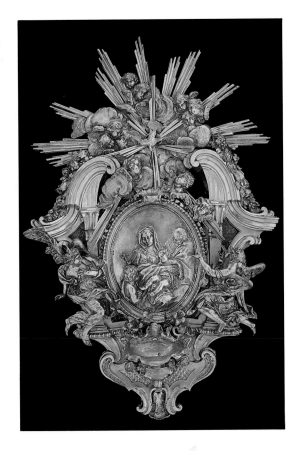

Giovanni Giardini da Forli
Italian (Rome), 1646–1722
Holy Water Stoup
About 1715
Silver, silver gilt, lapis lazuli
29⅛ in. high

The Ethel Morrison Van Derlip Fund
and the Christina N. and Swan J.
Turnblad Memorial Fund 63.35

Baroque decorative art was made visu-
ally luxurious by the abundant use of
intense colors, variegated marbles, and
precious metals and gems. Gold, silver,
and lapis lazuli are combined in this
holy water stoup by Giovanni Giardini
da Forli, one of the leading Roman
goldsmiths of his day. The central
medallion contains a low-relief scene
of the Holy Family with the young
Saint John the Baptist, after a painting
by Guido Reni. Flanking the medallion
are two angels; above it, the Holy
Spirit (in the form of a dove) appears
with a host of cherubim in an explo-
sion of splintery rays and puffy clouds.
Silver flowers and ribbons twine
throughout and spill down into the
golden shell that held the holy water.
This stoup, from the private chapel of
a Roman prince or a cardinal, is an
extremely rare work, since most Italian
silver objects were confiscated by the
French during the Napoleonic era and
melted down for their metal. A master-
piece of the period, it unites the
lavish ornateness of the late Baroque
style with a delicacy and refinement of
detail that hint of the Rococo.

Giovanni Battista Gaulli
Italian (Rome), 1639–1709

Diana the Huntress
About 1690
Oil on canvas
63⅝ × 83¼ in.

The Frances E. Andrews Fund 69.37

Leaving his native Genoa in 1657, Giovanni Battista Gaulli (known as Baciccio) went to Rome, where he studied the paintings of Pietro da Cortona and was befriended by the sculptor Gian Lorenzo Bernini. He executed highly illusionistic ceiling frescoes for the church of Il Gesù and became well known both as a religious painter and as a portraitist. In 1690, Cardinal Pietro Ottoboni commissioned this painting of Diana, the Roman goddess associated with the moon, chastity, and hunting. She is shown resting under a tree after the chase, accompanied by her dogs. Illumined by a cool, clear light, she gazes into the middle distance, where her entourage of nymphs hunts wild boar. On the ground beside her are a bow and a quiver of arrows; at her feet lies her quarry, a dead stag. The sculptural delineation of form and the rich coloration are typical of Gaulli's work. Here, the dogs have been represented with particular care, almost as portraits. The greyhound wears a collar decorated with the double-headed eagles of the Ottoboni coat of arms.

Bartolomé Esteban Murillo
Spanish, 1618–82

The Penitent Magdalen
About 1660
Oil on canvas
48¼ × 42¼ in.

The Bergmann Richards Memorial Fund, in memory of Marguerite Sexton Richards 82.23

In Spain, as in Flanders and Italy,

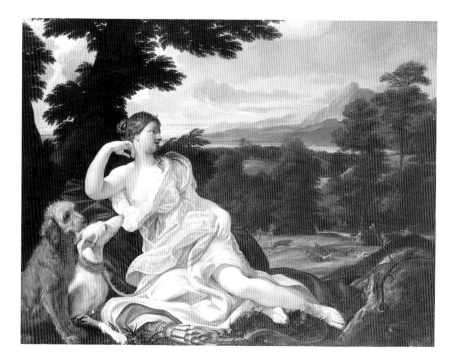

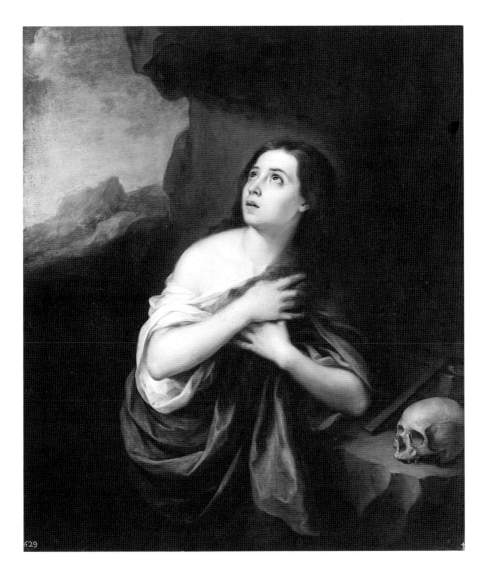

Baroque art served Roman Catholicism through its intensely emotional expression of religious themes. During the second half of the seventeenth century, Bartolomé Murillo was the leading painter of Seville, replacing Zurbarán as the city's most sought-after master and receiving numerous commissions from local churches and monasteries. His works are known for their fluid compositions, fine coloring, and softly modeled forms. The Institute's paint- ing portrays Mary Magdalene, the harlot who became a follower of Christ. She stands alone in a cave, her hair unbound to signify her penitence. The human skull on the ledge near her is a *memento mori*, a reminder of life's brevity and of human failings. Pervading this scene and most of Murillo's other images is a tenderness that later generations regarded as sentimental, but which today is once again appreciated as genuine religious feeling.

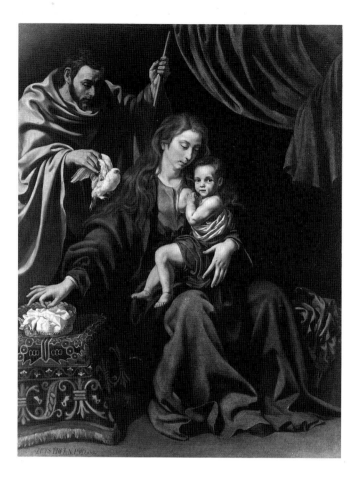

Luis Tristán
Spanish, 1586–1640
Holy Family
1613
Oil on canvas
56 × 43 in.
The William Hood Dunwoody Fund
74.2

Luis Tristán studied with El Greco in Toledo from 1603 to 1607 and later spent several years in Italy, where he must have seen examples of Caravaggio's dramatic naturalism. Painting strongly lit foreground figures against a dark background, as he has done in the *Holy Family*, was a device invented by Caravaggio and adopted by many other artists. Like Caravaggio, Tristán did not distort or idealize his subjects; rather, he insisted on portraying what was real and believable. The figures in this work look like people who might be encountered in daily life. And the precisely rendered still-life elements (Oriental rug, basket, handkerchief) also contribute to the realistic effect. The Child looks toward us, smiling, and seems to draw us into the world of the picture. Depictions of the Virgin nursing the Christ Child were unusual at this period, having lost favor after 1563, when the Council of Trent prohibited undue nudity in representations of the saints and Holy Family.

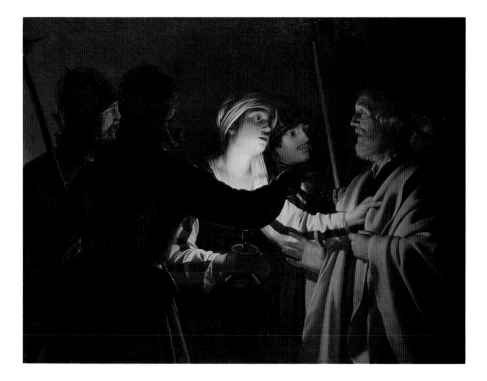

Gerrit van Honthorst
Dutch (Utrecht), 1590–1656
The Denial of Saint Peter
About 1620–25
Oil on canvas
43½ × 57 in.
The Putnam Dana McMillan Fund
71.78

Because the Dutch were officially
Calvinist Protestants and the
Reformed Church prohibited the use
of images in churches, few Dutch
artists produced devotional scenes.
In the city of Utrecht, however,
a number of Roman Catholic artists
continued to paint such themes. Gerrit
van Honthorst often represented

sacred subjects as nightscapes, or
nocturnes, which were set in dark
interiors dramatically lit by artificial
light from a hidden source. In this
example, the outstretched arm of
a Roman soldier conceals the candle
held by the maidservant who accuses
Peter of knowing Jesus. The candle-
light gives their faces an eerie, whitish
hue, heightening the psychological
tension of the moment when Peter,
afraid that he too will be arrested,
denies Christ. Peter wears a yellow
mantle, the garment traditionally
associated with him. Honthorst
executed this work at the peak of his
career, shortly after returning to
Utrecht from Rome in the early 1620s.

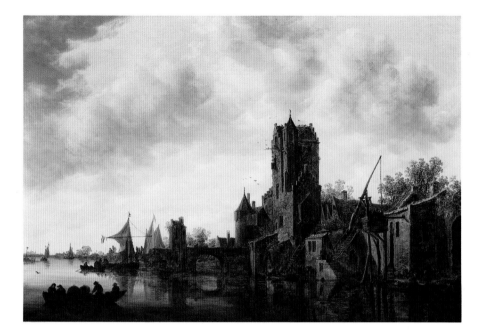

Jan van Goyen
Dutch (Leiden), 1596–1656
*River Landscape
(Pellekussenpoort near Utrecht)*
1648
Oil on panel
25½ × 37 in.
Gift of Bruce B. Dayton 83.84

As a young man, Jan van Goyen spent a year studying in Haarlem with Esaias van de Velde, one of the pioneers of Dutch landscape realism. In the 1630s, van Goyen settled in The Hague and became a leading practitioner of the tonal style of landscape painting that was being developed there. During this period he worked with a limited palette of brown, green, gray, and ocher. By the late 1640s, however, he had broadened the range of color in his compositions and achieved radiant light effects. The change in style can be seen in *River Landscape*, one of several paintings van Goyen made of the Pellekussenpoort, a medieval guard tower on the towpath between Utrecht and the village of Oud Zuilens. In this view, the tower forms part of an imaginary town on the riverbank. Combining fanciful settings and actual, identifiable buildings or sites was a common practice of the Dutch realist artists.

Meindert Hobbema
Dutch (Amsterdam), 1638–1709
*Wooded Landscape with
Water Mill*
Second half of the 17th century
Oil on canvas
40½ × 53 in.
The William Hood Dunwoody Fund
41.2

The visual immediacy of most Dutch landscape painting belies the fact that the artists worked inside from drawings and sketches, not out-of-doors as became common in later centuries. This wooded scene by Meindert Hobbema shows the freshness and clarity attainable with the traditional studio method. Hobbema was Jacob van Ruisdael's most gifted pupil and one of Amsterdam's leading artists during the 1660s. His cheerful canvases of Holland's forests, farmhouses, and water mills were highly regarded by his contemporaries, who especially appreciated his skill at rendering light penetrating shadowed areas. Hobbema painted little after the age of thirty, when he received an official city post as a customs inspector. After his death, his works quickly fell into obscurity. They were rediscovered in the nineteenth century by the Barbizon school and the French Impressionists Alfred Sisley and Camille Pissarro, who found in them the vivid color and dappled light effects they hoped to achieve in their own paintings.

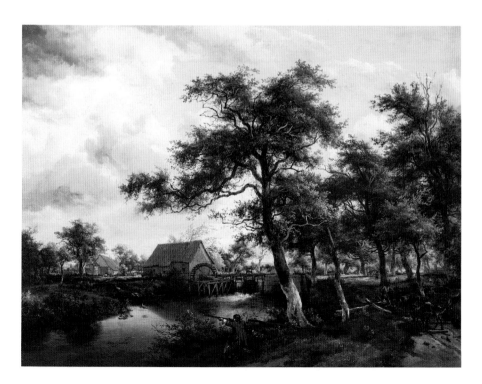

Philips Wouwerman
Dutch (Haarlem), 1619–68
*Festive Peasants before
a Panorama*
1653
Oil on canvas
27½ × 44 in.

Gift of Margaret L. Sweatt 81.107

In seventeenth-century Europe, there
was a good market for paintings of
merrymaking. Philips Wouwerman's
festive images were popular not only
with his fellow Dutchmen but with
French and German collectors too (the
Institute's Wouwerman once belonged
to the duchess of Berry). A student of
Frans Hals, Wouwerman specialized
in hunting and battle scenes and was
particularly skilled at picturing horses
in motion. He also liked to depict
groups of figures in outdoor settings,
thus joining his interest in landscapes
with his fondness for genre subjects.
In *Festive Peasants*, a crowd gathers
outside a country inn to drink, talk,
and dance. Some of the revelers swim
in the nearby river, while in the
middle distance two men square off for
a knife fight. This painting is one of
only a handful that Wouwerman both
signed and dated.

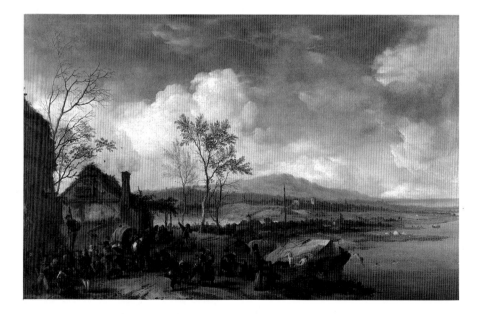

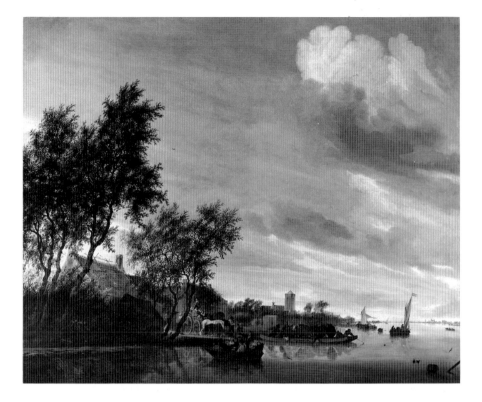

Salomon van Ruysdael
Dutch (Haarlem), 1600/3–1670
River Landscape with a Ferry
1656
Oil on canvas
41½ × 53 in.
The William Hood Dunwoody Fund
45.9

Although the provinces of the northern Netherlands had declared their independence from Spain in the late sixteenth century, the Hapsburgs did not formally recognize the Dutch Republic until 1648. By then, Holland had entered its golden age, as a leader in European commerce, shipping, and banking. Economic prosperity led to the growth of an affluent middle class—practical people who wanted their art to be as down-to-earth as they themselves were. Along with portraits and pictures of their daily life, the Dutch especially liked paintings of their land—of shoreline, rivers, and canals; vast, cloudy skies; and flat stretches of wooded plain. Salomon van Ruysdael, uncle of the more famous Jacob van Ruisdael, was a prominent Haarlem landscapist known for his peaceful river scenes. This one, in delicate greens, blues, and browns, has the lighter tonalities and looser brushwork of his later style.

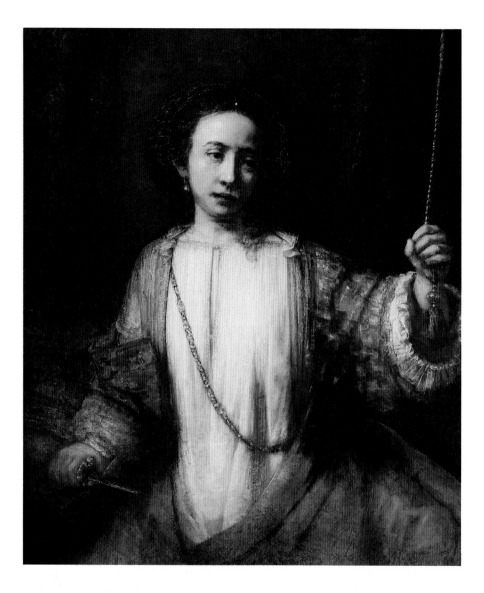

Rembrandt van Rijn
Dutch (Amsterdam), 1606–69
Lucretia
1666
Oil on canvas
41⅜ × 36⅓ in.
The William Hood Dunwoody Fund
34.19

Rembrandt painted this picture three years before his death. By that time, the aging artist had endured public disfavor, social disgrace, bankruptcy, and the deaths of his wife Saskia, three of his five children, and Hendrickje Stoffels, the woman who was his housekeeper and companion for nearly fifteen years. In the museum's *Lucretia*, he created a profoundly tragic work using a simple composition and the loose brushwork of his later style. Lucretia, a virtuous Roman matron, was raped by her husband's friend Sextus Tarquinius. To restore her family's honor, she committed suicide. Renaissance and Baroque paintings generally show her in a state of near undress, about to stab herself. The Minneapolis *Lucretia* is unusual in depicting her fully clothed and at the point of death. The blood on her garment and her ashen face and unfocused gaze convey the impression that we are witnessing the final moment of her life. Another version of this subject, executed by Rembrandt in 1664, is in Washington, D.C., at the National Gallery of Art.

Bartholomeus van der Helst
Dutch (Amsterdam), 1613–70
Portrait of a Burgomaster, Jacobus Trip
About 1660
Oil on canvas
48⅜ × 39⅜ in.
The John R. Van Derlip Fund
35.7.106

In seventeenth-century Holland the large demand for portraits of prosperous businessmen was often met by artists of stature, such as Rembrandt van Rijn and Frans Hals. In his day, Bartholomeus van der Helst was admired even more than Rembrandt. Leaving his native Haarlem in 1636, he settled in Amsterdam and by 1650 had become the city's foremost portraitist. He was especially favored by the ruling class of wealthy merchants, who liked his precise technique and finely detailed compositions. The Institute's painting of the burgomaster Jacobus Trip has all the polish, verve, and color of van der Helst's mature style. Trip was a mayor of Amsterdam whose family had made a fortune dealing in iron and armaments. But the artist does not flatter him. Contrasting Trip's soft, aging features with the crisp laces and embroidery of his garments, van der Helst shows us a contented, portly man who enjoys the comforts of life and the advantages of his position in society. Around the time this work was done, Rembrandt painted portraits of Trip's father (Jacob) and mother (Margaretha de Geer).

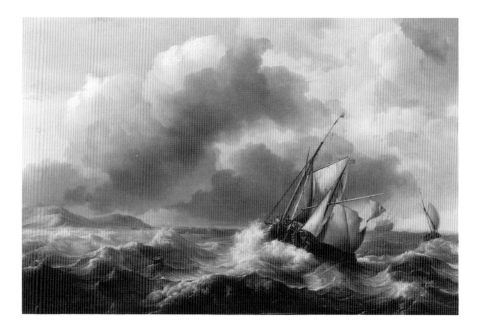

Ludolph Backhuysen
Dutch (Amsterdam), 1631–1708
*Fishing Vessels Offshore
in a Heavy Sea*
1684
Oil on canvas
25½ × 38½ in.

Gift of John Hawley, by exchange
82.84

To the Dutch, the sea was both friend
and foe. It was the stage for their naval
victories, the source of much of their
food, and the highway linking them to
other great commercial centers, in
both northern Europe and the Medi-
terranean. But it was also a constant
threat to their land, their crops, and
their very lives. Ludolph Backhuysen
has painted the sea on a windy day,
with storm clouds looming in the sky.
The fishing boats in the foreground
heel in the gusts, and one of them has
a torn mainsail. Several other vessels
are visible in the distance. Backhuysen
was familiar with such scenes, having
worked in his youth as a shipping
clerk in the small port of Emden, on
the North Sea. At the age of eighteen
he went to Amsterdam, where he
studied with Allaert van Everdingen
and Hendrick Dubbels. He became
a successful portraitist and etcher
and by 1672 was the leading marine
painter in the Netherlands.

French
The Colossus of Rhodes
(from *The History of Artemisia*)
About 1615
Tapestry weave, wool warp, wool and
silk weft with gold and silver threads
186 × 266 in.
The Ethel Morrison Van Derlip
Fund 48.13.9

The Institute owns ten tapestries from
a series illustrating the history of
Artemisia, queen of ancient Hali-
carnassus in Asia Minor. The story
of Artemisia became well known in
the sixteenth century when Nicolas
Houel, a member of the French court,
made it the subject of poems that
were read as allegories of the life of
Catherine de' Medici. Like Artemisia,
Catherine was a widow acting as
regent for her young son in a country
beset by wars and problems of state.
Since Houel's allegory also applied

to two later French queens, Marie
de' Medici and Anne of Austria,
it remained popular well into the
seventeenth century. The Institute's
Artemisia tapestries were made for
the French royal family, and several of
them were woven under the super-
vision of François de la Planche, the
Flemish weaver who set up the first
Gobelin factory on the outskirts
of Paris. Some two hundred tapestries
depicting scenes from Artemisia's
life are extant, and those in Minne-
apolis are among the finest. *The
Colossus of Rhodes* shows Artemisia
capturing the city of Rhodes by
decorating her fleet with laurel
branches, a ruse that made the
Rhodians believe the approaching
ships belonged to their own victorious
navy. Allegorically this incident refers
to Catherine's defeat of the Protes-
tants in a bloody massacre on Saint
Bartholomew's Day, 1572.

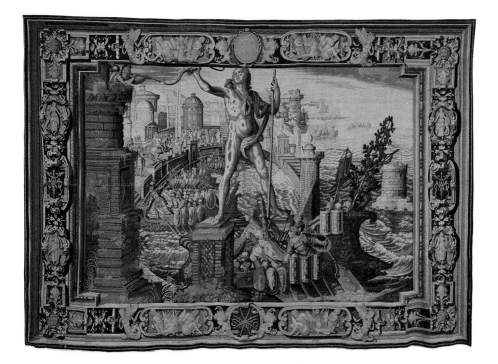

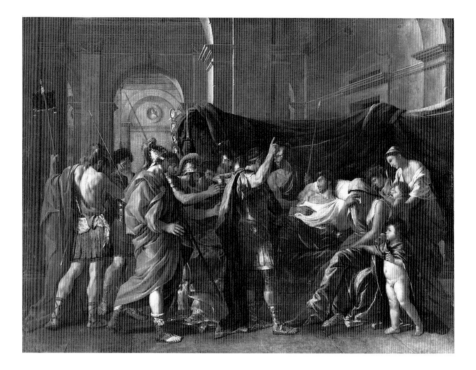

Nicolas Poussin
French, 1594–1665
The Death of Germanicus
1627
Oil on canvas
58¼ × 78 in.

The William Hood Dunwoody Fund
58.28

In contrast to the drama of Italian and Spanish art and the realism of Dutch painting, seventeenth-century French art was classical—idealized, harmonious, restrained. Balanced composition and didactic or moralizing content characterized this style, whose leading proponent was Nicolas Poussin. Poussin's study of antique art and the paintings of Raphael and Titian led him to the insistence on logic, order, and clarity that became the credo of the French Royal Academy when it was established in 1648. *The Death of Germanicus*, commissioned in 1627 by the Italian cardinal Francesco Barberini, was Poussin's first major history painting. It is based on Tacitus's account of the death of the Roman general Germanicus, poisoned in A.D. 19, probably by his jealous and insecure uncle, the emperor Tiberius. Surrounded by his soldiers and grieving family, Germanicus swears his followers to revenge and receives an oath of allegiance from his successor, the man in the blue cloak facing him with upraised arm. The raised arm is a focal point of the scene, drawing our attention and dramatizing the importance of loyalty, which takes precedence here over personal sorrow.

Simon Vouet
French, 1590–1649
*Angels with the Attributes
of the Passion*
About 1612–27
Oil on canvas
41 1/16 × 30 7/8 in. (each)
The John R. Van Derlip Fund
69.36.1,2

The theatrical, monumental qualities
of Italian Baroque painting were
introduced to France in the late 1620s
by Simon Vouet. Early in his career,
Vouet had been a follower of Cara-
vaggio. He lived in Italy for many
years and was considered one of
Rome's foremost artists. Returning
to France in 1627 at the request of
Louis XIII, he was appointed first
painter to the king and established a
large workshop in Paris, where he
taught some of the most talented
young men of the day, including
Charles Le Brun. The Institute's two
angels probably date from Vouet's
Italian period (1612–27). Sumptuously
robed in red and blue, one of them
carries a pitcher, tray, and cloth,
a reference to Pontius Pilate's symbolic
washing of his hands to absolve him-
self of responsibility for Christ's
condemnation and crucifixion. The
other angel, in green and tan, holds
the tablet from Christ's cross, inscribed
"Jesus of Nazareth, King of the Jews"
in Hebrew, Greek, and Latin.

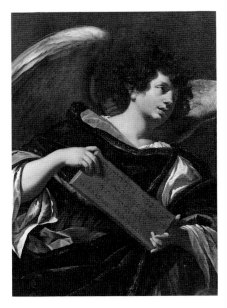

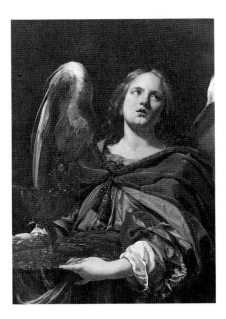

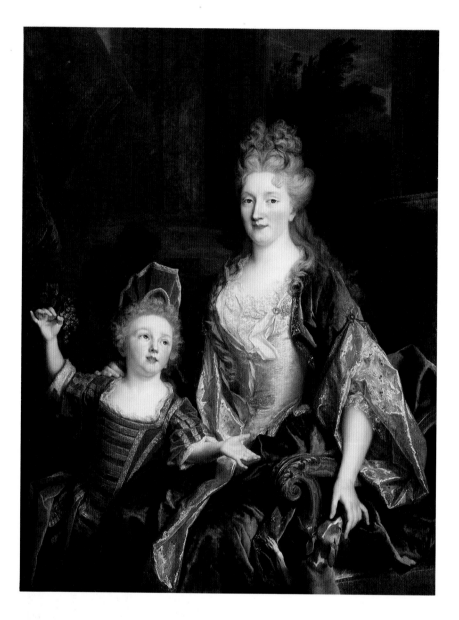

Nicolas de Largillière
French, 1656–1746

*Portrait of Catherine Coustard,
Marquise de Castelnau, Wife
of Charles-Léonor Aubry,
with Her Son Léonor*
About 1699–1700
Oil on canvas
54½ × 41¾ in.

The John R. Van Derlip Fund
77.26

While seventeenth-century Italian and
Spanish art glorified Roman Catholi-
cism and Dutch painting captured the
beauty of everyday reality, French art
of the period celebrated Louis XIV and
his court. The favorite portraitist of
this social elite was Nicolas de Largil-

lière, whose large Paris studio assisted him in producing over twelve hundred paintings of the most notable people of the age. Many of these works were engraved for sale to the public. The sitters in this portrait were fairly new members of the French aristocracy. Charles-Léonor Aubry's father, after twenty years as secretary to the king, had been made a hereditary noble—the usual reward for that office. Shortly before his wife and child sat for this likeness, Charles-Léonor himself had acquired the magnificent château of Castelnau, in the region of Berry, and with it the title of marquis. Largillière's ability to convey the charm and vivacity of his subjects is shown in the warm vitality of their composed faces and elegant figures. Young Léonor's attire—a red frock trimmed with gold braid—reflects the custom of dressing little boys like girls until the age of five or six.

from 1638 until his death. In this sculpture of Saint Jerome he portrays the great scholar and church father as an ascetic penitent, a well-known aspect of the saint's life. Jerome spent four years as a hermit in the Syrian desert, where legend says he was tempted by sexual hallucinations so vivid that he would beat his chest with a rock until they ceased. Lenckhardt's Jerome, emaciated and partly naked, looks toward heaven, beseeching God to release him from the torments of the flesh.

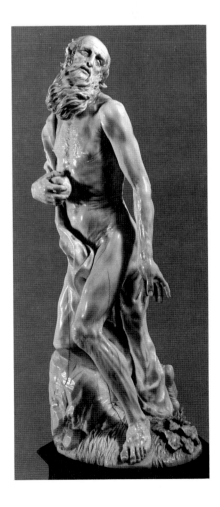

Adam Lenckhardt
German, 1610–61
Saint Jerome
About 1635–38
Ivory
10¼ in. high

The Christina N. and Swan J. Turnblad Memorial Fund 57.33

Ivory has been used for sculpture since Paleolithic times. Hard and fine grained, it takes a high polish and can be intricately carved. During the Baroque period, particularly in Germany and the Low Countries, ivory was often employed for statuettes and figurines, so-called cabinet pieces, intimate in scale and easy to transport. Adam Lenckhardt was a southern German artist who worked in Vienna

Hans Daniel Sommer
German, 1643–after 1685
Center Table
About 1690
Marquetry of tortoiseshell, brass, pewter, stone, horn, ebony, and mother-of-pearl
32 × 41 × 27 in.
Gift of Mr. and Mrs. Atherton Bean and the John R. Van Derlip Fund
80.55

Marquetry is a method of decorating furniture by gluing on thin sheets of mosaics made from wood, ivory, shell, metal, or other materials. It became widely used in Germany and the Low Countries during the late sixteenth century, and in Italy, France, and England somewhat later. Hans Daniel Sommer, a seventeenth-century specialist in fine marquetry, came from a family of distinguished sculptors and cabinetmakers in the village of Küzozelsau, in modern-day Baden-Württemberg. Sommer received numerous commissions from wealthy German aristocrats and burghers, but few of those pieces have survived. The Institute's table is one of only three by Sommer in existence. It is a tour-de-force of arabesque patterning, with intricate pewter designs on a red tortoiseshell ground and a border of flowers and *putti* formed of brass, marble, horn, and ebony. The tapered square legs and interlaced stretchers are covered with similar marquetry. This sumptuous table would have stood in the center of a room, a testament to the owner's wealth and discriminating taste. It is the most important piece of German Baroque furniture in the museum's collection and the only example of Sommer's work outside of Germany.

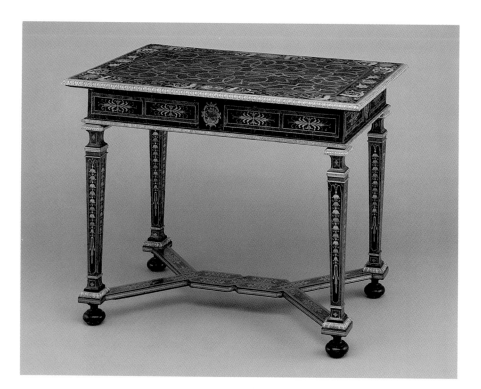

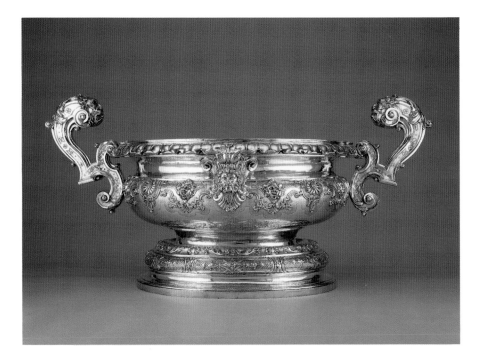

Paul De Lamerie
English, 1688–1751
Sutherland Wine Cistern
1719–20
Silver
18 in. high
The James S. Bell Memorial Fund
61.56

The Baroque style reached England late in the seventeenth century by way of Holland and France. With the revocation of the Edict of Nantes in 1685, Protestantism was no longer tolerated in France, and many Huguenots fled their Catholic homeland to settle in Holland or England. Paul De Lamerie was born in Holland to Huguenot parents who immigrated to England. He grew up in London and was apprenticed to Pierre Platel, an accomplished Huguenot silversmith who taught him to work in the ornate

Baroque manner. At the age of twenty-four, De Lamerie registered his first maker's mark at Goldsmiths' Hall and soon afterward was appointed goldsmith to the king. During those early years, he made the great wine cistern now in the Institute's collection. By 1746, the cistern had come into the possession of John, first Earl Gower and Viscount Trentham, and it passed from him to his descendants, the dukes of Sutherland. It is eighteen inches high and weighs almost 50 pounds. The massive elliptical basin was hammered from a single sheet of silver; the base, handles, molding, and ornamental detail were cast separately and soldered to the bowl. Floral, foliate, and figural motifs, from grinning fauns to seashells, embellish the surface, and the two large volute handles each terminate in a lion's head. Wine cisterns held cold water for chilling bottles of wine.

The Eighteenth Century

Antoine Watteau
French, 1685-1721
Standing Actor
About 1719-20
Red chalk drawing
6⅛ × 5⅛ in.
The John R. Van Derlip Fund 69.88

Even before the death of Louis XIV in 1715, the monumental classicism of French Baroque art was giving way to the lighter, gayer forms of the Rococo. The small scale, intimacy, and charm of the new style are evident in this chalk sketch by Antoine Watteau, one of the most important artists of the period. *Standing Actor* is a preparatory study for one of Watteau's last works, the oil painting *Les Comédiens Italiens*, now in the National Gallery in Washington, D.C. The deftly drawn actor, dressed as a young court gallant, gracefully fans his cape while twisting his supple body backward. In the painting, which shows a group of performers taking a curtain call, this gesture brings him face to face with the woman next to him. While working in Paris with Claude Gillot, a prominent designer of theater sets and costumes, Watteau had become fascinated with the Italian commedia dell'arte, and its stock characters—Octavios, Lucindas, and Pierrots—appear in many of his pictures.

Johann Georg Platzer
Austrian, 1702–60

Spring (from *The Pleasures of the Seasons*)
18th century
Oil on copper
15 × 21½ in.

Gift of Mrs. Walter H. Ude 61.37

In contrast to the pomp and grandeur of the Baroque style, Rococo art celebrated the erotic, the playful, and the pretty. It was the art of the salon and the town house, where gallantry and witty repartee held sway. In the theatrical and artificial world of Johann Platzer's *Spring*, couples dance with studied abandon and whisper in a delightful garden filled with flowers, music, and the intrigue of love. *Spring* belongs to a set of four, called *The Pleasures of the Seasons*, painted on small copper plates in rich enamel-like colors. Platzer, a contemporary of Boucher's, was born in the Tirol and spent most of his working life in Vienna.

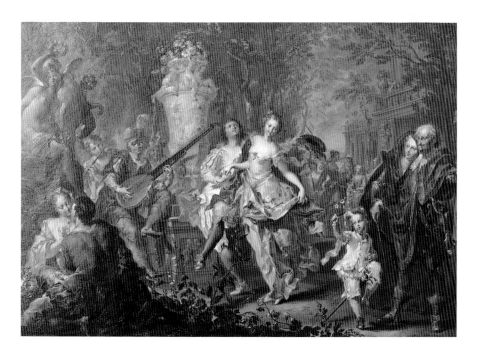

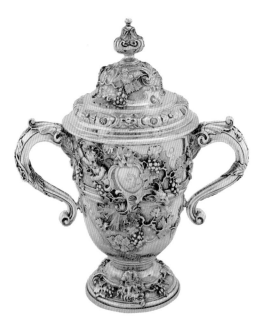

wine cistern, also in the Institute's collection) or the very plain Queen Anne mode. In eighteenth-century England, two-handled cups were often used to commemorate important events or given as prizes at horse races.

Paul De Lamerie
English, 1688–1751
Two-Handled Cup
1742–43
Silver
11¾ in. high
The James S. Bell Memorial Fund
61.46

The term *rococo* comes from the French words *rocaille* (rockwork) and *coquilles* (shells), which refer to decorative motifs fashionable during the eighteenth century. This covered silver cup is adorned with shells and scrolling grapevines. On the front and back are cartouches (one engraved with a horse's head, the other with a coat of arms) encircled by a wine-drinking cherub and masks of a lion and a goat. Such delicate, asymmetrical ornamentation is typical of De Lamerie's later work, when his Rococo manner was fully developed. His earlier pieces are in the heavier, more monumental Baroque style (like the Sutherland

Corrado Giaquinto
Italian (Naples), 1703–65
The Trinity with Souls in Purgatory
About 1742
Oil on canvas
39 × 29⅛ in.
The Putnam Dana McMillan Fund
68.2

Corrado Giaquinto trained in Naples with Nicola Maria Rossi and Francesco Solimena and in 1723 settled in Rome. There, his elegant Rococo forms and luminous colors made him the city's leading decorative painter, and his success led to his becoming first painter to the king of Spain, Ferdinand VI, in 1753. The Institute's picture of the Trinity dates from Giaquinto's Roman period. The upper part of the composition, based on his ceiling fresco for the church of San Giovanni Calibita in Rome, shows the crucified Christ taken into Heaven by God the Father and the Holy Spirit. In the lower portion, souls in Purgatory pray for Christ's resurrection and their own release from suffering. Giaquinto incorporated his initials into the base of the cross, making this painting one of his few signed works—an indication of his own high regard for it.

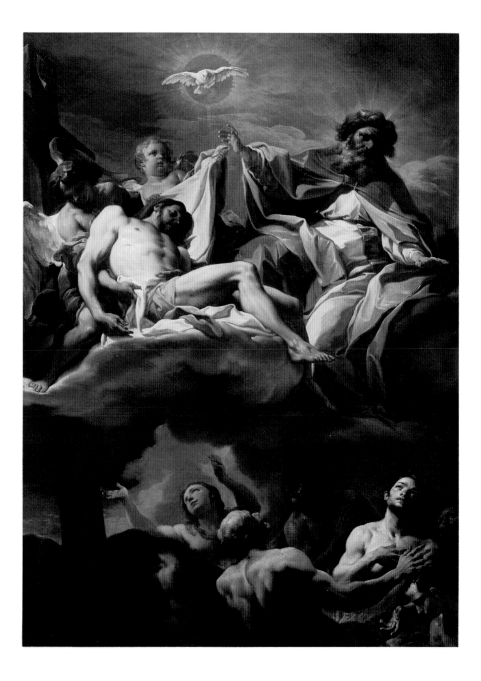

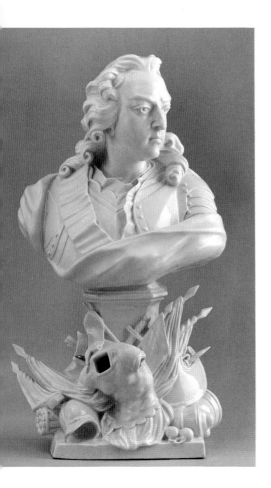

French (Chantilly)
Bust of Louis XV
About 1745
Soft-paste porcelain
18 in. high

The Groves Fund and the John R. Van Derlip Fund 83.140

Soft-paste porcelain, made from white clay and ground glass, was first produced in Europe during the late sixteenth century, at the Medici factory in Florence. Soon high-quality soft-paste wares were being created in France at Rouen and St-Cloud, and about 1725 a factory specializing in both tablewares and figurines was established at Chantilly, near Paris. The museum's bust of Louis XV was manufactured at Chantilly in the early years, when large porcelain portraits of the monarch became the vogue. The technique for making these busts was very difficult, and only a few examples are known today. This one was probably modeled after a bronze statue by Jean-Baptiste Lemoyne, Louis XV's official sculptor. The king is shown in armor, and the base of the work (cast separately) is composed of various trophies of war.

Charles Cressent
French, 1685–1758
Louis XV Commode
About 1745
Marquetry of various woods, gilt
bronze mounts, marble top
35 × 57¼ × 23 in.
Gift of the Groves Foundation 79.11

Paris was the cultural capital of
eighteenth-century Europe, and there,
in the elegant town houses of the
wealthy—in salons, boudoirs, and
bedrooms—the most sophisticated
Rococo decor could be found. In those
intimate surroundings, pastel colors
predominated, and smallness, comfort,
and versatility prevailed. Furniture,
in particular, was scaled down, and
cushions, upholstery, and caning were
used to great advantage. Charles Cres-
sent was among the leading *ébénistes*
(cabinetmakers) of the period, and
his patrons included the duke of
Orléans (regent of France during
Louis xv's childhood), the king of
Portugal, and the elector of Bavaria.
He was famous for his simple veneers
of rare, imported woods and his elabo-
rate mounts of gilt bronze. This
exquisite marble-topped commode
(chest of drawers) of satinwood and
purpleheart is decorated with an
extravagant overlay of scrolling acan-
thus leaves and ivy. Shallow cupboards
are incorporated into the sides, and
lion-clawed *sabots*, or metal "shoes,"
enclose the feet. Chests of this type—
with two drawers, serpentine fronts,
slender legs, and shaped aprons—are
known as Louis xv commodes, and
Cressent is credited with their design.

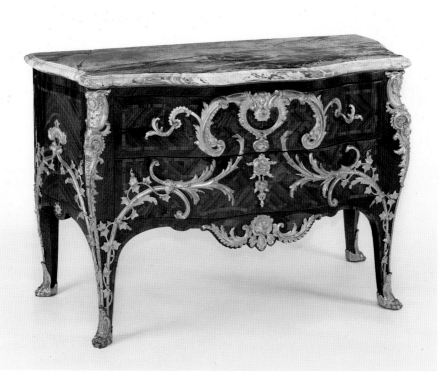

French (Strasbourg)
Tureen
Before 1754
Tin-glazed earthenware
Diameter 14½ in.
Gift of Mrs. Christian H. Aall in memory of her grandparents, Mr. and Mrs. M. J. Scanlon 84.85a–c

Throughout much of the eighteenth century the city of Strasbourg, in northeastern France, was the center of a thriving faience industry. Tin-glazed earthenware, or faience, was introduced to Europe from the East during the late Middle Ages. The earliest French-made pieces date to the late sixteenth century and most are decorated with biblical or mythological subjects. But in the eighteenth century, French factories produced blue-and-white wares and also *faïence japonnée* (with Oriental motifs), *faïence parlante* (with inscriptions), and *faïence patriotique* (with Revolutionary emblems and mottoes). Bright enamel colors, an innovation inspired by porcelain painting, became fashionable in the late 1740s and the 1750s, and at the same time there was a vogue for tureens shaped like birds, animals, flowers, and vegetables. The museum's large green and yellow "cabbage" tureen is an excellent example. It sits on a stand of leaves marked with the initials *PH*, for Paul Hannong, whose family owned the factory at Strasbourg for almost a century.

Designed by François Boucher
French, 1703–70
Apollo and Clytie
1749–72
Tapestry weave, wool warp, wool and silk weft
148 × 127 in.
The William Hood Dunwoody Fund
42.16

François Boucher was Watteau's most talented follower and the favorite artist of Louis XV and his mistress Madame de Pompadour. During his long and profitable career, Boucher not only made paintings and prints, but also illustrated books and designed stage sets, porcelains, and interior decorations. As director of the royal factories at Beauvais and Gobelin, he planned eight different sets of tapestries, many of which were woven several times and in various sizes. The museum's *Apollo and Clytie* was the final hanging in a nine-piece composition entitled *The Loves of the Gods*, produced at Beauvais for the French crown. According to Greek mythology Clytie, the beautiful daughter of the king of Babylon, fell in love with Apollo, the sun god. But he spurned her, and she wasted away, eventually turning into a sunflower as she constantly watched his daily journey across the sky. In Boucher's tapestry, Clytie appears in the heavens at Apollo's feet, gazing at his face, while he looks toward the team of horses that pulls his blazing chariot through the firmament. *Putti* scamper close by, and on the riverbank below, two water nymphs sit idly near a conspicuous clump of sunflowers. Boucher excelled at romantic scenes like this, which provided opportunities for depicting rosy nudes and idyllic landscapes.

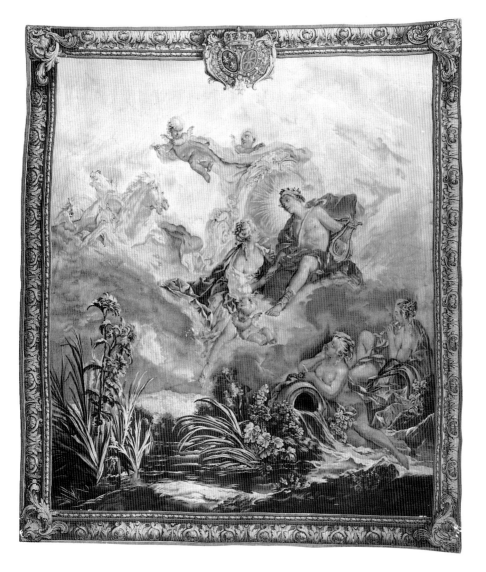

119

Italian (Venetian)
Writing Desk
About 1760
Painted and gilded wood
54 in. high
The Putnam Dana McMillan Fund
76.74

In the sixteenth century, as new trade routes were established—to the Americas across the Atlantic Ocean and to Asia around the Cape of Good Hope—Italy's Mediterranean ports lost their importance. By the eighteenth century, Venice, once the queen of the Adriatic, was in the last stages of its decline as a commercial and maritime power. But the city's aristocracy and wealthy bourgeoisie continued to furnish their *palazzi* and villas lavishly, with boldly designed pieces remarkable for lively carving and brilliant color. The top of this elaborate desk opens to reveal a writing surface and several drawers, some visible, others secret. Side panels conceal more clusters of drawers, and the large cupboard door in the lower front hides a chest of drawers in which clothing and valuables would have been stored. The exterior is decorated with floral paintings and gilt carvings—a style favored in eighteenth-century Venice. Conspicuously placed above the central keyhole, a small relief of Father Time suggests the transitoriness of all worldly delights.

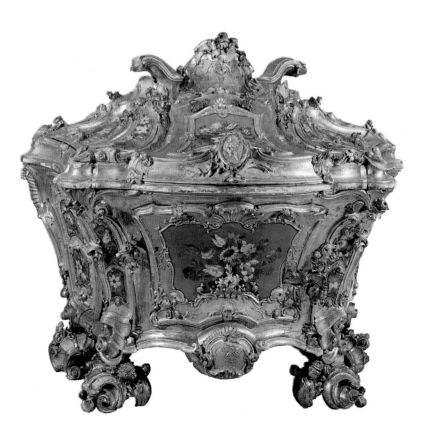

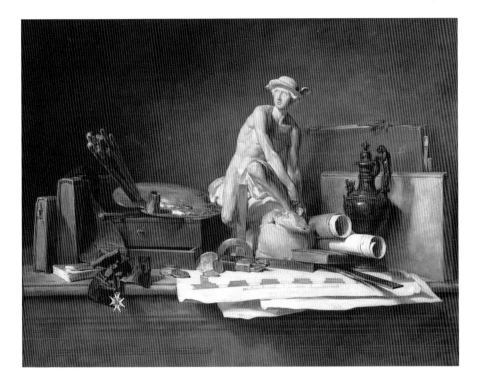

Jean-Baptiste-Siméon Chardin
French, 1699–1779

*The Attributes of the Arts
and the Rewards Which Are
Accorded Them*
1766
Oil on canvas
44½ × 57¼ in.

The William Hood Dunwoody Fund
52.15

Rejecting the fanciful, often frivolous
art of the Rococo, Jean-Baptiste-
Siméon Chardin chose instead to paint
genre scenes and still lifes. A highly
regarded member of the Royal
Academy, Chardin never lacked
commissions and often had to make
several copies of the same painting in
order to satisfy the great demand for
his work. The museum's *Attributes of*

the Arts is one of three versions that
he executed in the mid-1760s. One, for
Catherine the Great of Russia, is now
in the Hermitage Museum in Lenin-
grad; another, for the Parisian judge
the abbé Pommyer, is lost; and the
third, for the French sculptor Jean-
Baptiste Pigalle, was purchased by the
Institute in 1952. The arts repre-
sented are literature (books), painting
(palette, knife, and brushes), archi-
tecture (surveyor's tools and drawings),
sculpture (plaster cast), and gold-
smithing (metal ewer). And the
rewards of artistic excellence are
money and the medal of the Order of
St. Michael, the highest award of merit
then given. The statuette (*Mercury
Fastening His Sandals*) and the medal
of honor, specific references to Pigalle,
have caused scholars to speculate that
these pictures are Chardin's personal
tribute to his close friend.

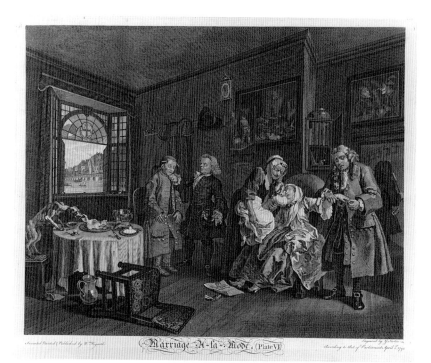

William Hogarth
English, 1697–1764
Marriage à la Mode (Plate 6)
1745
Engraving
15¼ × 18½ in.

The Ethel Morrison Van Derlip
Fund 16,945

The eighteenth century was an age
that delighted in satire, in Pope's *Rape
of the Lock*, Swift's *Gulliver's Travels*,
Voltaire's *Candide*, and William
Hogarth's pictures. Bearing such tell-
tale names as Moll Hackabout, Tom
Rakewell, and Lord Squanderfield,
Hogarth's characters teach by bad
example the virtues of honesty, loyalty,
and prudence. Hogarth's fame rests
largely on three series of works
(*A Harlot's Progress*, *A Rake's
Progress*, and *Marriage à la Mode*)
which, after being painted, were
engraved for sale to the public. This
print is the suicide scene from *Marriage
à la Mode*, a suite of six images
illustrating the consequences of an
arranged marriage between a young
middle-class woman and a vain aristo-
crat. After years of enduring her
husband's infidelities and debaucheries,
the neglected wife succumbs to the
overtures of Silvertongue, the family's
attorney, and agrees to become his mis-
tress. When the couple is discovered,
a duel between the husband and the
lover ensues, leaving the husband dead
of rapier wounds, the lover hanged
for murder, and the distraught wife
poisoned by her own hand. Hogarth's
master paintings for this series were
done in 1743 and are now in the
National Gallery in London; the
engravings made after them were
finished in 1745 and sold by general
subscription for the modest price
of one guinea a set.

Thomas Gainsborough
English, 1727–88
The Fallen Tree
About 1748
Oil on canvas
40 × 36⅛ in.
The John R. Van Derlip Fund 53.1

The scientific movement of the seventeenth century, led by such men as Galileo, Kepler, Bacon, Descartes, and Newton, profoundly altered the way people viewed the natural world. In the eighteenth century, the Age of Reason, the world was envisioned as an immense machine that obeyed mathematical and mechanical laws, that was predictable and could be used to benefit humanity. This outlook is reflected in art and literature of the period, such as the poetry of Alexander Pope and the idyllic landscapes of Thomas Gainsborough. Although primarily known as a society portraitist, Gainsborough began and ended his career as a landscape painter. He often sketched outdoors and brought rocks, moss, and twigs back to his studio to use as models. *The Fallen Tree*, executed when he was barely twenty years old, pictures the countryside near his home in Sudbury, Suffolk. The naturalistic rendering of wooded hillsides, docile cattle, and calm skies shows Gainsborough's familiarity with seventeenth-century Dutch landscapes, and the serenity pervading this image suggests an attitude of confidence in a rational, orderly universe.

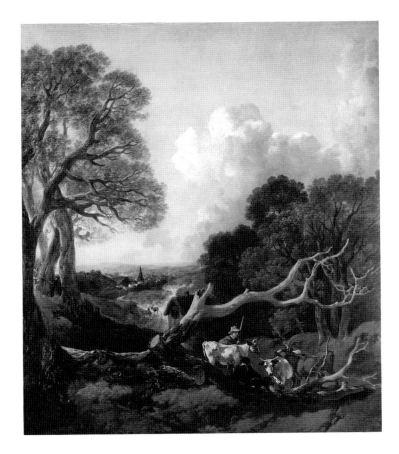

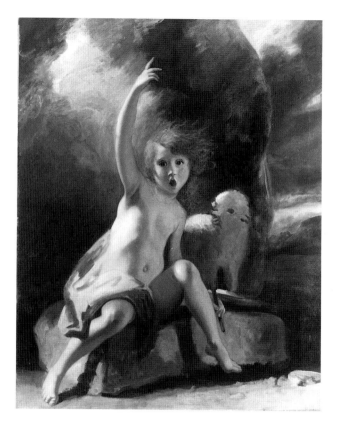

Sir Joshua Reynolds
English, 1723–92
*The Child Baptist in
the Wilderness*
About 1776
Oil on canvas
49½ × 39⅞ in.
The Christina N. and Swan J. Turnblad
Memorial Fund 68.18

Joshua Reynolds was already the most
fashionable portraitist in London
when, in 1768, he was unanimously
elected first president of the English
Royal Academy. Over the next two
decades he delivered a series of lec-
tures, to students and members of the
academy, on the proper education of
the artist. In these *Discourses*, as they
were known, Reynolds propounded

the official academic view that art
should embody lofty themes and ideal
forms in harmonious compositions.
His own paintings, however, often
possess a spontaneity and freshness of
approach that his writings usually lack.
Such is the case with this sensuous,
loosely brushed painting of Saint John
the Baptist. From a maelstrom of gray
and black, the child cries out to us with
open mouth and upraised arm. This
image of the Baptist may be an ideal-
ized portrait of a cockney youth. From
his early biographers, we learn that it
was Sir Joshua's habit "on meeting
a picturesque beggar in the street . . .
to send him or her to his house . . . to
sit for a fancy picture." A second, more
finished version of this work is in the
Wallace Collection in London.

Giovanni Battista Piranesi
Italian (Venice), 1720–78
Side Table
About 1769
Carved and gilded oak and limewood,
marble top
35½ × 59 × 29¼ in.
The Ethel Morrison Van Derlip
Fund 64.70

With the excavation of the buried
cities of Herculaneum and Pompeii in
the 1730s and 1740s and the writings
of the German antiquarian Johann
Winckelmann in the 1750s, all of
Europe became fascinated with "the
glory that was Greece / And the gran-
deur that was Rome." This renewed
interest in the ancient past led the
Venetian artist Giovanni Battista
Piranesi to Rome, where he etched
his famous *Vedute* (Views) — 135
prints that showed the architectural
ruins of the city in all their majestic

splendor. Piranesi was also a designer
of furniture, and in 1769 he published
Diverse Maniere . . . (Different
Fashions . . .), a volume of engravings
that contained his plans for a number
of household items, from tables and
chairs to vases and picture frames.
The book was dedicated to Cardinal
Giovanni Rezzonico, the nephew of
Pope Clement XIII. The Institute's side
table, which also dates to about 1769,
was made for the cardinal's state
apartments in the Quirinal Palace.
Five winged chimeras (mythological
she-monsters with the heads of lions
and the bodies of goats) form the legs
of the table, and a rich frieze of floral
swags, palmettes, and ox skulls sup-
ports the heavy marble top. Both frieze
and legs are liberally covered with gold
leaf. This table and its mate, which is
now in the Rijksmuseum, Amsterdam,
are the only surviving pieces of furni-
ture designed by Piranesi.

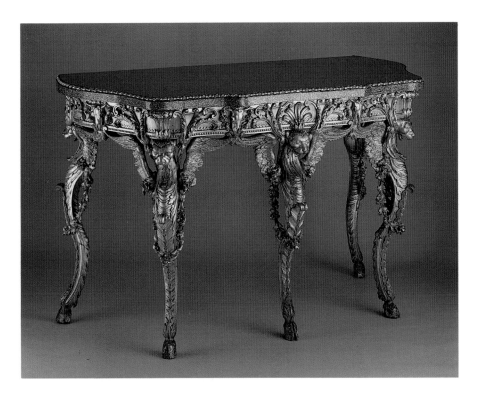

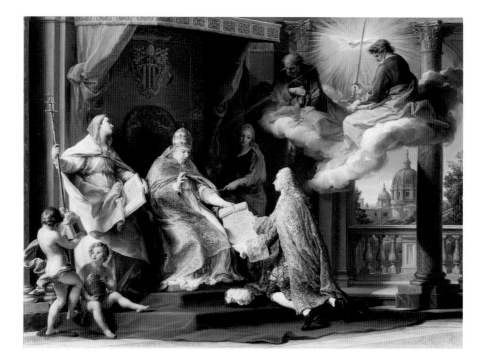

Pompeo Girolamo Batoni
Italian (Rome), 1708–87

Pope Benedict XIV Presenting in 1756 the Encyclical "Ex Omnibus" to the Count de Choiseul
1757
Oil on canvas
50¾ × 70⅛ in.

The William Hood Dunwoody Fund
61.62

Pompeo Batoni was best known as a painter of historical and religious scenes, but he was also Rome's leading portraitist from the mid-1740s until his death in 1787. An admirer of Raphael and a friend of Johann Winckelmann, he worked in a classically inspired style notable for its brilliant coloring, rich textures, and precise draftsmanship. In *Pope Bene-dict XIV Presenting the Encyclical*, Batoni represents a contemporary political event. King Louis xv of France had sought the pope's intervention to settle long-standing problems involving the Gallican church, the French parliament, and the Jansenist sect. Pope Benedict responded with a letter which he presented to the French ambassador, Count de Choiseul, in 1756. Batoni portrays the pontiff, attended by female personifications of faith and religion, handing the document to the count while Saints Peter and Paul witness the event from above. Between the heads of the two saints the Holy Spirit appears in the form of a dove. The painting was commissioned by Cardinal Domenico Orsini as a gift to Benedict XIV and contains an accurate likeness of the aging pope, who was also a great patron of Batoni's.

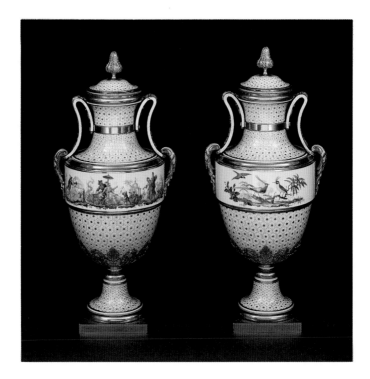

French (Sèvres)
Pair of Covered Vases
1780
Hard-paste porcelain, gilt bronze
18¾ in. high
The Groves Fund 80.36.1,2

Although Chinese potters had developed porcelain making during the T'ang dynasty (618–906), Europeans did not discover how to make hard-paste porcelain until early in the eighteenth century. The first European factory to produce this type of porcelain was set up in 1709 at Meissen, near Dresden, and for forty years the Germans had a monopoly on the trade. But in the 1750s the French learned the secret, and they soon took the lead. The factory at Sèvres, already famous for high-quality soft-paste porcelain, began creating hard-paste wares in the

late 1760s. At first these were made in a restrained Rococo manner, but later in the century artists like Falconet, Pigalle, and Houdon became associated with the manufactory and introduced a classicizing style. Whatever their design, Sèvres porcelains were always decorated with brilliant colors and liberal gilding. The Institute's pair of vases is very similar to a set originally sold to Marie Antoinette and now part of the English royal collection. The white grounds are painted with a turquoise and gold circle-and-dot pattern (*oeil-de-perdrix*), and the wide decorative bands are adorned with exotic birds and chinoiserie (Chinese motifs). Objects like these—opulent but never gaudy—appealed to the wealthy, who in the eighteenth century bought porcelain with the same enthusiasm that earlier generations had collected tapestries.

Designed by Philippe de Lasalle
French, 1723–1805
Woven Fabric
About 1770–75
Silk
116 × 21 ½ in.
The Groves Fund 83.36

Throughout the Middle Ages and
Renaissance, the finest European-
made silks came from Spain and Italy,
but during the late seventeenth
century, France took the lead in silk
production. The factories at Lyons,
where the museum's panel was woven,
were famous for their quality fabrics
and use of naturalistic patterns. This
piece, an example of the large furnish-
ing silks used as wall coverings in the
homes of the wealthy, was made for
Catherine the Great and once deco-
rated her rooms at the Tsarskoe Selo
palace. The delicate Rococo design of
flowers, birds, bows, and baskets is the
work of Philippe de Lasalle. Lasalle,
who had trained as a painter in Paris
with François Boucher, was the fore-

most supplier of furnishing silks to
the royal houses of France, Spain, and
Russia. His career reached its height in
the 1770s; however, he died a pauper,
bankrupted by the French Revolution.

Jean-Honoré Fragonard
French, 1732–1806
The Sacrifice of the Rose
About 1775–80
Black chalk and colored washes
on paper
17 × 13 in.

Gift of Mr. and Mrs. Clinton
Morrison 83.109

Like Antoine Watteau and François
Boucher, Jean-Honoré Fragonard was
known for his playfully erotic paint-
ings and murals—works that brought
him commissions from Louis XV and
from the king's mistresses, Madame
de Pompadour and Madame du Barry.
Eventually, however, Fragonard's
patrons tired of his pastoral idylls with
their frolicking "shepherds" and
"shepherdesses," and in 1773 Madame
du Barry rejected his *Progress of Love*
series in favor of Neoclassical panels
by the more fashionable painter
Joseph-Marie Vien. Fragonard tried to
adapt his style to the changing taste
by introducing Neoclassical elements
into his pictures. In this drawing, an
allegory of sexual love, a young woman
offers roses to the flaming torch of
Hymen, god of marriage. Although
the woman's tunic and the backdrop of
Corinthian columns add a Neoclassical
note, the fluttering cherubs' wings,
billowy clouds, and vigorously applied
colored washes create the visual
excitement typical of Fragonard's
Rococo images. Fragonard made five
paintings on this theme, which he
called *The Sacrifice of the Rose* or *The
Offering to Love*. He executed the
Institute's drawing before completing
the first oil version in the mid-1770s.

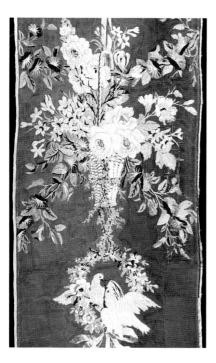

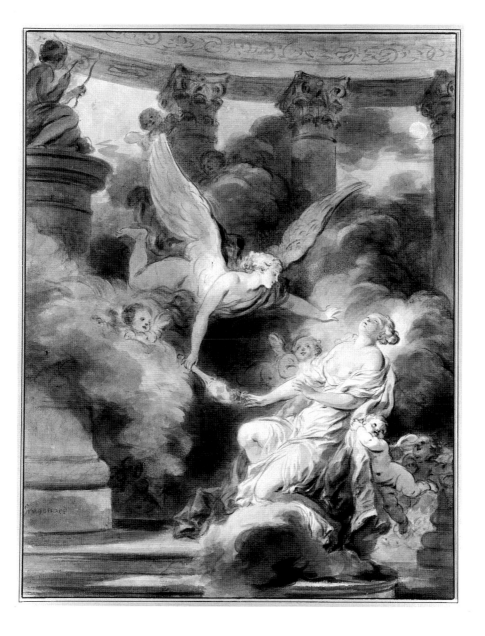

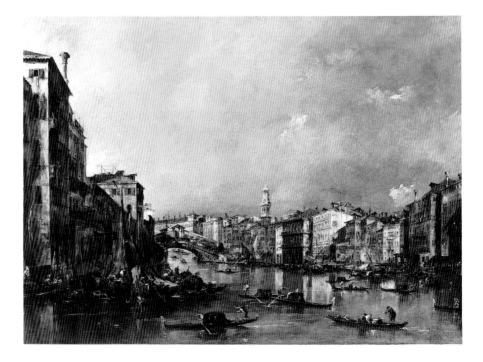

Francesco Guardi
Italian (Venice), 1712–93
*View up the Grand Canal
toward the Rialto*
About 1785
Oil on canvas
25¾ × 35⁷/₁₆ in.
The William Hood Dunwoody Fund
and gift of Mr. and Mrs. Theodore W.
Bennett 56.41

The Gothic traceries, Byzantine glitter,
and Baroque splendor of Venice held
as much fascination for the eighteenth-
century traveler as they do for the
modern tourist. But in the seventeen
hundreds, instead of paper postcards,
souvenirs took the form of oil paint-
ings called *vedute* (views). Francesco
Guardi, like his more popular contem-
porary Antonio Canaletto, was a

master of this new genre—the city-
scape. Unlike Canaletto's detailed
and precise images, Guardi's work is
painterly and abstract. In *View up the
Grand Canal toward the Rialto*, the
shimmering atmosphere is created by
quick, energetic brushstrokes of subtle
brown and beige tones punctuated
with red and orange. Deep shadows
obscure the forms on the left, while
the setting sun rakes across the build-
ings to the right, highlighting their
façades in a piercing white light.
During his lifetime, Guardi's paintings
brought only half the price usually
paid for Canalettos of the same size.
In the late nineteenth century,
however, his work was much admired
by the French Impressionists, and his
reputation finally caught up with that
of his compatriot.

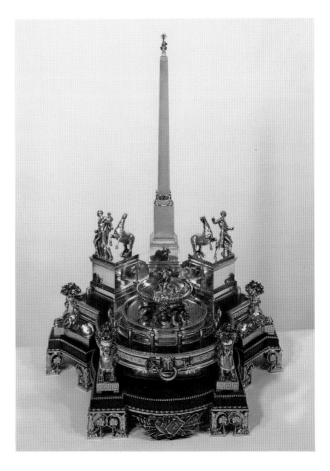

Vincenzo Coaci
Italian (Rome), 1756–94
*Inkstand Representing
the Quirinal Monument*
1792
Silver, silver gilt, and lapis lazuli
28½ × 20½ × 14¾ in.

Gift of the Morse Foundation
69.80a,b

This magnificent inkstand commemo-
rates the erection of the Quirinal
Monument in Rome during the pontifi-
cate of Pius VI. The monument, which
still stands in the piazza outside the
Quirinal Palace, consists of two ancient
Roman sculptures of horse tamers, an
Egyptian obelisk unearthed near the
Mausoleum of Augustus, and a foun-
tain taken from the Roman Forum.
The inkstand, presented to the pope in
April 1792, reproduces the monument
in miniature, with marvelous ingenuity
and craftsmanship. Moving a lever
causes two turtledoves to meet and
kiss. The sphinxes' headdresses lift out
to disclose candleholders. A drawer
opens, displaying a potpourri of
trompe l'oeil engravings. The animal
tamers and their horses swing out to
reveal an inkwell and a sandbox. And
under an elaborate superstructure of
cast and polished silver and silver gilt
is a marble writing desk. The inkstand's
leather carrying case masquerades as
a walled medieval town, replete with
gates, battlements, and a bell tower.

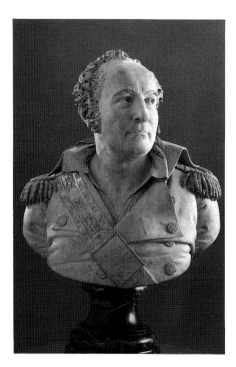

But here he wears the *petit uniforme* of an artillery division general, a rank he probably attained in 1797. Chinard's informal representation, showing Brune's uniform wrinkled and open at the neck, conveys the general's self-assurance and good humor. Despite this air of casualness, the surface detail is rendered with precision and displays Chinard's skill in modeling.

Joseph Chinard
French, 1756–1813
Bust of General Brune
After 1797
Terra-cotta with marble base
21 in. high
The Christina N. and Swan J. Turnblad Memorial Fund and the Putnam Dana McMillan Fund 77.31a,b

Terra-cotta (literally, baked earth) was traditionally used for models of sculptures that were to be executed in other materials. During the Enlightenment, however, the intimacy and spontaneity achievable with clay made it a popular medium for finished statuettes and portrait busts. Joseph Chinard sculpted numerous portraits, in both terra-cotta and marble, of famous people connected with the French Revolution and of Napoleon Bonaparte and his family. The subject of this bust, Guillaume Brune, became commander-in-chief of the French forces in Switzerland and of Napoleon's Army of Italy.

Pierre-Paul Prud'hon
French, 1758–1823
The Union of Love and Friendship
About 1793
Oil on canvas
57½ × 45 in.
The William Hood Dunwoody Fund and the John R. Van Derlip Fund
64.50

During the late eighteenth century, Europe's preoccupation with Greek and Roman antiquity fostered a new artistic style of "noble simplicity and quiet grandeur." Based on the idealized forms and serene poses of classical sculpture, it was known as Neoclassicism. Pierre-Paul Prud'hon, a master of allegorical painting, was both a friend and a rival of Jacques-Louis David, the great French Neoclassical artist of the Revolution. In *The Union of Love and Friendship*, Prud'hon combined a Neoclassical admiration for the perfect nude with his own penchant for warm colors and subtle shading. Cupid, the winged god of love, holds a blazing torch symbolizing his affection, while Psyche, the personification of friendship, sits languidly by his side. This painting was Prud'hon's first major commission after his return to France following a three-year sojourn in Italy, and it was first shown in the Paris Salon of 1793.

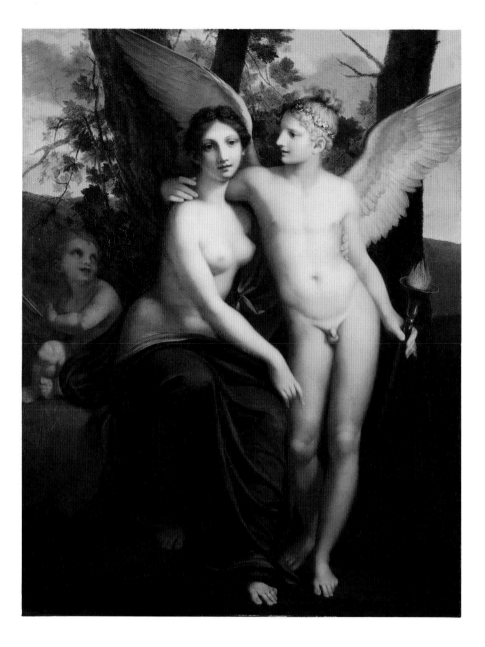

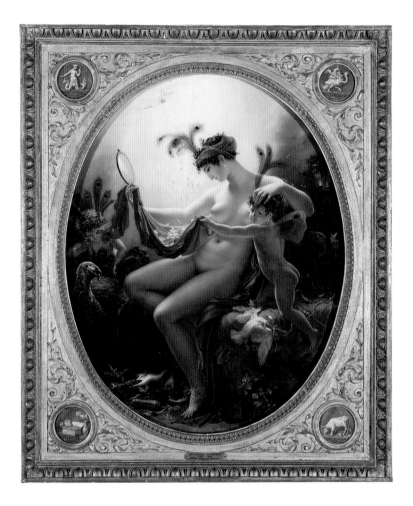

Anne-Louis Girodet
de Roucy Trioson
French, 1767–1824

*Portrait of Mademoiselle Lange
as Danaë*
1799
Oil on canvas
25½ × 21¼ in.

The William Hood Dunwoody Fund
69.22

Danaë was one of the many mortals
loved by the Olympian god Zeus, who
came to her in the form of a shower
of gold. This story provided the

inspiration for one of the more vicious
satires in the history of Western art—
Girodet's painting of Mademoiselle
Lange, a well-known Parisian actress.
She had rejected Girodet's first portrait
of her as unflattering and had refused
to pay for it; so Girodet retaliated by
making a second likeness, showing her
as vain, greedy, and faithless. Wearing
a headdress of peacock feathers
(emblems of empty pride), she sits
seductively on a squalid bunk, catching
coins in an outstretched cloth with the
help of a winged child who represents
her illegitimate daughter, Palmyre.
Near them, a white dove labeled

FIDELITAS (fidelity) lies dead, struck down by a piece of gold, while a second bird, CONSTANTIA (constancy), breaks its bonds and flies away. The leering turkey, sporting a large ring on one toe, stands for the man whom the actress beguiled and married for his fortune, and the head (or perhaps mask) under the bed is that of a rejected lover. This painting caused such a scandal that within two days of its unveiling at the Salon of 1799 Mademoiselle Lange procured a court order to have it removed from public view.

Bertel Thorvaldsen
Danish, 1768–1844
Ganymede and the Eagle
1817–29
Carrara marble
34¾ × 46⅜ × 18½ in.

Gift of the Morse Foundation
66.9

In conducting his many love affairs, Zeus often assumed disguises. To Leda he appeared as a swan, to Europa as a bull, and to Io as a cloud. To Ganymede, the young prince of Troy, he came as an eagle and carried the boy off to Mount Olympus to be his cupbearer. In keeping with Neoclassical taste, however, there is no hint of impropriety in Bertel Thorvaldsen's rendering of this Greek myth. We are shown a moment that is marked by dignity and restraint: the beautiful Ganymede, nude except for his cap, kneels to give the large bird a drink. Thorvaldsen was Europe's finest Neoclassical sculptor after Antonio Canova. This sculpture, which took twelve years to complete, was commissioned in 1817 by an English nobleman, Earl Gower. Thorvaldsen made several versions of the Ganymede story, and the Institute's, carved from white marble and polished to a luminous finish, is the prototype for the later ones.

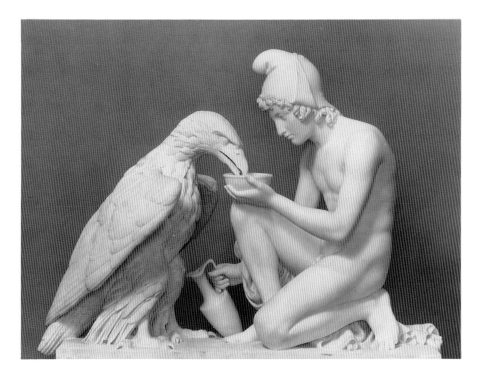

The Nineteenth Century

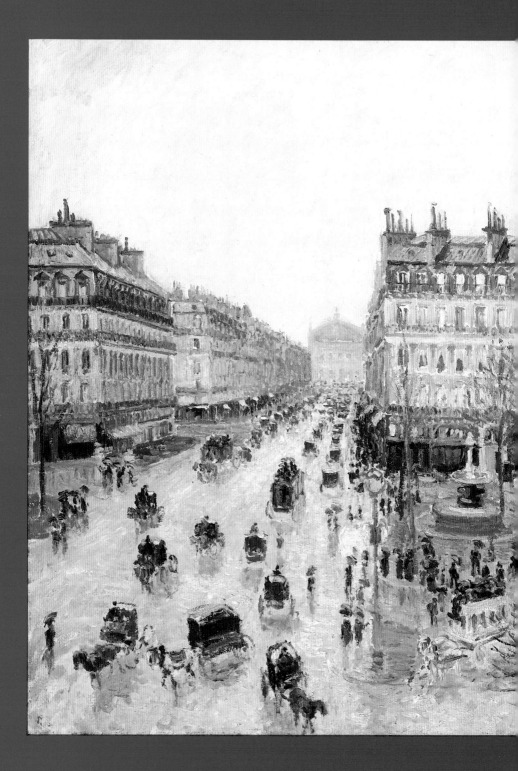

William Blake
English, 1757–1827
Nebuchadnezzar
1795
Color print finished in pen and
watercolor
16¹⁵/₁₆ × 23¾ in.
Miscellaneous purchase funds 12,581

Reacting against the intellectualism of
Neoclassicism, artists and writers of
the Romantic age emphasized imagi-
nation, emotion, and intuition. To the
English poet and painter William
Blake, imagination was the preeminent
element of human nature and constantly
at odds with reason. This print is
a larger version of a picture from *The
Marriage of Heaven and Hell* (about
1790), one of several illuminated books
that Blake both wrote and illustrated.
The biblical figure Nebuchadnezzar,
king of Babylon, went mad and "ate
grass like an ox, and . . . his hair grew
long as eagles' feathers, and his nails
were like birds' claws" (Daniel 4:33).
For Blake, Nebuchadnezzar represents
the bestial, which is one of the counter-
parts of reason in the artist's myth-
ology. By painting on millboard and
then transferring the still-wet image
onto paper, Blake made several copies
of this startling picture. At least two
others are extant, one in the Museum
of Fine Arts in Boston and the other
in the Tate Gallery in London. Blake's
hand-colored prints of 1795, such as
God Creating Adam, Newton, and
Nebuchadnezzar, are generally con-
sidered his best works.

El de la rollona.

Francisco de Goya
Spanish, 1746–1828
Nanny's Boy (*Los Caprichos*,
Plate 4)
1797–99
Etching and aquatint on paper
8⅛ × 5½ in.

Gift of Mr. and Mrs. John T. Adams,
Dr. and Mrs. David Bradford, Mr. and
Mrs. Benton J. Case, Mr. and Mrs. W.
John Driscoll, Mr. and Mrs. Reuel
Harmon, and the William Hood
Dunwoody Fund, by exchange
P.83.57.4

As a printmaker, Goya ranks with
Albrecht Dürer and Rembrandt van
Rijn. *Los Caprichos* (Caprices), his
best-known work, is a series of eighty
satirical etchings criticizing the hypoc-
risy, ignorance, and depravity that he
observed in those around him: the
foolishness of the aristocrat, the greed
of the cleric, the opportunism of the
professional, and the superstition of
the peasant. Published in book form in
1799, this was the first extensive set of
prints made in Spain. In *Nanny's Boy*
(*El de la rollona*), Goya lampoons the
nobility by picturing a grown man
in the dress and headband of a small
child. While a servant struggles to
keep him upright, the bearded toddler
entertains himself by sucking his
fingers; near at hand, an enormous
bowl of food and a padded potty-chair
indicate the primary diversions of this
"baby." Despite their sensational con-
tent, the *Caprichos* sold poorly, and
fearing censure from the Spanish
Inquisition, Goya pulled them off the
market. In 1803, he gave all of the
etched plates and 240 sets of the first
edition to King Charles IV, who had
them deposited in the Calcografía
Nacional. The Institute's copy of the
Caprichos is among the rarest and
finest. It is one of only sixteen bound
sets containing working proofs printed
under Goya's supervision.

Francisco de Goya
Spanish, 1746–1828
Self-Portrait with Dr. Arrieta
1820
Oil on canvas
45½ × 31⅛ in.

The Ethel Morrison Van Derlip
Fund 52.14

As court painter to both Charles III and Charles IV of Spain, Goya achieved considerable fame as a portraitist. *Self-Portrait with Dr. Arrieta*, the last of his many self-portraits, was executed late in his life at his country retreat near Madrid, La Quinta del Sordo (House of the Deaf Man). In 1819, Goya had fallen seriously ill, and his doctor, Eugenio García Arrieta, had nursed him back to health. On recovering, he presented Arrieta with this painting, which shows the physician ministering to his patient. The words at the bottom read in translation "Goya gives thanks to his friend Arrieta for the expert care with which he saved his life from an acute and dangerous illness which he suffered at the close of the year 1819 when he was seventy-three years old. He painted it in 1820." This inscription gives the canvas the look of an ex-voto, a type of religious painting still popular in Spain, which expresses gratitude for deliverance from a calamity. The three mysterious figures in the background may represent demons that haunted Goya while he lay close to death. Such devils first appeared in Goya's art in 1788, and they soon became a distinctive feature of his work.

Eugène Delacroix
French, 1798–1863
The Fanatics of Tangier
1838
Oil on canvas
38½ × 51½ in.
Bequest of J. Jerome Hill 73.42.3

In France, the Romantic style in painting reached its height during the 1810s and 1820s in the work of Antoine Gros, Théodore Géricault, and Eugène Delacroix. Delacroix, the unofficial leader of the movement, once remarked, "If by Romanticism is meant the free expression of my personal feelings, my aloofness from the standardized type of paintings prescribed by the schools, and my dislike of academic formulas, I must confess

that not only am I a Romantic, but that I already was one at the age of fifteen." *The Fanatics of Tangier* reflects this outlook and shows the French Romantics' preference for exotic subjects, excited movement, glowing colors, and fluid brushwork. In 1832, Delacroix had traveled to North Africa with the French ambassador, Count de Mornay, who was to negotiate a treaty of friendship with the sultan of Morocco. One day in Tangier, the two hid in an attic and through the cracks of a shuttered window witnessed the frenzy of the Isawas, a fanatical Muslim sect. The turmoil of that event is conveyed in this vigorous depiction of the Isawas thronging the street. Delacroix's Moroccan experiences affected him deeply and were a lasting source of inspiration to him.

Camille Corot
French, 1796–1875

Silenus
1838
Oil on canvas
97½ × 70½ in.
Bequest of J. Jerome Hill 73.42.2

Corot trained with the landscapist
Jean-Victor Bertin at the Ecole des
Beaux-Arts. He exhibited in the Paris
Salon of 1827 and soon became a regu-
lar participant, winning a second-class
medal in 1833 and the Legion of
Honor, one of France's highest awards,
in 1846. *Silenus* was painted expressly
for the Salon of 1838, which accounts
for its large size and classical subject
matter. Based on an episode from Ver-
gil's *Eclogues*, it shows the mythical
drunkard Silenus, "his veins swollen . . .
with the wine of yesterday," sitting by
a stream in a forest glade. His compan-
ions have bound him with garlands,
and while he smiles at the prank and
cries out to be released, a nymph rubs
his face with mulberries. His retinue
includes a bacchante (a female
follower of Bacchus, the wine god)
wearing a leopard skin and carrying a
pinecone-tipped staff, or thyrsus. In
the middle distance, some nymphs
dance in a circle with a young man and

a satyr. Despite the theme of revelry, the subdued coloring, precisely rendered figures, and carefully conceived landscape create a mood of tranquillity. Corot continued to paint such idylls throughout his long career, but never again on the ambitious scale of the *Silenus*.

Gustave Courbet
French, 1819–77
The Castle of Ornans
1855
Oil on canvas
32⅛ × 46 in.

The John R. Van Derlip Fund and the William Hood Dunwoody Fund
72.66

"Painting is an essentially *concrete* art, and can consist only of the representation of things both *real* and *existing*. . . .

An *abstract* object, invisible or non-existent, does not belong to the domain of painting. . . . Show me an angel and I'll paint one." With such statements, Gustave Courbet became the spokesman for the French Realists, a radical group of artists and writers— including Daumier, Millet, Balzac, and Flaubert—that emerged at midcentury. Championing the ordinary and the actual, and rejecting all mythological, religious, historical, and imaginary themes, the Realists constituted the first truly modern movement in art. Courbet's *Castle of Ornans* is an unidealized depiction of the countryside of eastern France near his native Ornans, the village in the river valley. "Castle of Ornans" refers to the hamlet on the cliffs, built on the site of a medieval fortress that had belonged to the dukes of Burgundy and was destroyed in the seventeenth century.

Gustave Courbet
French, 1819–77
Deer in the Forest
1868
Oil on canvas
51½ × 38¼ in.
Gift of James J. Hill 14.76

Gustave Courbet was an avowed realist, painting mainly nudes, portraits, and landscapes. An enthusiastic sportsman, he began to specialize in forest and hunting scenes during the late 1850s. *Deer in the Forest*, executed in warm browns, greens, and russets, displays the forthrightness typical of Courbet's mature style. Courbet often applied his pigments with a palette knife, a radical innovation in his day. By combining this technique with fluid brushstrokes, he created a great variety of surface textures. *Deer in the Forest*, a late work intended for the art market, once belonged to James J. Hill, the Minnesota railroad magnate whose collection of European paintings forms the basis of the Institute's nineteenth-century holdings.

Jean-François Millet
French, 1814–75
The Church at Chailly
About 1868
Pastel on paper
28½ × 33½ in.

Bequest of Mrs. Egil Boeckmann
67.31.4

Jean-François Millet, along with such artists as Théodore Rousseau and Jules Dupré, left the clamor of Paris to settle in the small town of Barbizon at the edge of the Forest of Fontainebleau. These artists moved their easels out-of-doors and began sketching and painting directly from nature, a revolutionary practice later adopted by the Impressionists. Like others of the Barbizon school, Millet depicted the simple beauty of the countryside and the dignity of those who worked the land. He is best known for his large paintings of peasants, like *The Gleaners*, but during the 1860s he turned increasingly to landscapes and nature studies and late in his career made over one hundred pastels. This one, drawn in autumnal tones of muted brown and green, shows the outskirts and parish church of Chailly, a village near Barbizon. Its quiet melancholy reflects Millet's sympathy for the rural poor at their unceasing labors. The expanse of plowed ground, seen in many of his pictures, suggests his view of the land as the ultimate source of nourishment and the basis of human existence. This outlook, derived from French philosophers of the eighteenth and nineteenth centuries, was consonant with Millet's own strong moral convictions and social concerns.

Sir John Everett Millais
English, 1829–96

Peace Concluded
1856
Oil on canvas
46 × 36 in.

The Putnam Dana McMillan Fund
69.48

The Crimean War (1854–56), which inspired Florence Nightingale's heroic nursing efforts and Alfred Lord Tennyson's poem "The Charge of the Light Brigade," ended with Russia's ambitions to rule southeastern Europe thwarted by the allied forces of Turkey, England, France, and Sardinia. *Peace Concluded* celebrates this victory in a scene of domestic tranquillity. Holding a newspaper account of the peace terms, a convalescing British soldier sits with his adoring family. (Millais's wife, Effie, posed for the woman, his friend Colonel Malcolm Paton for the soldier, and his Irish wolfhound for the dog.) Behind them, a laurel tree, traditional emblem of victory, partially obscures a painting of a battle. The four toy animals on the woman's lap represent countries that fought in the war: the lion stands for Great Britain, the

polar bear for Russia, the gamecock for France, and the turkey for Turkey. One little daughter holds her father's silver military medal, while the other exhibits a toy dove with an olive branch (signifying peace) in its beak. John Ruskin, the prominent nineteenth-century art critic, proclaimed this quiet, sentimental work to be "among the world's best masterpieces."

Honoré Daumier
French, 1808–79

The Fugitives
About 1868
Oil on canvas
15¼ × 27 in.

The Ethel Morrison Van Derlip Fund
54.16

A social and political satirist highly critical of the regimes of Louis-Philippe and Napoleon III, Honoré

Daumier produced over four thousand black-and-white lithographs for publication in the Parisian newspapers *La Caricature* and *Le Charivari*. But he considered these prints to be merely his "pushcart," cartoons made for hire. His real love was painting. Self-taught, he began working in oils in 1832, when he was imprisoned for six months on charges of sedition—and consequently freed from the weekly drudgery of printmaking. *The Fugitives*, from the late 1860s, shows a throng of people fleeing from a fire. Driven by the smoke and flames, they crowd across the picture plane toward us. Except for the horse and rider in the lead, a man looking back at the holocaust, and a woman throwing up her arms, the figures are not individually delineated but flow across the canvas in a relentless mass of black and brown. The theme of exodus fascinated Daumier, and he made three other paintings, several drawings, and two sculptures of the subject. A bronze relief, cast from a clay original after the artist's death, is also in the museum's collection.

Charles Cordier
French, 1827–1905
Bust of a Nubian or a Kabyle
1856–57
Silvered bronze, jasper, and porphyry
38¼ in. high
The William Hood Dunwoody Fund
76.3

Throughout the nineteenth century, Europeans remained fascinated with the unknown, the exotic, and the far-away. The sculptor Charles Cordier received government funds for travel to the French colony of Algeria so he could record likenesses of the various types of people who lived there. He took photographs, making careful notes on the national background and physical appearance of his subjects. On the basis of those ethnological studies, he sculpted twelve portrait busts representative of different groups of North Africans, which were exhibited at the Salon of 1857. One of them, *Negro of the Sudan*, served as his model for a number of others, including the Institute's. Our *Bust of a Nubian*, almost identical to one in the Louvre, is an example of the polychrome sculpture for which Cordier became famous. By combining materials of different colors, he achieved an effect that is both realistic and decorative. Here, he used striated jasper for the garments and turban, and silvered bronze for the head. Following Cordier's example, other sculptors began to employ color in their work, continuing a tradition that goes back to the ancient Greeks.

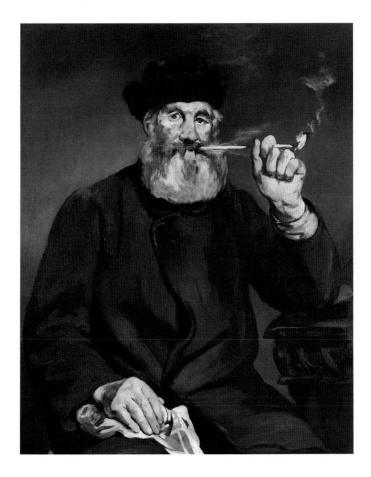

Edouard Manet
French, 1832–83
The Smoker
1866
Oil on canvas
39½ × 32¼ in.
Gift of Mr. and Mrs. Bruce B. Dayton
68.79

With the invention of photography in 1839, artists became increasingly interested in optics and the nature of light. Edouard Manet was one of the first painters to observe that objects viewed in full sunlight appear not as rounded forms but as two-dimensional shapes. By using a minimum of modeling and shading, he succeeded in representing this visual perception in his art. The characteristic flatness of his pictorial world can be seen in *The Smoker*, a portrait of the painter Joseph Gall, whom Manet had met in Paris in 1861. Manet presents him in a cloth coat and fur hat, smoking a long-stemmed clay pipe. The composition is broadly brushed, in the neutral grays and browns for which Manet became known. The geniality of the subject and the freedom of the brushstrokes reflect Manet's study of the seventeenth-century Dutch painter Frans Hals, and the contrast of dark tonalities with the bright blue of the handkerchief in the foreground shows his admiration for Velázquez and Goya.

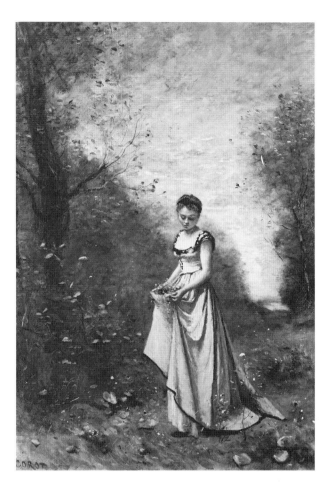

Camille Corot
French, 1796–1875
Springtime of Life
1871
Oil on canvas
41⅜ × 29⅜ in.

Bequest of Mrs. Erasmus C. Lindley in memory of her father, James J. Hill
49.2

Primarily a landscapist, often working *en plein air* (in the open air), Camille Corot was a leading artist of the Barbizon school. In general, his works have a more lyrical quality than those of the other Barbizon painters. His depictions of figures in wooded land-scapes echo the *fête galante* subjects popular at the French court during the eighteenth century, but they produce a different effect. In *Springtime of Life*, the young woman's solitude and downcast gaze, together with the sub-dued blues, greens, and whites of the misty woodland, evoke a mood of gentle melancholy. The silvery hues, achieved by adding lead white to the pigments, are characteristic of Corot's later images. *Springtime of Life* became famous during the artist's life-time and was included in the 1875 retrospective of his work at the Ecole des Beaux-Arts in Paris.

Alfred Gilbert
English, 1854–1934
The Kiss of Victory
1878–81
Marble
89½ in. high (including base)
The John R. Van Derlip Fund 76.32

The young Alfred Gilbert apprenticed himself to several established sculptors, including William Gibbs Rogers, Matthew Noble, and Joseph Edgar Boehm. It was from Boehm in particular, a Hungarian portraitist living in London, that Gilbert acquired his mastery of technique. Later, studying in France with Pierre-Jules Cavelier at the Ecole des Beaux-Arts, he made the model for *The Kiss of Victory*. And in 1878, at Cavelier's suggestion, he went to Rome to carve a marble version. The work portrays a wounded soldier dying in the arms of Victory, who kisses his brow. In some respects it follows the tradition of French heroic sculpture, which glorified persons and events by associating them with classical allegories. But it was conceived as an intimate group appropriate for a grand drawing room, not as a monument for a public square. Exhibited at the Royal Academy in 1882, the statue is Gilbert's first large piece. It is an early example of the "New Sculpture," a graceful, dynamic style that he practiced during the 1880s.

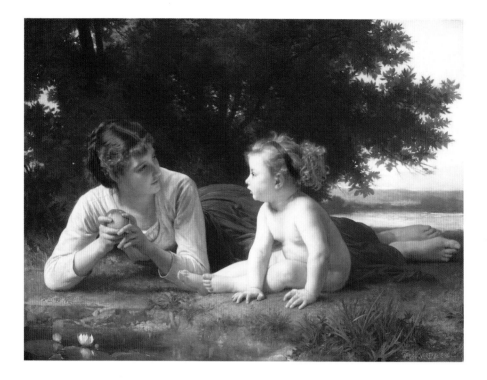

Adolphe-William Bouguereau
French, 1825–1905
Temptation
1880
Oil on canvas
39 × 52 in.
The Putnam Dana McMillan Fund and
the M. Knoedler Fund 74.74

Adolphe-William Bouguereau em-
ployed the traditional techniques and
subjects advocated by the official art
academies of France. A winner of the
Grand Medal of Honor, the Salon's
highest award, he received a number of
state commissions and became one of
the wealthiest and most sought-after
artists of his time. Although he pre-
ferred religious and mythological

themes, he began producing genre
scenes at the urging of his dealer,
Durand-Ruel. *Temptation*, executed at
the height of his career, is rendered
with the skill and verisimilitude typical
of Bouguereau's works. The solidly
modeled mother and child, informally
posed, glow with delicate flesh tones.
Bouguereau loved to depict women
and chose models that approached his
ideal of physical beauty. He painted
landscapes, as well as figures, from
direct observation. Here we see
the countryside near his native La
Rochelle. Pictures like *Temptation*
delighted Bouguereau's many patrons
and despite their overt sentimentality
are appreciated today for their tech-
nical aplomb and high degree of finish.

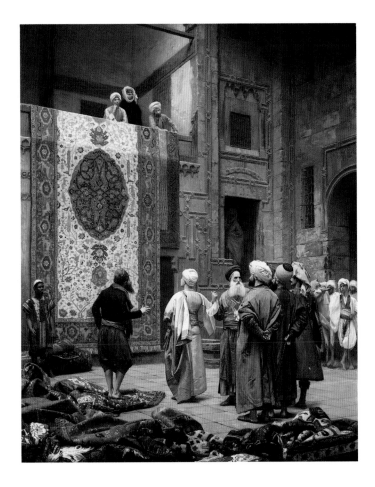

Jean-Léon Gérôme
French, 1824–1904
The Carpet Merchant
1887
Oil on canvas
33 × 25 ½ in.
The William Hood Dunwoody Fund
70.40

Schooled at the Ecole des Beaux-Arts and honored by the French Salon, Jean-Léon Gérôme was a prolific and popular artist. Like Delacroix and Cordier, he traveled extensively in North Africa and the Middle East, visiting Morocco, Algiers, Turkey, and Egypt. On these journeys he always took copious notes and made numerous sketches, which he annotated and later translated into finished oil paintings in his Paris studio. *The Carpet Merchant*, of 1887, portrays the Court of the Rug Market in Cairo, which Gérôme had visited two years earlier. Set within an imposing architectural framework, the animated scene displays the incisive detail, saturated colors, and skillful rendering of texture for which Gérôme was famous. The composition, though intricate, has been carefully planned to direct the viewer's attention to the richly dressed and turbaned figures at the center, whose activities are the subject of the picture.

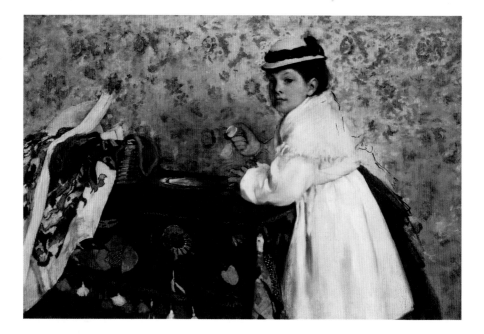

Edgar Degas
French, 1834–1917
Mademoiselle Hortense Valpinçon
1871
Oil on canvas
29¹⁵/₁₆ × 43⅝ in.
The John R. Van Derlip Fund 48.1

The French Impressionists regarded themselves as the ultimate realists of the nineteenth century. They found their subject matter in contemporary life, and they presented it by means of techniques that approximated the workings of nature itself. Edgar Degas shared their interest in recording transient reality, but unlike most of the Impressionists, who chose to paint the sunny out-of-doors, he preferred the racetrack, the theater, and the boudoir. Degas was also a portraitist, whose intimate studies of family and friends examine both the physical and the psychological character of his sitters. While visiting the country home of his childhood friend Paul Valpinçon, in Ménil-Hubert, Normandy, he painted Valpinçon's daughter Hortense. Her informal pose and the seemingly unplanned composition, with its random focus and truncated objects, suggest that Degas intended to capture a passing moment, in the manner of a snapshot. The asymmetrical format and contrasting patterns reflect his study of Japanese wood-block prints. This work was at some stage a double portrait; a slight disruption of paint on the wallpaper shows where a woman (presumably Hortense's mother) once leaned against the table. But Degas changed his mind and replaced that figure with a feminine attribute, the sewing basket.

Auguste Rodin
French, 1840–1917
Study for a Burgher of Calais
1884
Bronze
74⅞ in. high

Anonymous gift in memory of Walter
Lindeke 59.20

Heir to Michelangelo and Bernini,
student of Barye and Carrier-Belleuse,
Auguste Rodin was the greatest sculp-
tor of the nineteenth century, an artist
to whom the modern avant-garde
(Matisse, Picasso, Brancusi) would
look for inspiration and guidance. *The
Burghers of Calais*, commissioned
in 1884 by the municipal council of
Calais, was Rodin's first major public
monument. It honors six men who in
1347, during the Hundred Years' War,
gave themselves as hostages to King
Edward III of England so that he would
lift his siege of their starving city. The
museum's life-size bronze is a model
for the figure of Pierre de Wiessant.
Although in later versions the forms
are draped, Rodin sculpted them all
as nudes first. In the finished work,
Wiessant is posed with lowered head,
and the six burghers are tied together,
their faces and bodies expressing
anguish at the prospect of death. (In
fact, they were spared by the inter-
cession of Queen Philippa, Edward's
wife.) This portrayal of valor in terms
of realistic emotion instead of stereo-
typed heroism was highly unconven-
tional, causing the officials of Calais to
criticize the burghers' "defeated pos-
tures." Despite the objections, the
monument was erected in 1895,
though not in the setting Rodin
desired. Only in 1924 was it placed
in front of the city hall (the location
Rodin had had in mind) and its five-
foot-high pedestal exchanged for a
very low one, in accordance with
Rodin's wish that the grouping be
allowed to "mix with the daily life
of the town."

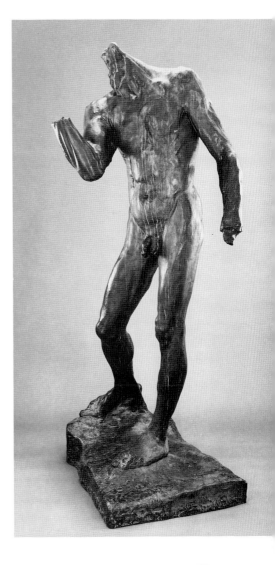

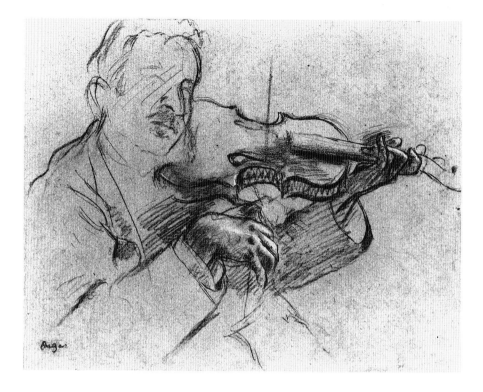

Edgar Degas
French, 1834–1917
The Violinist
About 1879
Charcoal heightened with white chalk
9⅜ × 12¹⁄₁₆ in.
Gift of David M. Daniels in memory
of H. D. M. Grier 72.59

A life-long admirer of Ingres, Degas
never forgot the older master's advice,
"Draw lines, young man, many lines."
From an early age Degas excelled at
drawing, and he used the medium for
both preliminary studies and finished
works. Moreover, he avidly collected
drawings by other artists, especially
Delacroix, Ingres, Manet, and Daumier.

The Violinist is one of several pre-
paratory charcoal sketches for *The
Rehearsal*, an oil painting of a ballet
class that is now in the Frick Collection
in New York City. Degas observed his
subjects keenly, "selecting the living
gesture and catching it at the telling
moment." Here, he concentrates on the
musician's hands and on the instru-
ment, heightening them with dashes
of white chalk. The awkward position
of the fingers and the lack of a chin
rest suggest that this man is a theater
or café fiddler, not a highly trained
professional. In Degas's time, dancing
classes were often accompanied by
a violinist, who might conduct the
lesson while he played.

Claude Monet
French, 1840–1926
*Still Life with Pheasants
and Plovers*
1879
Oil on canvas
26¾ × 35½ in.
Gift of Anne Pierce Rogers in
memory of John DeCoster Rogers
84.140

Claude Monet once expressed a wish
that he had been "born blind in order
to gain sight and be able to paint
objects without knowing what they

were." Then cognitive thought would
not have interfered with his ability to
see a form solely in terms of color and
light. For Monet, the real subject of
the Institute's still life was not dead
game birds but color. Each feather
glows with a multitude of carefully
applied pigments, and so do the white
tablecloth and shadowy background.
These rich hues are the more startling
for being used in a simple, almost
stark, composition. Monet made three
paintings of pheasants late in 1879
and showed this one in the Impres-
sionists' 1882 Paris exhibition.

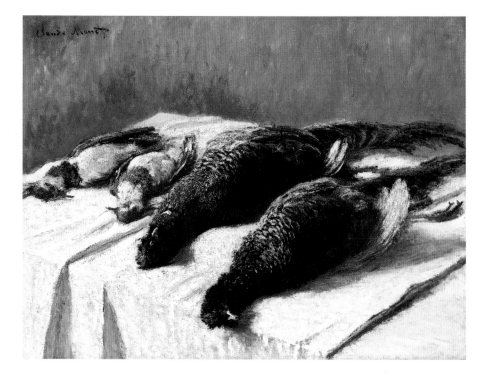

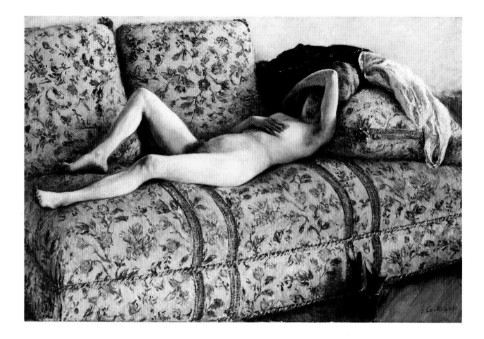

Gustave Caillebotte
French, 1848–1894
Reclining Nude
About 1880
Oil on canvas
51⅛ × 77 in.
The John R. Van Derlip Fund 67.67

When he entered the Ecole des Beaux-Arts in 1873, Gustave Caillebotte was already a wealthy naval engineer and architect. As an art student, he became friends with Monet, Renoir, and Degas and from 1876 onward participated in the Impressionists' exhibitions. He also bought some of their most controversial and important pieces. At his death, his bequest to the state of sixty-seven Impressionist paintings caused public dispute. However, part of it was accepted and now forms the core of the Louvre's Impressionist collection. Caillebotte's own work combines the Impressionists' approach to light and color with a directness and naturalism distinctively his. The Minneapolis picture is Caillebotte's only painting of a female nude. Against a pale blue background, the young model reclines on a floral sofa whose overstuffed corpulence contrasts markedly with her slender body. Yet the figure is frankly sensuous, painted with broad, sweeping brushstrokes in the tradition of odalisques by Delacroix and Manet.

Camille Pissarro
French, 1830–1903
Place du Théâtre Français, Rain
1898
Oil on canvas
29 × 36 in.
The William Hood Dunwoody Fund
18.19

The French Impressionists were a diverse group of painters who shared a fascination with the visual effects of light. They rendered the subtleties of reflected light in rapidly executed images composed of thousands of daubs of pure, bright colors. Like the artists of the Barbizon school before them, they moved their canvases outside so they could capture on-the-spot impressions of their surroundings. Camille Pissarro, the eldest of the group, is well known for both his landscapes and his cityscapes. In December 1897, he took a hotel room on the rue de Rivoli, overlooking the Théâtre Français, and from his window painted thirty-two views of the neighborhood at different times of the day and in various weather. *Place du Théâtre Français, Rain* belongs to that series. Although it vividly evokes the chilly dampness of a winter day— overcast skies, leafless trees, people huddled under umbrellas—it is not gloomy but conveys the pleasant excitement of a busy thoroughfare. "It is very beautiful to paint!" wrote Pissarro. "Perhaps it is not really aesthetic, but I am delighted to be able to do these Parisian streets which people usually call ugly, but which are so silvery, so luminous, and so vital."

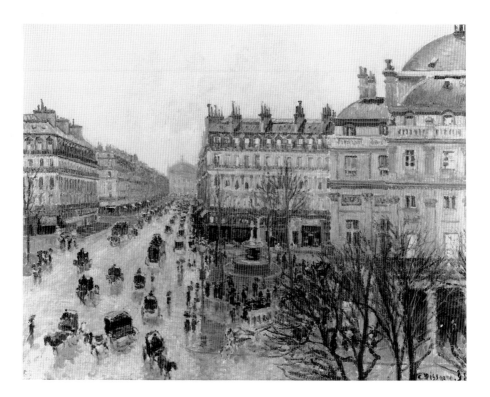

Paul Cézanne
French, 1839–1906
Chestnut Trees at Jas de Bouffan
About 1885–87
Oil on canvas
27¾ × 35⁵⁄₁₆ in.
The William Hood Dunwoody Fund
49.9

In their rush to record the fleeting effects of light and atmosphere, the Impressionists intentionally neglected other aspects of painting, such as volume, space, and symbolic and emotional content. During the 1880s, Paul Cézanne, Georges Seurat, Vincent van Gogh, and Paul Gauguin—all then working in France—felt this lack and tried to rectify it in their own art. Cézanne, the eldest of these Post-

Impressionists, said that he wanted to "make of Impressionism something solid and durable, like the art of the museums." To achieve stability of form and structure, he simplified his subjects to basic shapes, which he organized into a tight mosaic of interlocking planes and colors. In *Chestnut Trees at Jas de Bouffan*, the balanced distribution of blues, greens, and browns and the graceful latticework of the tall, dark trees create a strong and coherent composition. Jas de Bouffan (roughly, Home of the Wind) was Cézanne's country estate near Aix-en-Provence, which looked toward his beloved mountain of Ste-Victoire, seen here in the distance. Once part of the Frick Collection in New York City, *Chestnut Trees* is among the best-known works by Cézanne in the United States.

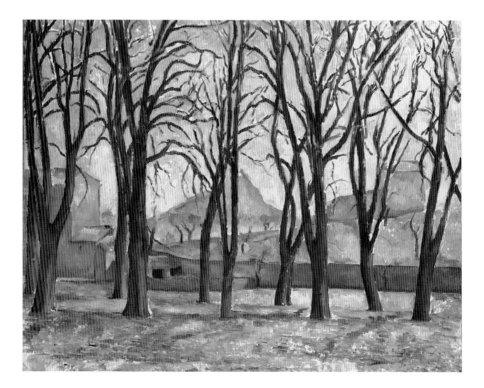

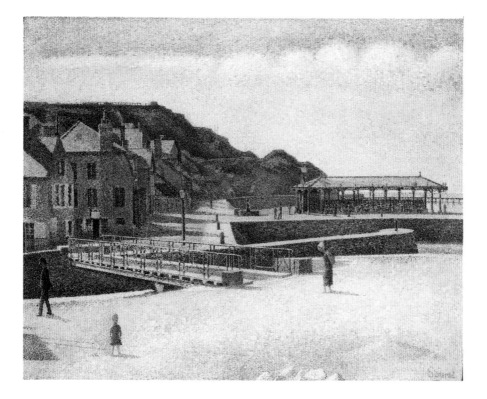

Georges Seurat
French, 1859–91

Port-en-Bessin
1888
Oil on canvas
26⅜ × 33³⁄₁₆ in.
The William Hood Dunwoody Fund
55.38

Like Cézanne, Georges Seurat was interested in pictorial structure and wanted to create ordered, well-balanced compositions. He studied color theory and optics and in the mid-1880s developed a novel technique known as divisionism, or pointillism. Instead of mixing the colors he desired, he applied small, uniformly sized dots of their prismatic components to the canvas. Seen from a distance, these pinpoints of color appear to vibrate, and the resultant hues are more vivid than if they had been blended by the artist. Seurat employed this precise and time-consuming manner of painting in the museum's picture of Port-en-Bessin, a small fishing village on the coast of Normandy. Cool blues, greens, and tans, interspersed with touches of yellow-orange and hot pink, form a scene of the waterfront in sun and shadow. Although Seurat died of pneumonia when he was only thirty-two years old, his distinctive method influenced such experimental painters of the twentieth century as Henri Matisse and Piet Mondrian.

Vincent van Gogh
Dutch, 1853–90
Olive Trees
1889
Oil on canvas
29 × 36½ in.
The William Hood Dunwoody Fund
51.7

Van Gogh's paintings express his intense love for the natural world, a depth of feeling that for him was almost a religious experience. The Institute's picture is one of fifteen canvases of olive trees that van Gogh executed between June and December of 1889. Earlier that year he had begun to suffer symptoms associated with epilepsy and had interned himself in the asylum of St-Paul, in the town of St-Rémy in southern France. There, during long periods of tranquillity, he created his most profound works, including the series of olive orchards. The intense color and heavy impasto of these canvases are typical of his style. The summer trees are depicted in blue-green tonalities. Here, however, the season is autumn, and vibrant oranges and yellows predominate. Van Gogh left St-Rémy in May 1890, moving to Auvers, near Paris, where he continued to paint until his death by suicide in July.

Paul Gauguin
French, 1848–1903
Tahitian Landscape
1891
Oil on canvas
26¾ × 36½ in.

The Julius C. Eliel Memorial Fund
49.10

Vain, quarrelsome, and self-indulgent, confident of his genius and something of a rogue, Paul Gauguin was undoubtedly the most flamboyant personality among the Post-Impressionists. As a young man, he spent six years at sea, in the merchant marine and the navy. Then he became a successful stockbroker, married, and took up painting in his spare time. Following a crisis in the stock market in 1882, he found himself without a job, and the next year he left his wife and five children in order to lead a bohemian life and pursue his art full time. After sojourns in Brittany, Panama, Martinique, and Arles, Gauguin sailed for Tahiti in 1891 and settled in the beachfront town of Mataiéa. In his paintings of the island and its inhabitants, the simplified shapes and shallow spaces, the heightened colors and shadowless light, form vivid and exotic patterns. Colored in brilliant greens, oranges, yellows, and purples, *Tahitian Landscape* represents a paradise of palm trees, mountains, and grassy meadows. Although Gauguin went back to France in 1893, he returned to Tahiti and later moved to the Marquesas, where he died.

Pierre Bonnard
French, 1867–1947
Dining Room in the Country
1913
Oil on canvas
64¾ × 81 in.
The John R. Van Derlip Fund 54.15

Pierre Bonnard considered himself
"the last of the French Impressionists,"
and much in his canvases and prints—
especially the radiant light and familiar
surroundings—reminds us of them.
But Bonnard developed his own style,
combining his distinctive sense of
color with an appreciation for the
decorative qualities found in Japanese
art and in the work of Paul Gauguin.
The simple forms of *Dining Room in
the Country* are broadly brushed in
glowing reds, greens, and lavenders.
This painting represents the dining
room of Ma Roulotte (My Gypsy
Caravan), the artist's country house on
the Seine at Vernonnet. The woman
leaning on the windowsill is probably
Marthe de Méligny (Maria Boursin),
whom Bonnard met in 1893 and even-
tually married. Inside, the room is
comfortable and cozy, with fruit on the
table, two small cats occupying the
chairs, and a bouquet of poppies on a
small table by the wall. Outside, a gar-
den of summer flowers blossoms under
a luminous sky. Starting in 1909, Bon-
nard often used an open door or win-
dow as a structural transition between
near and far spaces—the confines of
the interior and the openness of the
landscape beyond. Because he usually
depicted tranquil domestic scenes,
Bonnard, like his friend Edouard
Vuillard, has been called an *intimiste*.

The Twentieth Century

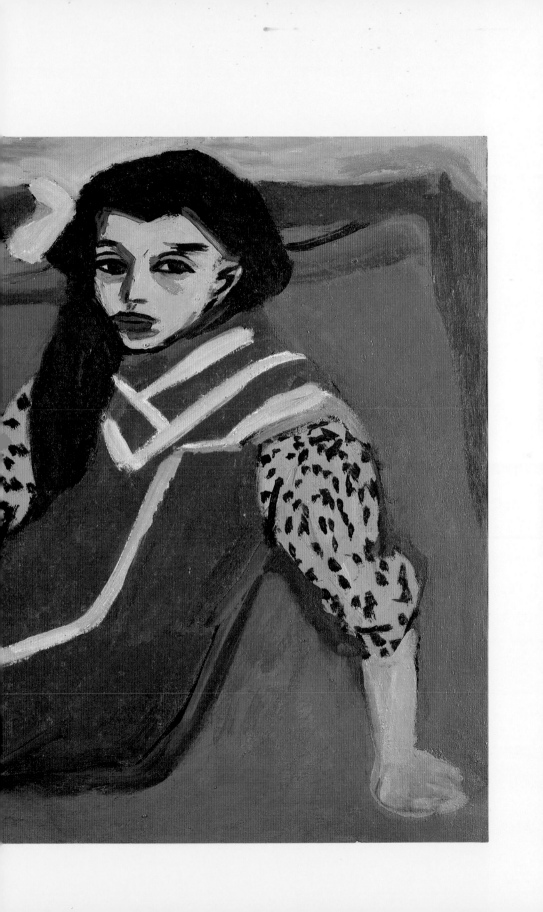

Henri Matisse
French, 1869–1954
Boy with a Butterfly Net
1907
Oil on canvas
69¾ × 45⁵⁄₁₆ in.
The Ethel Morrison Van Derlip Fund
51.18

A landmark exhibition at the 1905 Salon d'Automne in Paris introduced the first modern art movement of the century—Fauvism. Led by Henri Matisse, André Derain, and Maurice de Vlaminck, the Fauves (literally, wild beasts) painted in vivid colors, with forceful, unrestrained brushstrokes. Freeing color from its traditional descriptive role, they exploited its purely decorative, expressive, and structural qualities. In this life-sized portrait of Allan Stein (Gertrude Stein's nephew), the boy stands in a summer landscape of intense blue, green, and red. Both the figure and the setting have been drastically simplified and treated in terms of flat, broadly brushed areas of color. Matisse executed this painting shortly after visiting northern Italy, where he studied the works of Piero della Francesca, Duccio, and Giotto, and the influence of those artists is apparent in it. The schematic hills, high horizon, and luminous sky of the background recall the topography in many trecento frescoes, and the boy, occupying the canvas from top to bottom, suggests the monumental figures of Giotto.

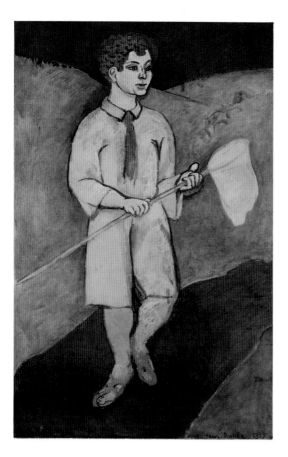

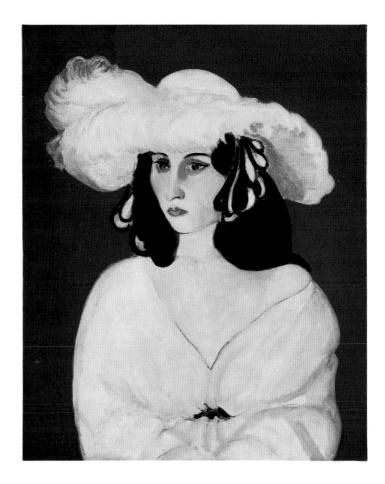

Henri Matisse
French, 1869–1954
The White Plumes
1919
Oil on canvas
28¾ × 23¾ in.
The William Hood Dunwoody Fund
47.41

"What I dream of," Matisse once wrote, "is an art . . . devoid of troubling or depressing subject matter, an art which might be for every mental worker, be he businessman or writer, like an appeasing influence, like a mental soother, something like a good arm-chair in which to rest from physical fatigue." His works from the years following World War I are notable for their serene subjects, warm colors, and elegant composition. *The White Plumes* is the larger of two paintings, both dating to 1919, of Antoinette, Matisse's favorite model in Nice. At the time, Matisse liked exotic clothing and collected or made costumes to use as studio props. He himself trimmed Antoinette's wide-brimmed, pale yellow hat with graceful white feathers and loops of black ribbon, undulating shapes that contrast dramatically with the tranquil simplicity of her face.

Henri Matisse
French, 1869–1954
Seated Nude
1925
Bronze
30¾ in. high
Gift of the Dayton Hudson
Corporation 71.9.3

Henri Matisse's first sculpture, made in 1899, was based on Antoine-Louis Barye's tension-filled *Jaguar Devouring a Hare*. In 1900, inspired by Rodin's *Walking Man*, Matisse began his first human figure, *The Slave*. Breaking away from these early influences over the next several years, he continued to depict the figure in various poses

and in different media. He was especially concerned with the problem of integrating a reclining body into its surrounding space. After working out the positioning in a drawing, a painting, and several lithographs, he began to model the *Seated Nude* in clay. Photographs taken while the work was in progress show that at first the form was rounded and smooth, but as Matisse pared away the surface with his knife, it gradually became more abstract and planar. The elongated torso and creased abdomen of the final version indicate straining stomach muscles—a stress subtly countered by the informal pose and the oversized right foot, which anchors the bronze firmly to its base.

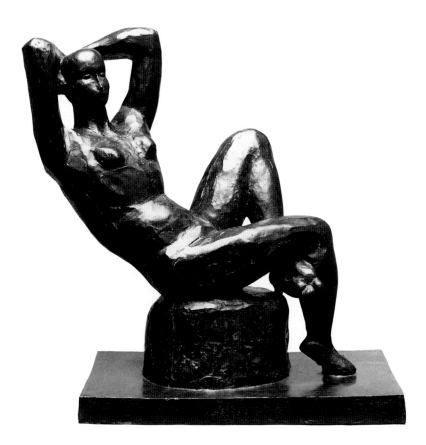

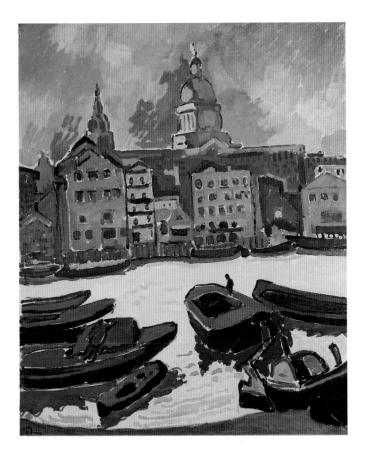

André Derain
French, 1880–1954
St. Paul's from the Thames
1906
Oil on canvas
39¼ × 32¼ in.

Bequest of Putnam Dana McMillan
61.36.9

In 1899, while a student at the Académie Carrière, André Derain met Henri Matisse, and over the next several years both artists benefited from an ongoing exchange of ideas. During the summer of 1905 they worked together at the Mediterranean seaport of Collioure, where they produced the first canvases in the startling new style that came to be known as Fauvism. These paintings are characterized by rapid brushwork; bright, arbitrary hues; and decorative, allover patterning. *St. Paul's from the Thames* belongs to a series of cityscapes that Derain executed in the winter of 1906–7 during a stay in London. Its bold design and brash colors—the acid yellow river, green-windowed buildings, and pink-and-mustard sky—exemplify Matisse's famous dictum, "L'exactitude n'est pas la vérité" (Exactitude is not truth). This was Derain's last Fauve picture. Thereafter he abandoned the glowing colors of Fauvism for an exploration of geometric form and structure.

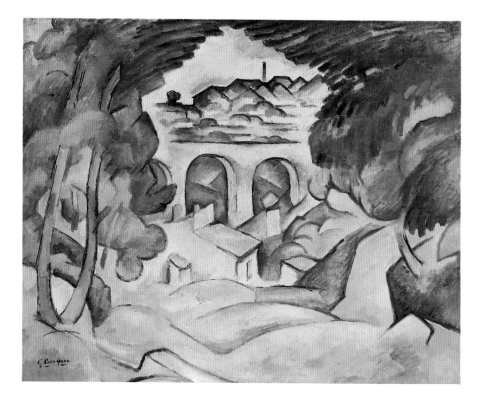

Georges Braque
French, 1882–1963
The Viaduct at L'Estaque
1907
Oil on canvas
25⅝ × 31¾ in.
The John R. Van Derlip Fund, the
Fiduciary Fund, and gift of Mr. and
Mrs. Patrick Butler and various donors
82.22

Georges Braque moved to Paris from
Le Havre in 1900 to study art and to
continue his apprenticeship as a house-
painter and decorator, the trade of his
father and grandfather. In 1905,
through his friendship with Othon
Friesz and Raoul Dufy, Braque came to
know the work of Matisse, and by 1906
he was painting in the high colors and

broken strokes of the Fauve style. Just
as quickly, he became interested in the
tightly structured compositions of Paul
Cézanne and began to adopt a more
abstract, geometrical manner, which
was later recognized as a forerunner of
Cubism. *The Viaduct at L'Estaque* is
important in Braque's artistic develop-
ment because it combines the brilliant
palette of Fauvism with incipient
Cubist form. It shows the seaport of
L'Estaque, near Marseilles, as a patch-
work of blue, green, yellow, and lilac,
the buildings, trees, mountains, and
bridges forming an integrated pattern
of regularized shapes and volumes.
This is Cubism at an early stage, before
it forsakes landscape for still life and
undertakes an all-out investigation of
the object through fragmentation into
multiple planes.

Edvard Munch
Norwegian, 1863–1944
The Kiss
1897
Color woodcut
18⅜ × 18¼ in.
The Herschel V. Jones Fund P.79.52

Most new art movements of the early twentieth century began in France, but Expressionism originated in Germany, with Munich, Dresden, and Berlin as the main centers of its development. Like the Fauves, the Expressionists distorted forms and used colors unconventionally, but for a different purpose. They wanted to give visual expression to the emotional content of their subjects. The Norwegian artist Edvard Munch had a strong influence on the Expressionists. Having studied first with another Norwegian, the painter Christian Krohg, and then in Paris, he went to Berlin, where he lived from 1892 until 1908. In addition to painting, Munch made over seven hundred etchings, lithographs, and woodcuts. One of his best-known woodcuts, *The Kiss* was first conceived as a painting of two lovers in an interior. The woodcut was printed from two blocks—one for the figures and another (a rectangle of coarsely grained wood) to create the "curtain" that veils the couple's silhouette.

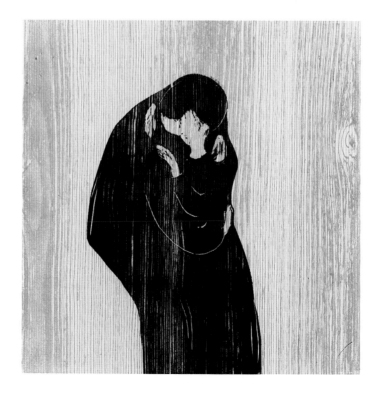

James Ensor
Belgian, 1860–1949
Intrigue
1911
Oil on canvas
37¼ × 44¼ in.
Gift of Mrs. John S. Pillsbury, Sr. 70.38

With Vincent van Gogh and Edvard Munch, the Belgian painter James Ensor is considered a pioneer of Expressionism. But as a creator of fantastic and bizarre images, Ensor also belongs to the tradition of Hieronymus Bosch and Pieter Brueghel the Elder. In *Intrigue*, grotesque masqueraders surround a blue-haired, green-caped woman and a man in a black top-hat—the artist's sister Mariette and her fiancé, Tan Hée Tseu. Mariette's engagement to Tan, a Chinese art dealer from Berlin, caused a scandal in the provincial city of Ostend, where Ensor and his family lived. In this painting the town gossips, safe in their disguises, have come out to taunt the couple, to point and stare, mock and laugh. That Mariette and Tan are also in costume suggests that they, too, wish to appear incognito. Obsessed by death and his own mortality, Ensor often made several copies of the same work to ensure that his art would survive him. The first *Intrigue* was painted in 1890, two years before his sister's marriage, and is now in the Royal Museum of Fine Arts in Antwerp. The Institute's version, dating to 1911, is a close replica of the first.

Ernst Ludwig Kirchner
German, 1880–1938

Seated Woman
1907
Oil on canvas
31¾ × 35⅞ in.
The John R. Van Derlip Fund 52.12

In 1905, four architecture students in Dresden—Ernst Kirchner, Fritz Bleyl, Erich Heckel, and Karl Schmidt-Rottluff—established a group they called Die Brücke (The Bridge), linking "all the revolutionary and surging elements" of modern art. Looking to van Gogh, Edvard Munch, the Fauves, and African sculpture, these young German Expressionists made paintings, woodcuts, and carvings of striking directness and

emotional intensity. Kirchner was one of Die Brücke's most articulate and productive members, creating works of immense strength and vitality through his bold handling of color and form. Applied in fierce, energetic strokes, the brilliant reds, blues, and greens of *Seated Woman* compose an arresting portrait. Sitting anxious and alone at the foot of a bed, this young woman wears life's disillusionments on her somber face. Kirchner's model was an orphan named Fränzi, who often posed for him in return for food and lodging. *Seated Woman* was one of his early paintings, and he kept it all his life. In 1938, after learning that hundreds of his works had been confiscated by the Nazis, labeled "degenerate," and destroyed, Kirchner committed suicide.

Egon Schiele
Austrian, 1890–1918
*Portrait of the Painter
Paris von Gütersloh*
1918
Oil on canvas
55⅛ × 43⁷/₁₆ in.
Gift of the P. D. McMillan Land
Company 54.30

While the Brücke and Blaue Reiter
artists were at work in Germany, in
Vienna Egon Schiele and Oskar
Kokoschka developed their own
expressionistic manner of painting.
By 1910 Schiele, like Kokoschka, had
gone beyond the suave Art Nouveau
idiom and evolved his own distinctive

style—tense, linear, stark, and tortured.
This portrait of his friend Paris von
Gütersloh was Schiele's last major
work, undertaken the year he and his
wife died in an influenza epidemic.
Gütersloh was a writer, actor, painter,
and stage designer, whom Schiele had
known and admired since 1909. The
portrait shows him in a moment of
intense concentration, facing forward
in his chair, hands upraised in a gesture
that both beckons and repulses the
viewer. The jagged black lines marking
the folds of his clothes, the swirling
paint of flesh and fabric, and the
glowing gold, orange, and rust back-
ground express the electrifying energy
of artistic inspiration.

Fernand Léger
French, 1881–1955
Table and Fruit
1909
Oil on canvas
33 × 38⅞ in.
The William Hood Dunwoody Fund
47.8

Cubism, the most far-reaching and revolutionary art movement of the twentieth century, began with the Spaniard Pablo Picasso and the Frenchman Georges Braque, who worked together closely in Paris from 1909 until the outbreak of World War I. Whereas the Fauves were mainly interested in the effects of color, and the Expressionists in conveying emotion, the Cubists were fascinated by form. In the movement's initial phase—later called analytical Cubism—the artist fragmented a subject into small geometrical components and ordered them on the canvas so as to present many different aspects simultaneously. Thus freed from the static perspective of Renaissance art, Cubist painters could attempt a more complete and dynamic picture of the world. In *Table and Fruit*, Léger reduced the forms to cylinders, cones, and spheres, which he organized into an array of shifting planes and shapes. But apples, bananas, pears, and grapes, along with a dinner fork and wooden table legs, remain recognizable among the dislocated objects and spaces. The subdued gray, brown, and black palette is typical of analytical Cubist works.

Juan Gris
Spanish, 1887–1927
Still Life
1917
Oil on panel
28¾ × 36³⁄₁₆ in.
The John R. Van Derlip Fund 51.20

The attempt to reveal objects through the methods of analytical Cubism— by subdividing, abstracting, and recombining—led eventually to the "subject" becoming utterly unrecognizable. Synthetic Cubism developed as a more accessible and colorful alternative to analytical Cubism's confusing visual effects and neutral tonalities. In this synthetic Cubist still life by Juan Gris, the clearly identifiable forms of a guitar, bottle, compote, and desk and drawer provide the theme for kaleidoscopic variations of lines, curves, and angles. Gris liked to find similarities in dissimilar objects. Here, the sensuous contours of the guitar are echoed in the outlines of the compote and the shadows it casts. Gris, who had left Madrid at nineteen to study in France, lived in the Montmartre section of Paris and had a studio next to Picasso's in a building known as the Bateau-Lavoir. Under Picasso's influence, he began painting in the Cubist manner in 1911, and he developed this style until his death at age forty.

Joan Miró
Spanish, 1893–1983
Spanish Playing Cards
1920
Oil on canvas
25½ × 27½ in.
Gift of Mr. and Mrs. John Cowles
62.73.2

Joan Miró left Barcelona in 1919 for
a three-month sojourn in Paris, where
Pablo Picasso, a fellow Spaniard,
introduced him to the leaders of the
European avant-garde. For the first
time, Miró saw a large number of

Picasso's and Braque's Cubist canvases,
and these inspired a group of still
lifes—including *Spanish Playing
Cards*—that he executed in 1920. The
stylized realism of Miró's previous
work is combined here with the geo-
metric faceting of synthetic Cubism.
Densely painted in black, lavender,
green, and red, the objects (compote,
decanter, knife, and cards) retain their
identity, but the surrounding space is
fractured into patterned lines and
angles. Miró continued working this
way until 1924, when he became part
of the Surrealist movement.

Pablo Picasso
Spanish, 1881–1973
Woman in an Armchair
(*Composition*)
1927
Oil on canvas
28¾ × 25⅝ in.
Gift of Mr. and Mrs. John Cowles 63.2

A master of many styles, Pablo Picasso was at various times a classicist and a realist, a Cubist and a Surrealist. Yet his handling of line and form is instantly recognizable. In *Woman in an Armchair*, the figure's amoeba-like body is intentionally distorted; her head, torso, and limbs are exaggerated and deformed almost beyond recognition. The jumble of lines, patterns, angles, and shapes that surrounds her is unsettling and creates a disturbing tension. In contrast to this sense of anger and frustration, however, two silhouetted heads in gray and white face each other calmly, as though floating disengaged on the picture's surface. Like many other images of women painted by Picasso in the late 1920s and early 1930s, *Woman in an Armchair* reflects his deteriorating marriage with his first wife, the Russian ballerina Olga Khokhlova.

Fernand Léger
French, 1881–1955
Le Petit Déjeuner
About 1921
Oil on canvas
25½ × 36½ in.

Gift of Mr. and Mrs. Samuel H.
Maslon 76.5

Trained as an architectural draftsman,
Fernand Léger began studying art in
1903 and by 1910 had become a master
of Cubist painting. From 1914 until
1917, he served as a sapper in the
French army and was gassed at the
Battle of Verdun. His war experiences
caused him to reject his earlier Cubist
compositions as elitist abstractions.
"At the time," he wrote, "I was dazzled
by the breech of a 75 millimetre gun

which was standing uncovered in the
sunlight. . . . Once I got my teeth into
that sort of reality I never let go of
objects again." Léger's mature style
joins this fascination with technology
to his love of geometrical shapes and
bright colors. In this new manner, he
began a series of nudes in 1920 that
culminated in one of his best-known
paintings, *Le Grand Déjeuner*, now in
the Museum of Modern Art in New
York City. The Institute's *Le Petit
Déjeuner* (Breakfast), one of two oil
studies for that work, includes all the
important details of the finished
composition. The heavy, rounded
forms of three nude women, set
against planes of vivid pattern, are
monumental, impersonal, and remote,
creatures born of Léger's revolutionary
"machine" aesthetic.

Wassily Kandinsky
Russian, 1866–1944
Study for Improvisation V
1910
Oil on pulp board
27⅞ × 27½ in.
Gift of Mr. and Mrs. Bruce B. Dayton
67.34.2

As a young man in Moscow, Wassily Kandinsky took university degrees in law and economics before leaving his homeland in 1896 to study painting in Munich. At first he worked in the Art Nouveau style, but then, influenced by Henri Matisse and by the Fauves, he explored abstraction and the arbitrary use of color. In 1911, with Gabriele Münter and Franz Marc, he founded Der Blaue Reiter (The Blue Rider), a group of artists who repudiated materialism and sought to express spiritual values in their art. Kandinsky soon became the leading pioneer of abstract painting in Europe and wrote influential theoretical works, notably *Concerning the Spiritual in Art*, in which he examined the psychological effects produced by various colors. He contended that the meaning of his own paintings was conveyed by the colors and abstract forms, and he intentionally "veiled" his literal subject matter. The biblical themes of the Apocalypse and the Flood appear frequently in his work, signifying the end of the present, materialistic era and the advent of a more spiritual age. *Improvisation V* probably contains references to those events. The looping green and blue shape at the lower left may symbolize waves. In the upper

right corner, the two riders probably allude to the horsemen of the Apocalypse. And at the lower right, a woman in a blue cloak kneels before a tall figure with streaming golden hair who may represent the risen dead associated with the Second Coming of Christ and the Last Judgment.

Piet Mondrian
Dutch, 1872–1944
Composition with Red, Yellow, and Blue
1922
Oil on canvas
16½ × 19¼ in.
Gift of Mr. and Mrs. Bruce B. Dayton
65.5

Piet Mondrian's impersonal, non-representational style of painting, which he called Neoplasticism, became the basis of De Stijl (The Style), an international art movement that began in Holland in 1917. Striving for absolute simplicity, purity, and clarity, Mondrian eventually limited himself to using only rectangles, straight horizontal and vertical lines, and primary colors (red, yellow, and blue) plus black, white, and gray. He was consciously attempting to create spiritual harmony through the unification of opposites, and the absence of any reference to natural forms or recognizable objects was intended to give his art a timeless, transcendent quality. *Composition with Red, Yellow, and Blue* typifies Mondrian's disciplined, austere approach. Despite its asymmetry, the composition is so carefully balanced that the omission of any element would destroy the unity of the whole.

Constantin Brancusi
Romanian, 1876–1957
Yellow Bird
About 1912
Polished bronze
37¾ in. high
The John R. Van Derlip Fund 55.39

Constantin Brancusi began making
abstract sculptures at about the same
time Wassily Kandinsky, his contem-
porary, was exploring abstraction in
painting. Kandinsky eventually chose
to obscure the natural objects that
provided the starting point for his
abstractions, whereas Brancusi took
natural forms to an extreme of simpli-
fication but never completely excluded
them from his work. *Yellow Bird*
belongs to a series of twenty-eight
marbles and bronzes exploring the
theme of birds and their flight, which
Brancusi executed between 1910 and
the early 1950s. His inspiration for
these sculptures was a Romanian folk-
tale about a dazzling golden bird called
the Maiastra, whose magical song
restored sight to the blind and youth
to the aged. The shiny polished bronze
of *Yellow Bird* recalls the Maiastra's
brilliant plumage, and the vertical
thrust of the neck suggests open-
throated song. This sleek bird stretches
toward the sky, straining against
gravity and the weight of its clumsy,
earthbound support. In subsequent ver-
sions it is freed, soaring heavenward
as Brancusi's famous *Bird in Space.*

Amedeo Modigliani
Italian, 1884–1920
Head of a Woman
About 1910–14
Limestone
26 in. high

Gift of Mr. and Mrs. John Cowles
62.73.1

Amedeo Modigliani was mainly a portraitist and a painter of female nudes, but in 1909, at the urging of his friend Constantin Brancusi, he began carving stone. Most of Modigliani's sculptures, including the Institute's *Head of a Woman*, were never finished, and after 1915 he abandoned the medium altogether. Yet these simple, stylized works possess a strength and boldness reminiscent of Archaic Greek figures or African masks, art forms with which Modigliani was familiar. Like his painted images, his sculptures are characterized by tubular necks, wedgelike noses, large eyes, and pursed lips. The serenity and refinement of these smooth, elongated shapes convey no hint of the artist's uneven temperament. Handsome, melancholic, and flamboyantly dissipated, Modigliani led a bohemian life blighted by illness, poverty, and drugs. At thirty-six, he died of tuberculosis at the Hôpital de la Charité in Paris.

185

Giorgio de Chirico
Italian, 1888–1978
The Scholar's Playthings
1917
Oil on canvas
35¼ × 20¼ in.

Gift of Mr. and Mrs. Samuel H.
Maslon 72.75

Giorgio de Chirico, with Carlo Carrà, founded the *scuola metafisica*, the Metaphysical school of painting. This short-lived style, emphasizing the mysterious and bizarre, anticipated the Surrealist movement of the 1920s and 1930s. In de Chirico's well-known "city square" paintings of 1910–14, realistic architectural elements cast deep shadows over piazzas haunted by solitary figures. From 1915 until 1919, mannequins and still-life objects dominated his canvases. *The Scholar's Playthings* dates to the height of de Chirico's Metaphysical period. Using skewed perspective, he depicts a closed space containing anatomical charts, drafting implements, and an image of a factory. These objects could represent the tools (or "playthings") of the artist, who studies anatomy, drawing, and architecture as part of his training. The building and triangles may also refer to engineering, the profession of de Chirico's father; and the charts, which suggest the practice of medicine, possibly allude to the painter's frequent illnesses.

Joan Miró
Spanish, 1893–1983
Head of a Woman
1938
Oil on canvas
18 × 21⅝ in.

Gift of Mr. and Mrs. Donald Winston
64.44.1

In 1924 André Breton, a poet deeply interested in the ideas of Sigmund Freud, published the first Surrealist manifesto. Breton proposed the use of automatic writing to tap subconscious thoughts and images as a source for poetry. "Surrealism," he said, "rests on a belief in the superior reality of certain forms of association hitherto neglected, in the omnipotence of the dream, in the disinterested play of thought." It was "the disinterested play of thought" that led Joan Miró to his particular kind of intuitive Surrealism. "I do not begin with the idea that I will paint a certain thing," he wrote. "I start to paint and while I am painting the picture begins to take effect, it reveals itself. In the act of painting, a shape will begin to mean woman, or bird . . . the first stage is free, unconscious." The museum's grotesque "woman" flailing malformed arms belongs to Miró's so-called savage period, from about 1936 to 1939, when he created disturbing images evoked by the horrors of the Spanish civil war. Gripped by rage and anguish, she seems to be both an aggressor and a struggling victim.

Yves Tanguy
French, 1900–1955
*Through Birds, through Fire,
but Not through Glass*
1943
Oil on canvas
40 × 35 in.

Gift of Mr. and Mrs. Donald Winston
in tribute to Richard S. Davis 75.72.2

The intuitive, or abstract, Surrealist
style of the 1920s was superseded
during the 1930s by the meticulous,
almost academic paintings of the figura-
tive, or naturalistic, Surrealists. Such
artists as Yves Tanguy, René Magritte,
and Salvador Dali took recognizable
objects and events out of their normal
context and combined them in unusual
and often disquieting ways. Tanguy
populated his otherworldly landscapes
with forms later dubbed "biomorphs"—
shapes that seem both animate and
inanimate. *Through Birds, through
Fire, but Not through Glass* is a deliber-
ately obscure title for an ultimately
inexplicable work. In the center fore-
ground stands a large biomorph around
which smaller ones lie or float, creating
the illusion of receding space. Though
the atmosphere is hazy, these objects
cast sharp black shadows, an eerie
contradiction that adds to the ominous,
forbidding quality of this image.

René Magritte
Belgian, 1898–1967
The Promenades of Euclid
1955
Oil on canvas
64⅛ × 51⅛ in.
The William Hood Dunwoody Fund
68.3

Surrealism was an art of fantasy, dream, and the unconscious, delving into the recesses of the human psyche to discover mysterious, bizarre, and often disturbing images. René Magritte, however, was a Surrealist painter more fascinated by puzzles and paradoxes than by the nature of the unconscious. *The Promenades of Euclid* presents the age-old problem of illusion versus reality. In this witty picture within a picture, the canvas in front of the window seems to exactly replicate the section of city it blocks from view. But does it? Perhaps the twin forms of tower and street exist only in the artist's imagination. Or perhaps the canvas is transparent, and what we see is the actual city. In discussing a similar work, Magritte explained: "The tree represented in the painting hid from view the tree situated behind it, outside the room. It existed for the spectator, as it were, simultaneously in his mind, as both inside the room in the painting, and outside in the real landscape. Which is how we see the world: we see it as being outside ourselves even though it is only a mental representation of it that we experience inside ourselves."

Ernst Barlach
German, 1870–1938
The Fighter of the Spirit
1928
Bronze
146 in. high
The John R. Van Derlip Fund 59.16

Nearly twenty thousand works by
Europe's most highly regarded modern
artists were removed from German
museums during the Third Reich.
Condemned as "decadent, degenerate,
Bolshevik, and Jewish," they were
burned or else sold abroad to finance
Hitler's war preparations. The well-
known German Expressionist Ernst
Barlach was persecuted with the rest
of the country's artistic vanguard.
He was placed under house arrest,
forbidden to teach or exhibit, and
threatened with loss of privacy in
which to work. His sculptures and
prints were removed from public view,
and his plays and books banned. *The
Fighter of the Spirit*, which represents
the ascendancy of the spiritual over
the bestial in human nature, had been
commissioned by the city of Kiel as a
memorial to the dead of World War I.
In 1937 the SS confiscated it as a pacifist
and unpatriotic work and had it cut
into several pieces. Although an order
was given to melt it down, this was
never carried out and the statue
escaped destruction. After the war it
was repaired and reinstalled in Kiel,
outside the church of St. Nicholas.
The Institute's cast, the only known
full-sized copy, was taken from the
reconstructed original and shows the
saw-toothed marks made when the
Nazis dismantled the sculpture.

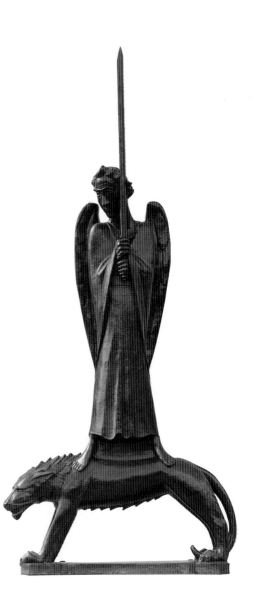

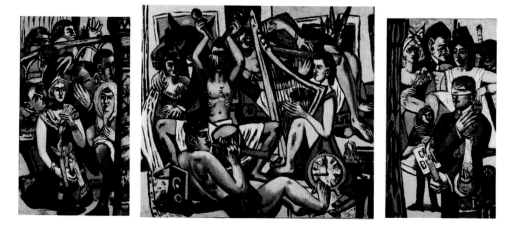

Max Beckmann
German, 1884–1950
Blindman's Buff
1945
Oil on canvas
81¼ × 91¼ in. (center panel)
73½ × 40 in. (left panel)
73⅞ × 41¾ in. (right panel)

Gift of Mr. and Mrs. Donald Winston
55.27.1–3

In the summer of 1937, the Nazis organized an exhibition of "degenerate art" that included ten of Max Beckmann's works. Around the time this exhibit opened in Munich, Beckmann and his wife left their home in Berlin to visit a relative in Holland. They never returned. For the next ten years they lived mainly in Amsterdam, where Beckmann executed five of the nine triptychs which are his most important paintings. *Blindman's Buff*, like much of his art, is allusive and symbolic, inviting explication yet resisting explicit interpretation. The triptych (three-paneled) format was traditional in medieval and Renaissance altarpieces and thus has religious associations. Beckmann called the figures in the central panel "the gods" and the animal-headed man the "minotaur." The garlanded Grecian piper and the fierce drummer, the dreamy harpist and the bare-breasted pipe player on the couch, form a quartet that comprises both the classical and the barbaric, the erotic idyll and crude sensuality. They call the tune in this cabaret where time has no end or beginning (the clock face lacks XII and I) and people seek amusement in sex, champagne, and cigarettes. The blindfolded man and kneeling woman in the wings, whose poses recall portraits of donors in Renaissance altarpieces, are connected by the symmetry of their positions, their gestures, and the objects they hold.

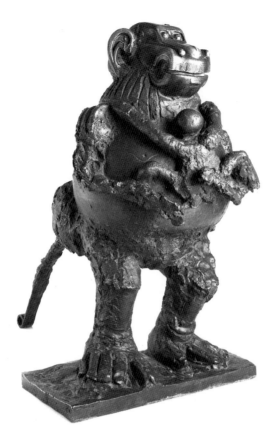

Pablo Picasso
Spanish, 1881–1973
Baboon and Young
1951
Bronze
21½ in. high

Gift of Mr. and Mrs. John Cowles
55.45

Pablo Picasso was one of the most innovative, prolific, and admired artists of this century. A painter, sculptor, printmaker, and ceramist, he worked in many styles and materials, as comfortable with Surrealism as with Cubism, as at ease with paper, clay, or glass as with oil paints and bronze. As a sculptor, he pioneered the technique called assemblage, constructing works partly or entirely of "found" objects, both natural and man-made. In *Baboon and Young*, he used toy automobiles, a storage jar, and a car spring to create a playful image of motherhood. The two metal cars, undersides together, are the baboon's head; the round earthenware pot, with its high handles, makes up her torso and shoulders; and the curving steel spring forms her backbone and long tail. The rest of her body and the figure of her child were modeled from clay, and the whole piece was cast in bronze. In this sculpture, Picasso has conjured the extraordinary from the ordinary, humorously juxtaposing ready-made and hand-built surfaces.

Henry Moore
English, 1898–1986
Warrior with Shield
1953–54
Bronze
60 in. high
Gift of Mr. and Mrs. John Cowles
54.22

Despite the dominance of abstract art during the twentieth century, a number of modern sculptors—Henry Moore, Marino Marini, Leonard Baskin, Alberto Giacometti—have continued to depict the human figure. Moore's *Warrior with Shield* represents a maimed soldier no longer able to hold a weapon but valiantly defending himself with his shield. He is the embodiment of the heroic spirit, indomitable in the face of death. Many scholars believe this work symbolizes England's courageous opposition to Germany in World War II. Moore, who served as an official war artist, made thousands of drawings of London's subway system in use as an air raid shelter. He said that "the position of the [warrior's] shield and its angle give protection from above," a comment probably alluding to the danger from falling bombs during the Nazi blitzkrieg, which Moore witnessed. Of the six casts made of this sculpture, the Institute's is the only one in an American collection.

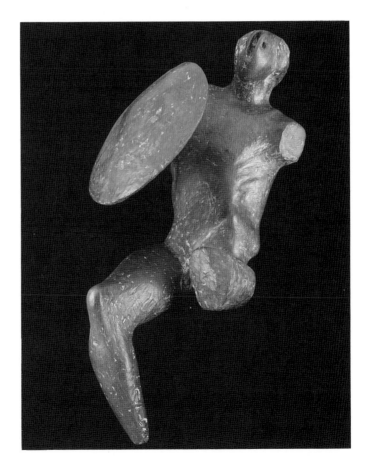

American Art

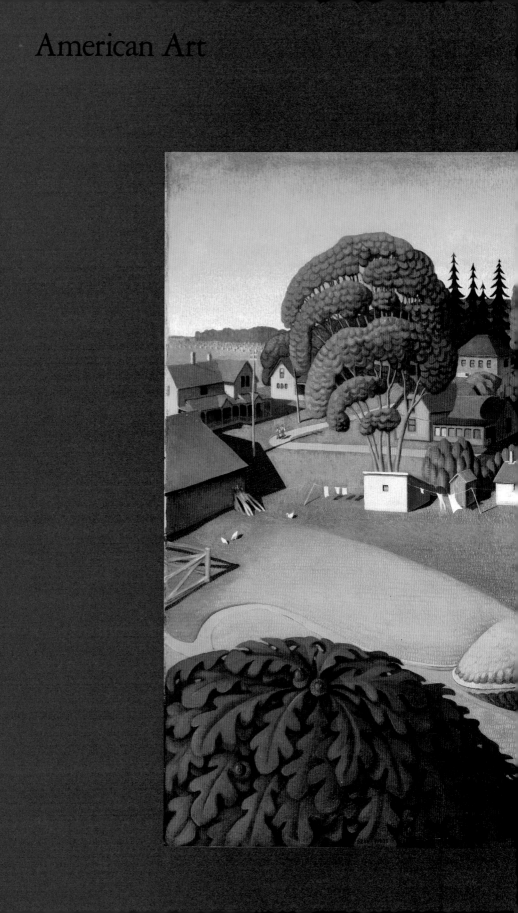

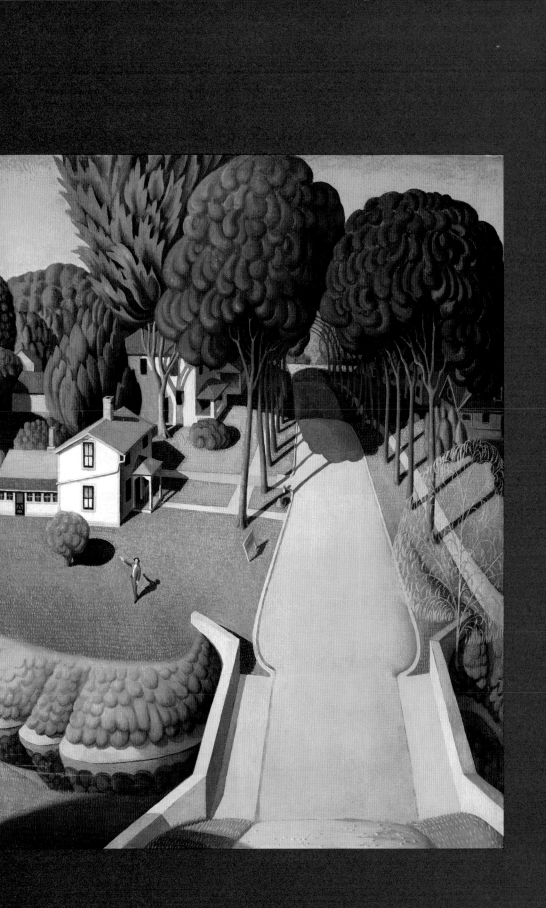

Roeloef Demarest
Active mid-18th century

Kas
About 1740–69
Sweet gum and poplar
77½ × 72¾ × 26¼ in.
The Putnam Dana McMillan Fund
81.3

"A sensible people," John Adams once remarked of the Puritans, and the same could be said of all America's early settlers. Whether French Huguenots, Scottish Presbyterians, or Swedish Lutherans, the colonists were hardworking and ambitious, valuing usefulness over fancy, practicality above ornamentation. Colonial artists usually employed their talents in fashioning utilitarian objects: silver and pewter utensils, pottery and glassware, textiles and furniture. This large two-doored wardrobe, called a *kas* (from the Dutch *kast*), was one of a pair designed by Roeloef Demarest for the Isaac Perry house in Orangetown, New York. With its heavy stepped cornice and bulbous turnip feet, it is typical of pieces made on Long Island and along the Hudson River during the seventeenth and eighteenth centuries. This *kas* is particularly interesting because several of its bilsted (sweet gum) panels are painted to simulate the graining of finer woods and the moldings are gilded or ebonized. Storage presses like this—indispensable in dwellings built without closets—would have held linen and clothing. Often they were part of a bride's dowry.

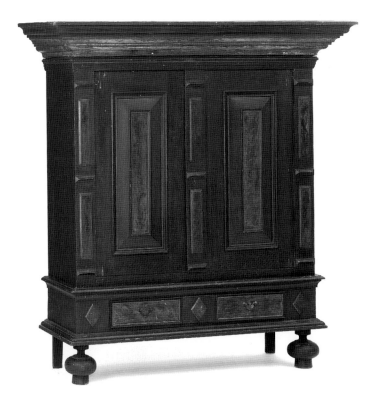

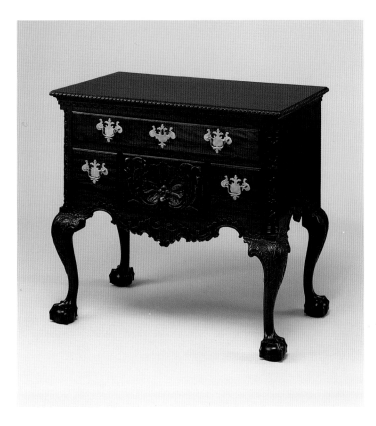

Philadelphia, Pennsylvania
Lowboy
1760–80
Mahogany
31 × 34 × 21 in.

Gift of James F. and Louise H. Bell in memory of James S. and Sallie M. Bell
31.21

During the colonial period, the cities of Philadelphia, Boston, and Newport became important centers of furniture production. Since American cabinet-makers frequently based their work on designs from Thomas Chippendale's pattern book, *The Gentleman and Cabinet-Maker's Director*, published in London in 1754, American Rococo furniture dating from about 1755 to 1790 has come to be known as "Chippendale." The most elaborate chests, tables, and chairs were made in Philadelphia, and this lowboy, with its rich, graceful carving and highly polished imported mahoganies, is an excellent example of the style. Garlanded colonnettes occupy the two front corners, the top is edged with a delicate twisted molding, and the skirt is embellished with a relief of acanthus leaves that spills onto the knees of the cabriole legs. The vigorously executed shell, on the lower drawer panel, was a favorite Rococo motif. Like most American Chippendale, this lowboy has ball-and-claw feet, an element adapted from the Chinese motif of a dragon's claw clutching a pearl.

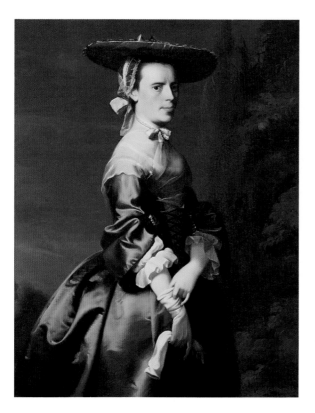

John Singleton Copley
1738–1815
Portrait of Mrs. Nathaniel Allen
About 1763
Oil on canvas
49½ × 40 in.
The William Hood Dunwoody Fund
41.3

John Singleton Copley lamented his fellow Bostonians' limited appreciation of painting. "Was it not for preserving the resemblance of particular persons, painting would not be known in the place. The people generally regard it no more than any other useful trade, as they sometimes term it, like that of a carpenter, tailor or shoemaker, not as one of the most noble arts in the world." Yet it was precisely this attitude that allowed

portraiture—that most straightforward and documentary form of artistic expression—to thrive in colonial America. And so it was as a portraitist that Copley made his reputation. In the 1770s he settled permanently in England and turned to history painting, but throughout his career he continued to do portraits. This picture of Mrs. Nathaniel Allen, the wife of a Gloucester, Massachusetts, businessman, shows his ability to capture a likeness of both form and character. Mrs. Allen stands in an elegant three-quarters pose before a copse of feathery trees, gracefully tugging at the glove on her right hand. Belying this pretense in gesture and stance, however, her direct gaze and stern expression suggest that she is a strong-willed, forceful woman.

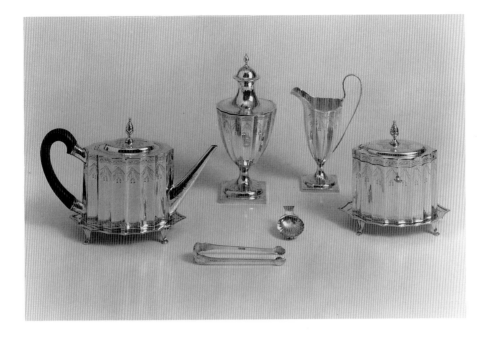

Paul Revere
1735–1818
Templeman Tea Service
1792–93
Silver
Teapot, 6⅛ in. high; tea caddy, 5¾ in. high; covered sugar urn, 9⅝ in. high; creampot, 7½ in. high; sugar tongs, 5½ in. long; tea shell, 2½ in. long; strainer, 11⅛ in. long
Gift of James F. and Louise H. Bell
60.22.1–9

The most respected and best-paid craftsmen of eighteenth-century America were the furniture makers and goldsmiths. (The term "goldsmith" referred to both goldsmiths and silversmiths.) Though best known as the patriotic horseman who roused the Minutemen to action the night of 18 April 1775, Paul Revere was a successful silversmith and engraver,

a dentist, a merchant, and an industrialist. He established a foundry that produced some of the first bells cast in this country, and also operated a mill for rolling sheet copper by a method that he himself had devised. Rolled sheet metal was a time- and money-saving innovation, and sheet silver, which Revere used for much of the Templeman tea set, was particularly suitable for fashioning the thin, fluted walls of these objects. Revere's account book states that this service was commissioned by John and Mehitable Templeman of Boston. Their monogram, *JMT*, appears on the footed stands for the teapot and the caddy and on the urn-shaped sugar bowl. Delicately engraved tasseled drapery and floral motifs decorate the various articles of the service. Matched tea sets were unusual in Revere's day and very few have survived intact.

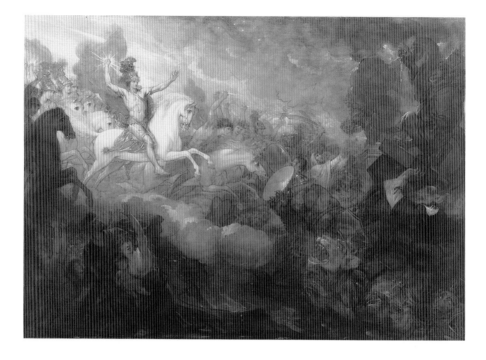

Benjamin West
1738–1820
The Destruction of the Beast and the False Prophet
1804
Oil on panel
39 × 56½ in.

The William Hood Dunwoody Fund
15.22

Both Benjamin West and his contemporary John Singleton Copley were talented artists frustrated by the colonials' insatiable taste for "likenesses." They longed to see the Raphaels, Titians, and Correggios of Europe; to hear the lofty orations of Sir Joshua Reynolds; to paint historical and mythological scenes in the grand manner. Both of them left America for London and never returned. West became history painter to King George III and president of the Royal Academy. He designed *The Destruction of the Beast and the False Prophet* as part of a series of apocalyptic paintings intended for the king's proposed Chapel of the History of Revealed Religion, a project later abandoned. The subject is from the Book of Revelation (19:11–21): "Then I saw heaven opened, and behold, a white horse! He who sat upon it is called Faithful and True.... And the armies of heaven... followed him on white horses.... And the beast was captured, and with it the false prophet.... These two were thrown alive into the lake of fire that burns with brimstone." In later works such as this, West's dramatic composition and style anticipate nineteenth-century Romanticism.

Jasper F. Cropsey
1823–1900

Catskill Mountain House
1855
Oil on canvas
29 × 44 in.

Bequest of Mrs. Lillian Lawhead
Rinderer in memory of her brother,
William A. Lawhead, and the William
Hood Dunwoody Fund 31.47

During the 1820s, the vast, rugged, and untamed landscape became the dominant theme of American art, especially for a group of painters that came to be known as the Hudson River school. These artists, among them Thomas Cole, Asher B. Durand, and John Kensett, saw the world as God's handiwork, "fraught with high and holy meaning." They wandered through the American wilderness, recording the topography with a scrupulous attention to detail that reflected their belief in nature's divine origin and their reverence for its unspoiled beauty. This concise and fastidious realism can be seen in Jasper Cropsey's *Catskill Mountain House.* A second-generation Hudson River school artist, Cropsey liked to paint autumnal views of the Catskill and White mountains. Here, the wooded hills and clear skies have as a focal point the Mountain House, a famous hotel near Catskill, New York, built in the early nineteenth century to accommodate summer tourists. Cropsey had sketched the resort as early as June 1852, and he made this painting—his final version of the scene—in 1855 for James Edgar, a businessman from Chicago. Like others of the Hudson River school, Cropsey never lacked commissions and enjoyed financial success throughout his long career.

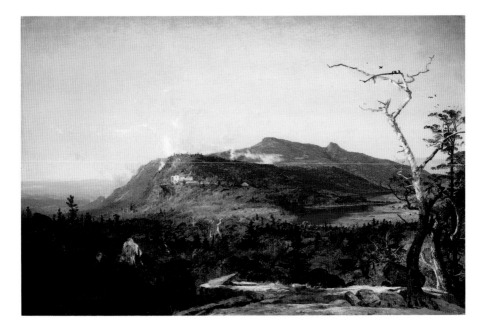

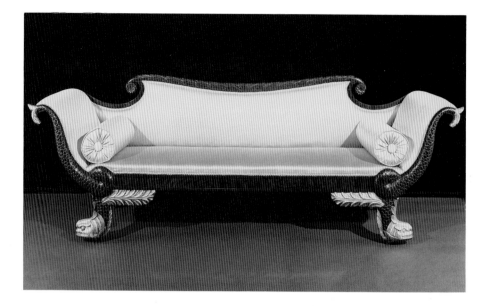

New York
Sofa
About 1820–25
Mahogany and polychromed pine
35 × 104 × 27½ in.

The William Hood Dunwoody Fund
and gift of Harry M. Drake, Mr. and
Mrs. Charles Bell, the James Ford Bell
Foundation, Mrs. John Roller, and
Mrs. Peter Anson 82.75

During the late eighteenth and early
nineteenth centuries, the art of ancient
Greece and Rome excited avid interest
in both Europe and America, leading
to the revival of many classical subjects
and forms. Borrowing from English
and French sources, American furni-
ture of the Federal period (about

1790–1825) reflects this widespread
affection for the classical past. The
sleek lines, scrolling arms, and dolphin
feet that distinguish the Institute's
couch are derived from Greek proto-
types, and even the tubular bolsters
are of antique design. The carved pine
dolphins, painted dark green in imita-
tion of aged bronzes, add a lively,
whimsical note, thrusting their tails
upward into the arms and trailing gilt
foliage onto the front seat rails.
In keeping with nineteenth-century
American taste, the piece has been
reupholstered in gold satin. Several
other Neoclassical sofas with dolphins
are known, including one at the Metro-
politan Museum of Art in New York,
one at the Museum of Fine Arts in
Houston, and one at the White House.

Baltimore, Maryland
Album Quilt
1844–45
Appliquéd, pieced, and embroidered
cotton and chintz
107 × 107¾ in.
Gift of Stanley H. Brackett in memory
of Lois Martin Brackett 75.9.1

In a country where people took to
heart the maxim "Waste not, want
not," little was thrown away. From
colonial times through the Civil War
and afterward, remnants of the fabrics
used for garments, upholstery, and
draperies were kept, to be combined in
the most spectacular of all blankets,
the handmade quilt. Before 1750, most
quilts were pieced: small patches of
material were sewn together to form a
large, overall design. After the Revo-

lution, however, the appliqué quilt,
constructed of cutouts stitched to a
larger background fabric, gained favor.
Generally, the finest "show" quilts—
those intended for display rather than
use—were appliquéd. Some of the best
of these were done in and around Balti-
more during the 1840s and 1850s. The
Institute's Baltimore album quilt,
which dates to the mid-1840s,
is a cotton and chintz version of the
nineteenth-century autograph album,
each of its thirty-six blocks having
been created and inscribed by a differ-
ent woman. This colorful potpourri of
floral wreaths, exotic vases, and song-
birds, bordered by a meandering vine
of tan leaves and red flowers, was
made as an extravagant keepsake to
honor a friend, relative, or respected
member of the community.

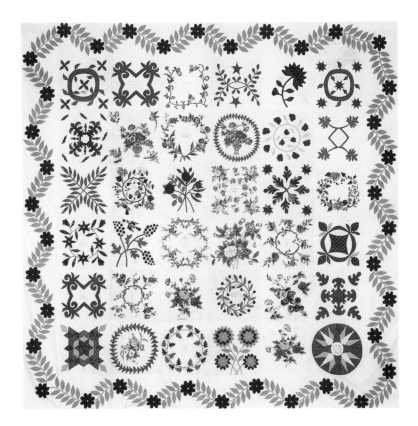

Eastman Johnson
1824–1906
The Letter Home
1867
Charcoal and graphite on paper
24 × 30 in.
The Julia B. Bigelow Fund by John
Bigelow 74.17

Genre painting—the representation of scenes from daily life—developed alongside the landscape and still-life traditions that flourished in nineteenth-century America. Genre painters chronicled the best and the worst of American life, from corn-huskings and haymaking to street brawls and slave auctions. Eastman Johnson, with William Sidney Mount and George Caleb Bingham, was a leading genre artist as well as a portraitist. In this pencil drawing, we glimpse life in an army field hospital outside Gettysburg, Pennsylvania, during the Civil War. Shaded from the sun by an overhanging tree, a convalescing soldier dictates a letter to the young nurse sitting beside him. Instead of the smoke and clamor of battle, Johnson has chosen to depict a moment of compassionate tranquillity. The soldier's convalescence can be seen as analogous to the healing of the nation that must occur when the war is over. Johnson made this highly finished work to benefit the U.S. Sanitary Commission, an organization that raised money to aid the wounded. The period frame incorporates bronze medallions from the Great Central Fair held in Philadelphia in 1864 and the North-Western Sanitary Fair held in Chicago in 1865. The Museum of Fine Arts, Boston, owns an oil painting by Johnson that is almost identical to the Minneapolis drawing.

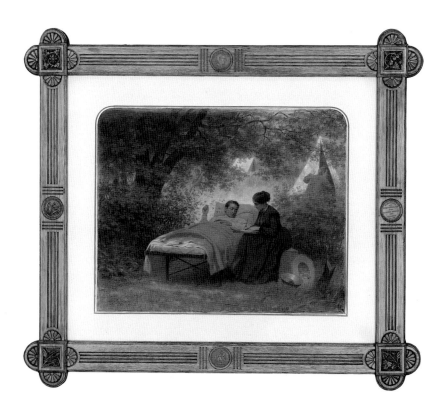

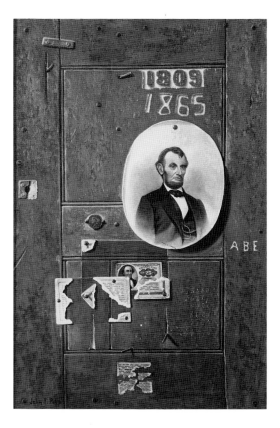

John F. Peto
1854–1907

Reminiscences of 1865
After 1900
Oil on canvas
30 × 20 in.

The Julia B. Bigelow Fund by John Bigelow 44.25

American still-life painting reached its technical high point in the second half of the nineteenth century with the *trompe l'oeil* (fool-the-eye) realism of William Harnett and John F. Peto. The neutral tone, somber mood, and humble subjects of Harnett's and Peto's works reflect a world still blighted by the destruction of civil war. These artists painted worn and battered objects: old pipes and books, tattered postcards and letters, rusted hinges

and nails. In *Reminiscences of 1865*, Peto pays homage to Abraham Lincoln. Lincoln's birth and death dates and the nickname Abe are crudely "carved" with green and cream-colored paints on a nicked and peeling door. An oval engraving of the slain president hangs on a brass tack, and a twenty-five-cent shinplaster, a tarnished coin, torn paper notices, and assorted bent and broken hardware litter the surface of the wood. Beginning in the 1890s, Peto made a dozen canvases on the Lincoln theme. Despite his obvious skill in executing such images, Peto received little recognition during his lifetime and was completely forgotten after his death, until the discovery in the 1950s that many of his paintings bore the forged signature of Harnett, his better-known contemporary.

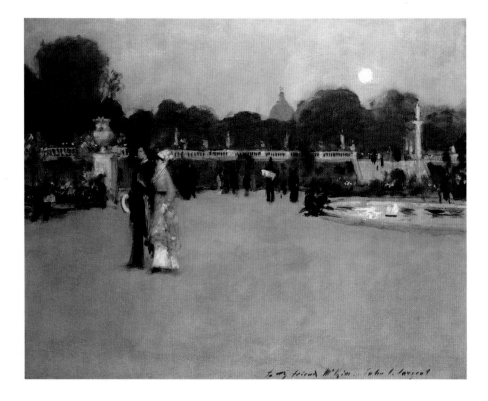

John Singer Sargent
1856–1925

Luxembourg Gardens at Twilight
About 1879
Oil on canvas
29 × 36½ in.

Gift of Mrs. C. C. Bovey and Mrs. C. D. Velie (the Martin B. Koon Memorial Collection) 16.20

In the decades following the Civil War, many American artists studied in Europe; some, like Mary Cassatt and James Abbott McNeill Whistler, spent most of their lives there. John Singer Sargent was born in Italy to American parents living abroad. He trained first in Florence and Rome and in the 1870s moved to Paris to work in the studio of Carolus-Duran. There he made rapid progress and soon was painting with the expressive brushstrokes and luminous colors that became the hallmarks of his mature style. In *Luxembourg Gardens at Twilight*, he skillfully evokes place and mood in soft grays, greens, and pinks. Executed during his sojourn in France (1874–84), this painting recalls the canvases of the French Impressionists in its technique and atmosphere. Another American expatriate, the writer Henry James, saw in the young Sargent "the slightly 'uncanny' spectacle of a talent which on the very threshold of its career has nothing more to learn."

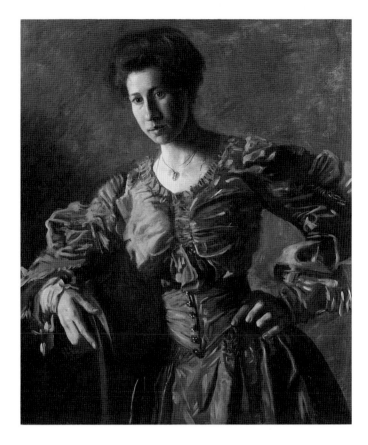

Thomas Eakins
1844–1916
Portrait of Miss Elizabeth L. Burton
1906
Oil on canvas
30 × 25 in.
The William Hood Dunwoody Fund
39.53

Thomas Eakins considered "distortions" of any kind to be "ugliness." Both as a genre painter and as a portraitist, he approached his subjects objectively, recording their features with honesty and insight. This straightforwardness won him little favor with his sitters, who often refused the works they commissioned from him or accepted them only to destroy them. Elizabeth Burton, an artist herself, lived next door to the Eakinses in Philadelphia. She sat for her portrait in a blue silk dress trimmed with brown ruching. Her plain face and hair, casual pose, and serious expression show her to be a thoughtful and unpretentious young woman. Before the portrait was completed, Miss Burton married and left Pennsylvania to do mission work in North Borneo. Eakins later presented the unfinished picture to her mother as a gift.

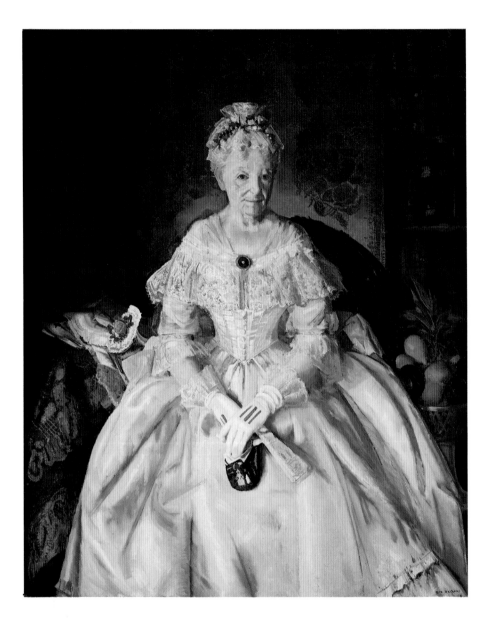

George Bellows
1882–1925
Mrs. T. in Cream Silk, No. 2
1920
Oil on canvas
53 × 44 in.
The Ethel Morrison Van Derlip Fund
60.33

Like other early twentieth-century realists, George Bellows was primarily interested in depicting urban street life, but he also painted landscapes and portraits throughout his twenty-year career. While teaching for two months at the Art Institute of Chicago, he met Mrs. Mary Brown Tyler at a reception

at the Chicago Arts Club and asked her to pose for him. She sat for him several times, first in a wine-colored dress from her youth and then in the gown she had worn at her wedding in 1863. Here she wears her wedding costume, a cream silk with blue and lavender ribbons and ivory shoulder lace. An earlier version, smaller and lacking the black Oriental purse Mrs. Tyler holds in this picture, is in the Hirshhorn Museum in Washington, D.C. Mrs. Tyler belonged to a prominent family, and her relatives, who found the portrait undignified, insisted that the sitter's identity remain anonymous—hence the title *Mrs. T.*

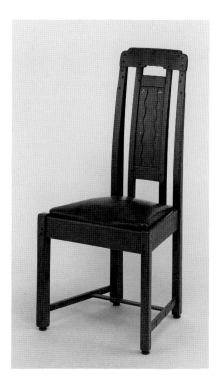

Charles Greene and
Henry Greene
1868–1957; 1870–1954
Side Chair
1907
Mahogany and ebony, with mother-of-pearl, copper, and pewter inlays
42½ × 20 × 18 in.

The Putnam Dana McMillan Fund
83.1

The American Arts and Crafts movement, introduced at the Philadelphia Centennial of 1876, flourished until World War I. A reaction against industrialization and mass production, the Arts and Crafts movement originated in England with the ideas of John Ruskin and William Morris. Its proponents hated the waste and anonymity of mechanization and advocated a return to the well-designed, handwrought object. Charles

and Henry Greene, trained as architects at the Massachusetts Institute of Technology, were outstanding members of the group, along with their contemporaries Louis Tiffany, Gustav Stickley, and Frank Lloyd Wright. In 1893, the Greenes left Boston and moved to Pasadena, where they built the first "California bungalows"—those one-storied shingled houses that blend so well with the rocky terrain of the West Coast. This side chair was among the furnishings the Greenes designed for the Robert R. Blacker residence on Hillcrest Avenue, the first of four architectural commissions in Pasadena that established their fame. With its high back, delicate inlays, and flaring seat, the chair is at once graceful and austere. Like the house, it shows the Greenes' love of rich, unvarnished wood and simple, carefully articulated details.

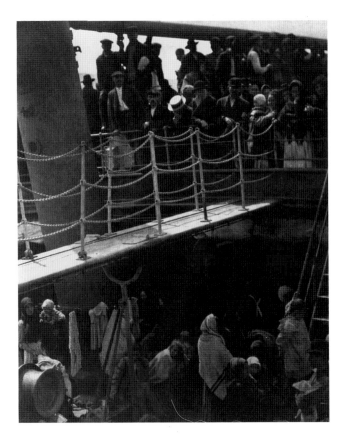

Alfred Stieglitz
1864–1946
The Steerage
1907
Photogravure from *Camera Work*
(October 1911)
7¹¹/₁₆ × 6³/₁₆ in.
Gift of Miss Julia Marshall 69.133.36

In 1905, Alfred Stieglitz opened the Little Galleries of the Photo-Secession at 291 Fifth Avenue in New York City and began his efforts to expose a bewildered American public to the most radical and controversial art forms of the time. He was the first in the United States to show the work of European avant-garde artists like Rodin, Cézanne, Picasso, and Brancusi and to promote artists in the American vanguard, such as Arthur Dove, Max Weber, and Georgia O'Keeffe. He also exhibited African sculpture and the drawings of children as art forms and insisted that photography, too, was a fine art. The sharply focused, unmanipulated images of his own photographic work are in the style known as "straight" photography. *The Steerage*, one of the best-known pictures in the history of photography, was taken in June 1907 while Stieglitz was on board the SS *Kaiser Wilhelm II* en route from New York to Paris. As a first-class passenger, he stood on the upper deck, observing his fellow travelers from above, and he was spell-

bound by what he saw. "The scene fascinated me: a round straw hat; the funnel leaning left, the stairway leaning right; the white drawbridge, its railings made of chain; white suspenders crossed on the back of a man below; circular iron machinery; a mast that cuts into the sky, completing the triangle." These simple abstract forms—circles, rectangles, and triangles—constitute the structural basis of this moving photograph, which Stieglitz described as "a picture based on related shapes and deepest human feeling."

John S. Bradstreet
1845–1914
Lotus Table
About 1903–7
Cypress wood
28⅜ in. high
Gift of Wheaton Wood 82.43.11

John S. Bradstreet, a New Englander by birth, arrived in Minneapolis in 1873 and soon established himself as an interior decorator and furniture designer. In 1904 he opened the Craftshouse, a workshop and salesroom handling Tiffany lamps, Grueby pottery, and Asian and Islamic artifacts of all kinds. Bradstreet himself designed furniture and paneling inspired by *jin-di-sugi*, the traditional Japanese method of aging cypress wood. But instead of burying the wood, as the Japanese did, Bradstreet weathered it artificially, scrubbing the surface with a wire brush to create the characteristic *sugi* pattern and texture. The museum's table is one of his most successful and imaginative pieces. Its pedestal and base are carved to resemble stems and roots, and the circular top represents a pond covered with flowers and leaves. The table came from the Prindle house in Duluth, whose fully furnished parlor the Institute acquired in 1982.

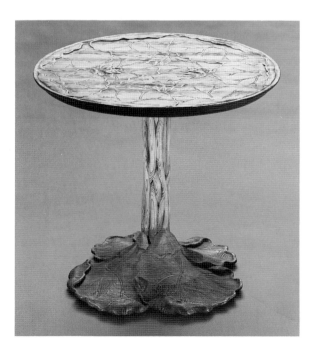

American

Lewis W. Hine
1874–1940
Factory Children, North Carolina
1908
Gelatin silver print
4⅝ × 6¹¹⁄₁₆ in.
The Ethel Morrison Van Derlip Fund
74.39.16

"Straight" photography was in part a reaction against the soft-edged, impressionistic "pictorialist" style of most turn-of-the-century photography, exemplified by the works of Alvin Langdon Coburn, Clarence H. White, and Gertrude Käsebier. Lewis W. Hine, an early advocate of the straight approach, made brutally direct, sharply focused pictures that exposed the cruel exploitation of children as a cheap labor force. These images appeared regularly in newspapers and magazines and helped secure the passage of child labor laws in this country. From 1908 until 1918, as a staff member of the National Child Labor Committee, Hine traveled throughout the East Coast, the Deep South, and the Midwest, investigating labor practices in textile mills, canneries, fisheries, and coal mines. Everywhere, he found severe abuses. Of the children he met on his journeys he wrote, "I have heard their tragic stories, watched their cramped lives, and seen their fruitless struggles in the industrial game where the odds are all against them." This photograph, taken outside a North Carolina factory, portrays four victims of such enslavement. Covered with lint, they stand between their taskmasters, a Simon Legree character in a black cowboy hat and a cocky young man in overalls. They are frontally posed and look directly at us. One of the boys even manages a faint smile for the camera, suggesting that these children, though tired and powerless, are not yet resigned to the wretchedness of their situation.

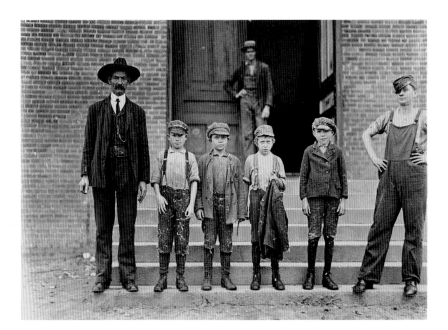

Georgia O'Keeffe
1887–1986

City Night
1926
Oil on canvas
48 × 30 in.

Gift of the Regis Corporation, W. John Driscoll, and the Beim Foundation; the Larsen Fund; and by public subscription 80.28

Along with Marsden Hartley, John Marin, and Arthur Dove, Georgia O'Keeffe was a member of the "291" group, a coterie of artists nurtured and promoted by the photographer Alfred Stieglitz. O'Keeffe, who had studied at the Art Institute of Chicago, the Art Students League, and Columbia University, first exhibited at Stieglitz's Little Galleries in 1916. Although she is best known for large-scale images of flowers and sun-bleached landscapes of the American Southwest, during the 1920s she executed a series of paintings inspired by the brick, mortar, and steel of New York. *City Night* belongs to this group, which includes views of Forty-seventh Street, Lexington Avenue, and the East River. With typical spareness, O'Keeffe has reduced the architecture of the metropolis to simple geometric forms and translated those shapes into the streamlined buildings of *City Night* — austere monoliths that soar beyond the moon in the dark evening sky.

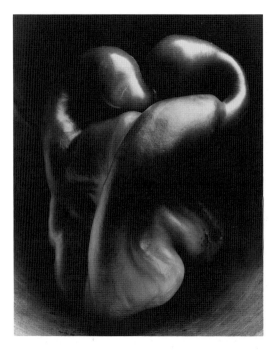

Edward Weston
1886–1958
Pepper No. 30
1930
Gelatin silver print
9⁷⁄₁₆ × 7½ in.
Bequest of Dorothy Millett Lindeke
84.56.1

Edward Weston began his career
working in the soft-focus style of the
pictorialists, but in the early 1920s
he turned to "straight" photography,
seeking clarity and precision of form
and detail, whether in a nude torso,
a sand dune, or a seashell. "The camera
should be used for a recording of *life*,
for rendering the very substance
and quintessence of the *thing itself*,
whether it be polished steel or palpi-
tating flesh," he wrote in his *Daybook*
of 1924. To achieve this end, he used
a classic eight-by-ten view camera,
outfitted with a rapid rectilinear lens,
and printed his negatives on glossy
paper. For several years during the late
1920s and the 1930s, he photographed
vegetables—artichokes, cabbages,
chard, mushrooms, pumpkins, squash.
The "amazing convolutions" of green
and red peppers fascinated him and
made him think of "sculpture, carved
obsidian." The simple monumentality
and bold directness of *Pepper No. 30*
are typical of Weston's work at that
time. Every bulge and hollow is
revealed, even the occasional bruise
and spot. Observing signs of decay in
one of his peppers, Weston remarked:
"I must get this one today: it is begin-
ning to show the strain and tonight
should grace a salad. It has been sug-
gested that I am a cannibal to eat
my models after a masterpiece. But I
rather like the idea that they become
a part of me, enrich my blood as well
as my vision."

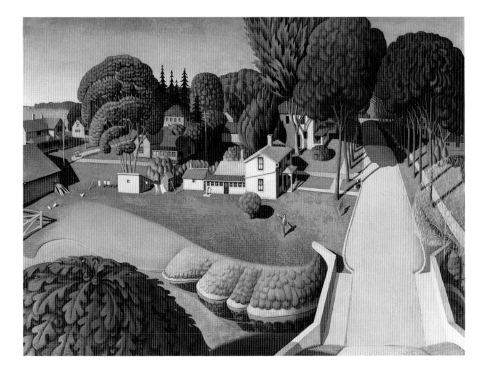

Grant Wood
1892–1942
The Birthplace of Herbert Hoover, West Branch, Iowa
1931
Oil on composition board
29⅝ × 39¾ in.
The John R. Van Derlip Fund 81.105; owned jointly with the Des Moines Art Center

With the stock market crash of 1929, unemployment, bankruptcy, and foreclosure became commonplace in the United States. Seeing the crushing poverty and despair of the Depression, many American artists rejected the Cubist styles of the 1920s in favor of a representational art that could provide social and political comment. Edward Hopper and Andrew Wyeth showed the loneliness and alienation of daily existence. Social realists like Ben Shahn and William Gropper attacked the complacency of the well-to-do and championed the worker. And regionalists such as Grant Wood, Thomas Hart Benton, and John Steuart Curry painted nostalgic images of America's heartland that helped the nation recover its confidence and pride. A leader of the regionalist movement, Wood celebrated America's agrarian and small-town roots in his pictures of the Midwest. *The Birthplace of Herbert Hoover*, finished the year after *American Gothic* had brought the artist national acclaim, pays homage to Iowa's most famous citizen. An anonymous figure, standing in an immaculate yard, points out the white cottage (at the rear of the main house) where in 1874 Hoover was born. This modest dwelling, built by Hoover's blacksmith father, seems to affirm the popular American belief that a person of humble origin can attain the highest office in the land.

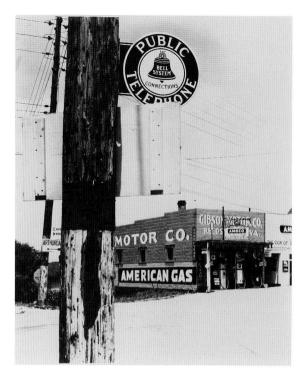

Walker Evans
1903–75
*Highway Corner, Reedsville,
West Virginia*
1935
Gelatin silver print
9 × 7⁷/₁₆ in.
The William Hood Dunwoody Fund
75.26.17

In 1935, during the Great Depression, the federal government employed photographers to take pictures that could be used to show the urban poor the plight of the rural poor and thus help preserve the fragile coalition that supported the New Deal. This undertaking produced a rich visual history of the American people confronting a spiritual and economic crisis, a portrait documenting the human will to survive adversity and to survive with dignity.

One of the photographers hired by the Farm Security Administration was Walker Evans. From late 1935 until 1937, he traveled throughout the East and South photographing everyone and everything, from Pennsylvania coal miners to Alabama sharecroppers and from soil erosion to eclectic architecture. Evans's pictures are sharply focused, detailed, and insistently factual, like this image of a highway intersection in Reedsville, West Virginia. Although open for business, the gas station has no customers, and the bright light accentuates its emptiness. At once dreary and grand, this simple structure with its boldly lettered advertising becomes an icon of American culture. The critic Thomas Dabney Mabry saw in such photographs "a power which reveals a potential order and morality at the very moment that it pictures the ordinary, the vulgar, and the casually corrupt."

Alexander Calder
1898–1976

Ahab
1953
Painted metal
177 in. high

Gift of Bruce B. Dayton and Mr. and Mrs. Gerald A. Erickson, by exchange
83.77

Alexander Calder is credited with inventing the modern sculptural form known as the mobile. He had received a degree in mechanical engineering before studying drawing at the Art Students League in New York City. In 1930, after seeing Piet Mondrian's geometrical abstractions and thinking "how fine it would be if everything... moved," he became interested in kinetic sculpture. Not surprisingly, Calder's first mobiles seemed like motorized paintings. But their brightly colored elements turned with such tedious regularity that Calder soon abandoned mechanical motion and began building metal and wire forms that could be animated by the wind. *Ahab*'s balanced arrangement of steel rods and black disks shows how highly refined his technique became. The elegant biomorphic shapes appear to float, changing configuration with every movement of the air. Calder's objects "are like the sea," wrote the philosopher Jean-Paul Sartre. "They cast the same spell, always beginning again, always renewed." This mobile (whose title brings to mind the maniacal captain who pursued Moby Dick, the white whale) is one of several monumental pieces that Calder made in the late 1940s and the 1950s. Too large to hang in the artist's studio, it was constructed in two parts and assembled out-of-doors.

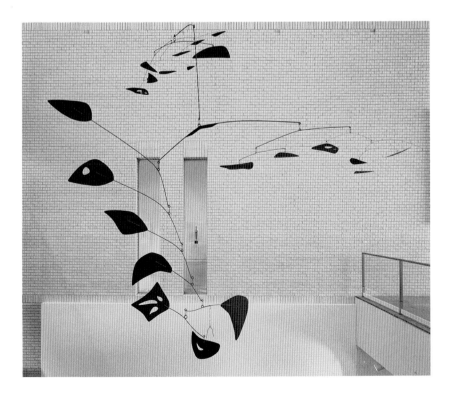

American

Philip Guston
1912–80

Bronze
1955
Oil on canvas
76×72 in.

The Julia B. Bigelow Fund by John
Bigelow 58.34

Immediately following World War II,
New York City became the center of
an international art movement that
drew attention away from Europe and
focused it on America. This revolu-
tionary new style, known as Abstract
Expressionism, characterized the work
of two distinct but related groups of
artists: the gesture, or action, painters

(Hans Hofmann, Willem de Kooning,
and Jackson Pollock) and the color-
field abstractionists (Mark Rothko,
Clyfford Still, and Barnett Newman).
Philip Guston, like these early Abstract
Expressionists, believed art should be
personal, subjective, and spontaneous.
He painted with the aggressiveness
typical of action painters, attacking the
canvas with his brushes and oils and
revealing in the raw exuberance of his
brushstrokes both the creative process
and his own temperament. But his
sensuous refinement of color and
surface, evident in the cascading reds,
pinks, and grays of *Bronze*, set Guston
apart from his contemporaries and led
one critic to call him an "Abstract
Impressionist."

Lee Friedlander
Born 1934
Mount Rushmore, South Dakota
1969
Gelatin silver print
$6^{11}/_{16} \times 9^{15}/_{16}$ in.
National Endowment for the Arts
purchase grant and miscellaneous
matching funds 76.58.9

Like the Ashcan school painters of the
early nineteen hundreds, the Four-
teenth Street school of the thirties,
and the Pop artists of the sixties, Lee
Friedlander finds his subjects in the
commonplace and the banal. Since he
began photographing in 1948, he has
produced a large and varied body of
work, from his early pictures of jazz
musicians and city streets to his more
recent studies of flowers and trees.
Over a period of a dozen years, he criss-
crossed the United States, taking
thousands of photographs of public
statues and stone markers, some of

which were published in 1976 as *The
American Monument*. One of the best-
known prints from this sequence is
Mount Rushmore, South Dakota.
Instead of taking a predictable,
head-on shot of the memorial, Fried-
lander aimed his camera at the glass
wall of the visitors' center, capturing
a kaleidoscopic vision of realities and
reflections. Tourists outside the build-
ing seem to mingle with those inside,
and the two larger-than-life sight-
seers in the foreground appear to have
their backs to the monument on which
their camera and field glasses are
trained. Of such moments Friedlander
writes: "The camera is not merely
a reflecting pool and the photographs
are not exactly the mirror, mirror on
the wall that speaks with a twisted
tongue. The mind-finger presses the
release on the silly machine and it
stops time and holds what its jaws can
encompass and what the light will
stain. That moment when the land-
scape speaks to the observer."

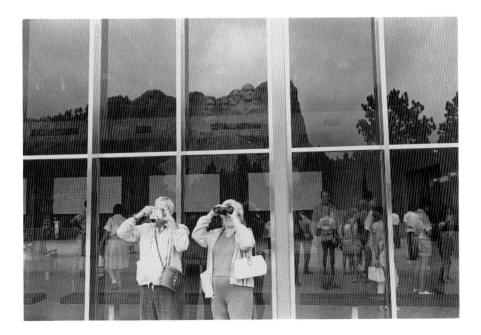

Frank Stella
Born 1936
Tahkt-I-Sulayman, Variation II
1969
Acrylic on canvas
120 × 240 in.

Gift of Mr. and Mrs. Bruce B. Dayton
69.132

In rejecting the emotional and improvisational qualities of Abstract Expressionism, many young American artists of the 1960s sought to make their work highly impersonal and analytical. Frank Stella, along with Kenneth Noland and Ellsworth Kelly, was at the forefront of this new generation of painters. His wall-sized *Tahkt-I-Sulayman, Variation II*, part of a series named for ancient Islamic sites and cities, shows his penchant for flat,

geometrical paintings with smooth, evenly brushed surfaces. It combines Day-Glo colors with a complex pattern of arcs, circles, and semicircles formed by interlocking protractor shapes. For Stella, these images are little more than a well-planned exercise in theme and variations. "I always get into arguments with people who want to retain the old values in painting—the humanistic values that they always find on the canvas. If you pin them down, they always end up asserting that there is something there besides the paint on the canvas. My painting is based on the fact that only what can be seen there *is* there. It really is an object. If the painting were lean enough, accurate enough, or right enough, you would just be able to look at it. All I want anyone to get out of my paintings, and all I ever get out of

making use of ordinary, everyday objects in their work, Rauschenberg and Johns paved the way for Pop art, with its reliance on commercial, mechanical, and urban imagery. Johns limited himself to such familiar subjects as flags, targets, beer cans, and light bulbs, which he described as "preformed, conventional, depersonalized, factual, exterior elements." He began painting numbers in 1955 and since then has made lithographs, etchings, and drawings of zero through nine in both color and black-and-white. By using numbers in a context where they can have no mathematical meaning, Johns turns them into artistic motifs and leads the viewer to ponder the distinction between abstraction and representation, between the idea of a number and its materialization in Johns's drawing as a tangible object. "With Johns," writes the critic Michael Crichton, "the issues of perception—of what you see, and why, and how you decide what you are looking at—are not merely questions to be decided in order to produce some final effect. They are, instead, the focus of the work itself."

them, is the fact that you can see the whole idea without any confusion. What you see is what you see."

Jasper Johns
Born 1930
Figure 2
1963
Graphite wash, charcoal, and chalk on paper mounted on linen
26⅛ × 21¼ in.

The William Hood Dunwoody Fund
70.71

Like Robert Rauschenberg, Jasper Johns shared the composer John Cage's view that even the banal and commonplace have aesthetic applications. By

Chuck Close
Born 1940
Frank
1969
Acrylic on canvas
108 × 84 in.
The John R. Van Derlip Fund 69.137

The Photo Realists of the 1970s (including Richard Estes, Ralph Goings, and Chuck Close) prefer the impersonal to the personal, the objective to the subjective, and the photographic reproduction to the flesh-and-blood model. In fact, the artists associated with this style all use the photograph and the airbrush to give their paintings precision and emotional distance. The subject for Close's *Frank* was not Frank himself but an eight-by-ten-inch photograph of him. Close first imposed a grid on the photo and then with black acrylic paint translated the image of his friend onto the nine-by-seven-foot canvas—square by square, line by line, dot by dot. The entire work required only a couple of tablespoons of paint, which Close sprayed onto the canvas. To create the white highlights, he scratched away some of the pigment with razor blades and electric erasers. Close considers the likeness achieved with this painstaking technique to be a "by-product." His real concern is with optical focus and human perception. "Close is interested in blur," writes a noted critic, "which he feels the human eye eliminates but the camera allows us to see and explore."

Asian Art

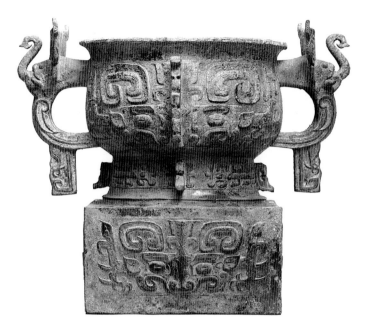

Chinese (late Shang dynasty)
Kuei (Food Vessel)
11th century B.C.
Bronze
10⁷/₁₆ in. high, diameter 13¾ in.
Bequest of Alfred F. Pillsbury 50.46.8

The recorded history of ancient China begins with the Shang dynasty (1523–1028 B.C.). During this period, the Chinese devised a written language and developed a sophisticated bronze technology which enabled them to produce the magnificent ceremonial vessels that are the masterpieces of early Chinese metalwork. This *kuei*, like other ceremonial bronzes, was cast from a ceramic piece-mold. The decoration—always an integral part of Shang ritual wares—consists of *t'ao-t'ieh* masks and stylized dragons in relief against a background of incised spirals. The *t'ao-t'ieh*, or "monster mask," motif, which appears on many Shang bronzes, protected the grave from evil spirits; the dragon, associated with water and rain, signified life and rebirth. The unusual handles combine an elephant's head with a bird's wings and tail. Ceremonial vessels were meant to contain sacrificial food and wine and were made in various prescribed forms. This *kuei*, with its square pedestal and heavy handles, would have held offerings of grain and vegetables for the ancestors. Like many ancient Chinese bronzes, it bears an inscription. On Shang pieces, such as this, the inscriptions usually designate clan or ownership, but on later vessels the texts are usually more complex, referring to specific dates, persons, and events.

Chinese (Six Dynasties period)
Kuan Yin
571
Black marble with traces of color
and gilding
76 in. high
The William Hood Dunwoody Fund
18.5

Bodhisattvas are Buddhist divinities
who have postponed entering nirvana
in order to help other beings. Kuan
Yin, the Bodhisattva of Mercy and
Compassion, was a favorite with
Chinese Buddhists. The Institute's
marble Kuan Yin dates to the Six
Dynasties period (221–581), a time of
economic depression and political
instability, during which three distinct
sculptural styles developed. This image
is of the type known as columnar,
characterized by monumental, full-
bodied forms and profuse, detailed
surface ornamentation. The elaborate
carved clothing, which includes jewelry
and scarves, signifies Kuan Yin's
temporal existence, whereas the lotus
bud held in the left hand symbolizes
purity and perfection. The figure was
originally painted and gilded. Its right
hand and the two guardian lions from
the back of the base are missing,
a result of vandalism during the reign
of Wu Ti, who prohibited Buddhism
in 574 and encouraged the desecration
of Buddhist images.

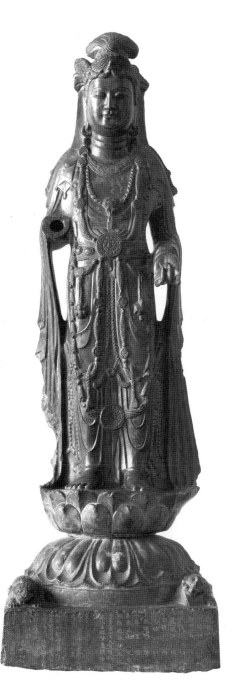

Chinese (T'ang dynasty)
Horse
About 725
Glazed white clay
20½ in. high
The Ethel Morrison Van Derlip
Fund 49.1.6

The aristocracy of ancient China built elaborate tombs supplied not only with food, furniture, and clothing, but also with companions and servants, so that nothing necessary or enjoyable would be lacking in the afterlife. During Shang times (1523–1028 B.C.), people and animals were killed and interred with their masters and mistresses, a practice known as immolation. But by the fourth century B.C., pottery figures (*ming-ch'i*) were being used instead, a change in custom that led to the production of mortuary ceramics like the museum's horse, which dates to the T'ang dynasty (618–906). It belongs to a group of ten figurines (excavated in 1948 from an imperial grave near Lo-yang) that is one of only two complete tomb retinues in Western collections. Like the other pieces in the set, the horse was cast in white clay from a mold and decorated with freely dripped blue, green, and caramel-colored glazes, a traditional T'ang technique called *san-ts'ai* (three-color). The lavish use of cobalt blue, instead of the ordinary straw-colored glaze, indicates that the retinue was commissioned by a wealthy family who could afford this rare and costly material. Besides providing the deceased with a steed in the afterlife — so he could ride into battle, play polo, or hunt — the horse figurine was a symbol of power and high social status.

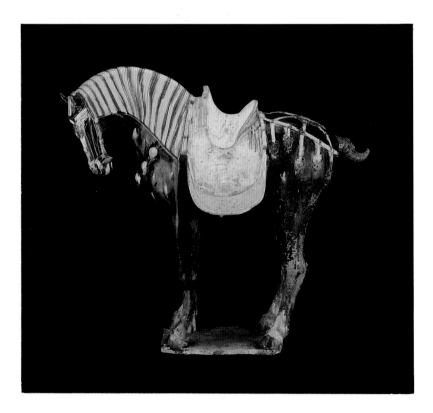

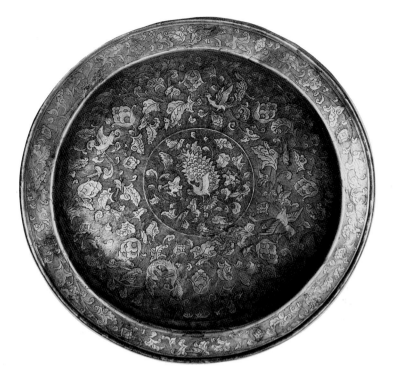

Chinese (T'ang dynasty)

Dish

About 8th century
Silver with chased and gilt decoration
Diameter 9¾ in.

Gift of Mrs. Charles S. Pillsbury, her son, Phillip Winston Pillsbury, and her daughters, Mary Stinson Pillsbury Lord, Katherine Stevens Pillsbury McKee, and Helen Winston Pillsbury Becker, in memory of Charles S. Pillsbury 51.28.3

Under the T'ang dynasty (618–906), China enjoyed a golden age of economic prosperity, artistic and literary accomplishment, religious toleration, and military might. Led by the capable Li Yüan, who ruled from 618 to 627, and then by his son Li Shih-min, the Chinese empire became the greatest power on earth, extending from Manchuria to Indochina and from the Caspian Sea to Japan. A trade route known as the Silk Road connected the capital at Changan with the Mediterranean cities of Antioch and Alexandria, and along this important thoroughfare goods and ideas passed between East and West. The museum's silver and gilt dish, though made by Chinese craftsmen for the imperial court, shows the influence of Middle Eastern techniques and motifs, particularly those of Sassanian Persia. Instead of being cast (the usual Chinese method), it was hammered from a thin sheet of silver, in the Persian manner. The delicately incised floral and bird arabesques resemble decoration found on Sassanian silver and textiles; but the technique of parcel gilding, which highlights the designs against the matte background, originated in China.

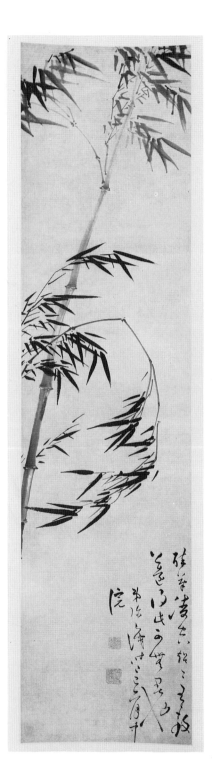

Shao Mi
Chinese, active 1620–60
Bamboo
1629
Ink on paper
47 × 12 in.
The John R. Van Derlip Fund 43.6

The Chinese tradition of literati paint-
ing — painting by cultured amateurs
rather than the professional artists of
the court or academy — began in the
eleventh century and continued to
flourish under the Ming dynasty
(1368–1644), especially in the city of
Su-chou, in the southern province
of Kiangsu. There, removed from
academic and court traditions, an aris-
tocracy well versed in Confucian
teachings employed its leisure in
scholarship, poetry, painting, and
calligraphy. These literati valued
subjective expression above repre-
sentational accuracy or technical
proficiency. They held landscape
painting in high esteem and particu-
larly favored pictures of bamboo, for
this plant, which bends but does not
break, symbolized the character of the
ideal Chinese gentleman. The simple,
sure strokes of this hanging scroll by
Shao Mi convey the suppleness and
strength of the bamboo and exemplify
the literati attitude toward painting. In
the lower right-hand corner, Shao Mi
writes: "The brush must be free and
unhindered / In order to achieve its
highest potential. / That accomplish-
ment, sir, can only be attained / Outside
the inkwell — in the mind of the artist."

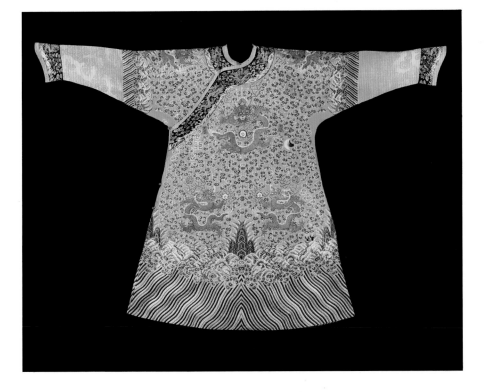

Chinese (Ch'ing dynasty)
Empress's Twelve-Symbol Robe
Late 18th–early 19th century
Yellow satin, embroidered with silk
and gold threads
51⅛ in. long
The John R. Van Derlip Fund 42.8.15

This robe was made for the wife of
Ch'ien-lung (ruled 1736–95), the ablest of
China's Manchu emperors and a prolific
painter, poet, and calligrapher. Defeat-
ing the native Chinese Ming dynasty,
the nomadic Manchu conquered China
in 1644 and held power until 1912.
During their reign, many of the artistic
and literary achievements of earlier
periods were collected, preserved, and
catalogued, and contemporary arts

thrived, especially jade carving and
textile making. The museum's robe of
yellow satin, cut in the Manchu style,
with side slits, narrow sleeves, and
"horseshoe" cuffs, is embroidered with
images of the universe (clouds, moun-
tains, and waves), nine five-clawed
dragons, twelve imperial symbols, and
numerous orange bats. The dragons
(associated with knowledge and benef-
icence) and the twelve symbols (here
representing kingly virtues) show that
this garment was meant for the royal
family. The numbers nine and five
were considered auspicious, and the
bats, too, were thought to bring the
wearer good luck. Used only for state
and religious ceremonies, robes such
as this have survived as brilliant
vestiges of the splendor of court life
under the Ch'ing dynasty.

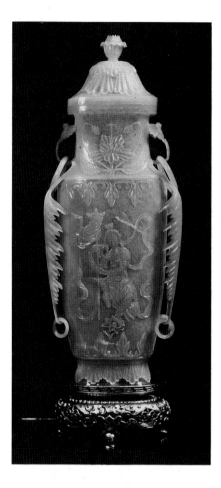

high luster. This white vase was carved from a single chunk of jadeite by means of abrasion, the traditional method of working that hard and extremely tough stone. Using wooden tools, the artist rubbed the jade block with sand made from an even harder substance, such as garnet or corundum. The domed cover and raised foot are adorned with fluted petals, and the neck is decorated with a pattern of poppies. One panel shows a bodhi-sattva (a Buddhist deity) in a billowing gown standing on a lotus blossom. On the other panel, the bodhisattva, balancing on the double wheels of the law, plays a horn. On each side of the vase is a long fern leaf. Completion of an object this large and intricate might take up to three years.

Chinese (Ch'ing dynasty)
Covered Vase
1736–95
White camphor jade
11 in. high

Gift of Mr. and Mrs. Augustus L. Searle 37.56

The Chinese consider jade the most valuable of all gemstones. They call it *yü*, which means precious, noble, and strong. The two types of jade, nephrite and jadeite, both had to be imported to China from central Asia, Siberia, or Burma. Nephrite is usually dark (brown, red, black, gray, or yellow) with a dull, waxy sheen, whereas jade-ite ranges from blue, emerald green, and mauve to pure white and has a

Japanese (Heian period)
Amida Nyorai
Late 12th century
Cypress wood with traces of lacquer and gilt
63½ in. high

The John R. Van Derlip Fund 78.20

The Buddhist religion has been a great force in Japanese life and art. From India, where it originated during the sixth and fifth centuries B.C., Buddhism spread to China in the first century A.D.; and from China it reached Japan, by way of Korea, in the sixth century. A Buddhist sect very popular in Japan during the Heian period (794–1185) was Jōdo (Pure Land), whose adherents worshiped the Buddha (Enlightened One) Amida Nyorai, the compassionate Lord of the Western Paradise. The Institute's cypress statue of Amida Nyorai, like many twelfth-century Japanese wood sculptures, was made by means of

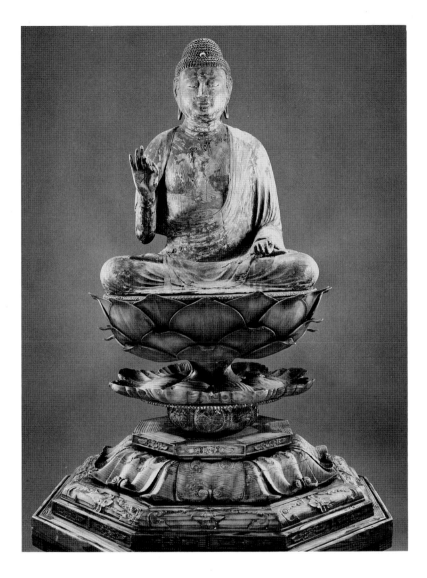

a technique called *yosegi*. Instead of using a single piece of wood, the sculptor formed the image from several blocks, which he carved, hollowed out, and then joined with pegs. This type of construction produced objects very light in weight relative to their size. The carved wooden surface was generally decorated with paint, lacquer, or gilt, applied over a coating of gesso. The gold leaf that covered the Institute's statue suffered extensive damage in a temple fire, and the original lotus-shaped pedestal was destroyed. (The present lotus, though not of the period, is appropriate in size and style to this Amida Nyorai.) The sensitively carved and well-preserved figure of Amida, sitting cross-legged in contemplation and making a symbolic gesture of welcome, is an excellent example of late Heian statuary.

Japanese (Kamakura period)
Taima Mandala
About 1325
Color and gold on silk
50½ × 46¹⁄₁₆ in.
Gift of Mary Griggs Burke in memory
of Jackson Burke 85.9

Buddhists see life as filled with
ignorance and suffering whose root is
desire: "The lust of the flesh, the lust
of life, and the love of this present
world." But the pain of existence—of
birth, disease, decay, and death—can
be overcome through meditation and
discipline leading to the attainment
of nirvana, a state of nonbeing that
brings to an end the successive
reincarnations all living things must
endure. A Buddha, an enlightened

one, has achieved this state of absolute
peace. Amida, the Buddha of Immea-
surable Light, offered the simplest way
to nirvana, and his cult was therefore
very popular. In this silk painting,
Amida is enthroned under an elaborate
canopy at the center of his paradise in
the west, known as Jōdo (Pure Land).
Kannon and Seishi, the bodhisattvas
of compassion and wisdom, sit beside
him. Behind him is a Chinese-inspired
palace; at his feet are a golden lotus
pond and a throng of worshipers.
The right and left borders contain
scenes of Amida's life, and illustrations
of the nine stages of spiritual attain-
ment occupy the bottom. This hanging
scroll is a rare copy of a famous
eighth-century tapestry owned by
the temple of Taima-dera in Nara.

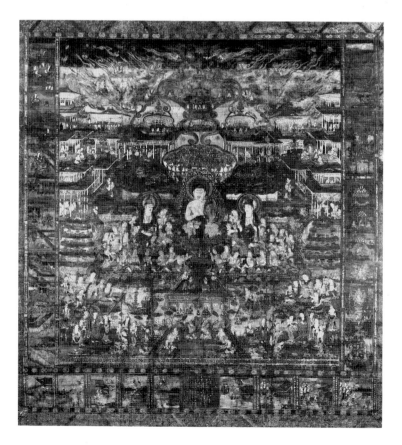

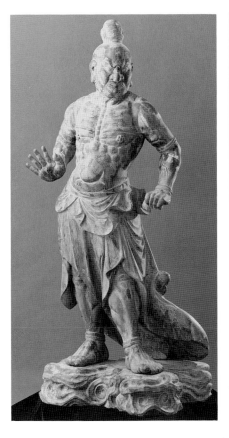 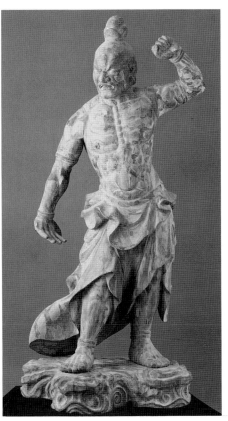

Japanese (Nambokucho period)
Pair of Guardian Figures
About 1360
Hinoki (cypress) wood with traces
of lacquer
76 in. high

Gift of the Regis Corporation
83.76.1,2

In the Nambokucho period (1333–92),
Japan was controlled by the samurai —
fierce and courageous warriors known
for their boldness in action and skill
in the martial arts. The qualities of
strength, energy, and daring admired
by the samurai can be seen in works
of art produced at that time. These
muscular guardian figures, Misshaku
Kongo (with raised fist) and Naraen
Kongo, represent overt power and
latent might. They would have been
placed opposite each other in a
Buddhist temple compound as protec-
tion against evil spirits. Large wooden
statues like these were constructed by
a multiple-block technique called
yosegi, which allowed sculptors to
create dynamic forms of great plasticity
on a monumental scale. Both figures
were originally covered with black
lacquer applied over a gesso ground.

Yamada Yorikiyo (called Doan)
Japanese, 1520?–71
Tiger and Dragon
About 1550
Ink on paper
65 × 141 in. each

Gift of Mr. and Mrs. Charles H. Bell, the James Ford Bell Foundation, the Aimee Mott Butler Charitable Trust, the Centennial Gala Committee, and the Carl A. Weyerhaeuser Charitable Trusts 83.75.1,2

The development of the freestanding folding screen (*byōbu*) was one of Japan's great contributions to pictorial art. These lightweight, portable screens functioned indoors as room dividers and outdoors as windbreaks. Constructed of paper or silk on a hinged and lacquered frame, *byōbu* generally had six panels and were made in pairs, providing a large surface for continuous horizontal decoration. The paintings were usually done separately and then pasted onto the panels. Doan, a Zen monk, was well known for his bold compositions and energetic brushwork. Like most other painters of the Muromachi period (1392–1568), he worked solely in black ink. This dramatic set of screens portrays a tiger in a landscape of rocks and bamboo and a dragon in a swirling mass of clouds and waves. These two animals, the most important in Japanese and Chinese Buddhist art, are associated with wind and water. Together they represent the elemental creative forces of the universe.

Kei Sesson
Japanese, 1504–89
White Herons in Plum and Willow
About 1575
Ink on paper
69½ × 144 in. each
Gift of Mr. and Mrs. Richard P. Gale 65.7.1,2

The Buddhist sect called Zen, which originated in China, emphasizes meditation, discipline, and self-reliance. Zen became a major influence in Japan during the Muromachi period (1392–

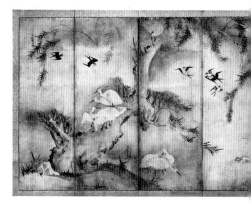

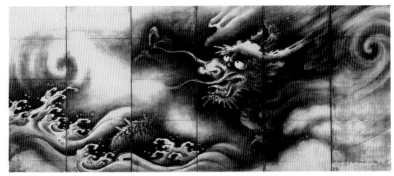

1568). In a time of political confusion and constant warfare, Zen monasteries flourished as centers of learning, and Zen priests were the leading artists of the age. Along with garden designing, flower arranging, and the tea ceremony, monochrome ink painting, called *suiboku-ga*, was a Zen-inspired art. The spare, elegant *suiboku* paintings were done on paper or silk, usually in black ink only. Kei Sesson, a Zen priest, spent most of his career in northeast Japan as an itinerant preacher and painting instructor. In this pair of folding screens, executed with the fluid, energetic strokes typical of his style, Sesson depicted motifs that refer to spring and summer and to virtues of the ideal Zen monk. The blossoming plum alludes to the coming of spring, and the willow tree is associated with summer. The two carp signify tenacity and strength; the herons, purity and longevity; and the swallows, prosperity and success. These screens— among the finest examples of Sesson's work outside of Japan—are the most important Japanese paintings in the museum's collection.

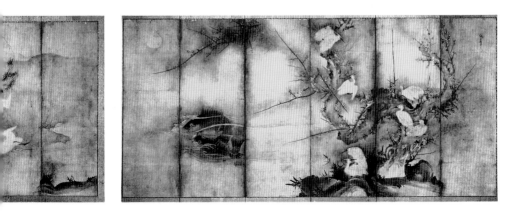

Tawaraya Sōtatsu
Japanese, died 1643
*Nobles Viewing the Nunobiki
Waterfall*
About 1634–43
Color on paper
9⅞ × 8⅛ in.
The John R. Van Derlip Fund 66.40

The black-and-white images of the
Muromachi priest-painters were super-
seded in the Momoyama (1568–1615)
and early Edo (about 1615–1700)
periods by boldly patterned, lavishly
colored paintings. Tawaraya Sōtatsu
was a master of this highly decorative

new style and with Hon'ami Kōetsu is
regarded as the founder of the Rimpa
school of painting. Little is known
about Sōtatsu's life, but his works are
distinguished by their daring compo-
sition, supple brushwork, and fresh
coloration. In this small album leaf, he
combined bright blues and greens with
touches of gold to illustrate an episode
from the *Ise Monogatari* (Tales of
Ise). This literary classic of the tenth
century describes the travels of a
Japanese man through his homeland.
In the scene represented here, he visits
Nunobiki Falls with a group of friends,
and the magnificent view inspires
one of them (an assistant guards com-

mander) to compose the poem that appears in the upper left-hand corner of Sōtatsu's painting: "Which I wonder is higher / This waterfall or the fall of my tears / As I wait in vain / Hoping today or tomorrow / To rise in this world."

Kaigetsudō Ando
Japanese, 1671–1743
Standing Courtesan
About 1710
Ink and color on paper
31½ × 11½ in.
Bequest of Richard P. Gale 74.1.29

During the Edo, or Tokugawa, period (1615–1868), Edo (present-day Tokyo) displaced Kyoto as the center of Japan's political, economic, and cultural life, and in this remote fishing village turned metropolis, a wealthy merchant class arose. These self-made men spent their free time in the Yoshiwara district of the city, where their money bought them amusements of all kinds: the performances of Kabuki actors and dancers, the antics of sumo wrestlers and puppeteers, and the company of elegant women. The most popular courtesans, admired for their beauty, intelligence, and charm, were idealized in mass-produced paintings and prints, which the bourgeoisie eagerly purchased. The delicate creature in this hanging scroll poses seductively against a neutral background, coyly turning away her face to show her flawless, graceful neck and suggestively lifting her sumptuous kimono to display it to best advantage. Such portrayals of beautiful women are called *bijin-ga*. They belong to the tradition known as Ukiyo-e (pictures of the floating world), which celebrates the transitory pleasures of life.

Japanese (late Edo period)
Karaori (Outer Noh Robe)
About 1825
Silk brocade
63 in. long

The Ethel Morrison Van Derlip Fund
81.90.2

According to Japanese legend, Noh drama began when a god descended from a sacred pine tree and entered into an actor, causing him to dance. Historically, Noh (literally, talent or skill) originated during the fourteenth and fifteenth centuries as an outgrowth of the popular theatricals called *sarugaku*, which were performed outside Shinto shrines and Buddhist temples. But Noh soon developed into a high art form and an entertainment for aristocrats. It was a drama of stylized movements and gestures, music and dance, tragedy and redemption. Performances were staged at court by all-male troupes wearing carved wooden masks and dressed in exquisite silk robes. The type of costume known as *karaori* (Chinese weave), because its prototypes were elaborate brocades imported from China, was worn only for female roles. The bold design of this robe—flowers, grasses, and vines on a latticework of bamboo—was created entirely on the loom, by means of a float-weave technique. The numerous chrysanthemums and bunches of grapes in the pattern indicate that the play was probably set in autumn.

Korean (Yi dynasty)
Storage Jar
17th century
Stoneware with iron underglaze
16¼ in. high

Gift of an anonymous St. Paul friend
81.113.6

During the five-hundred-year reign of the Yi (1392–1910), Confucianism supplanted Buddhism as Korea's state-approved religion. More an ethical and moral code for daily conduct than a theology, Confucianism stresses the importance of a simple, austere life. The Confucian preference for the modest and the unpretentious can be seen in Yi ceramics, pottery very different from the sophisticated celadons of the preceding Koryo dynasty (918–1392). Yi wares are sturdy utilitarian vessels—jars, bottles, and bowls of all shapes and sizes—that were meant for everyday use in even the most ordinary households. This tall white stoneware pot, decorated with a dragon motif to bring the owner good luck and long life, was made for storing grain. Yi ceramics were collected by Japanese connoisseurs and tea masters of the sixteenth and seventeenth centuries, who admired their bold designs and pleasing shapes.

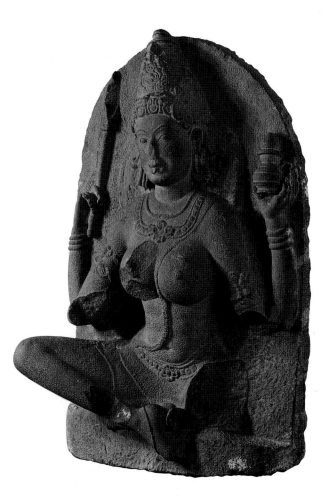

Indian (Chola period)
Saptamātrikā
10th century
Gray granite
45 in. high
The Christina N. and Swan J. Turnblad
Memorial Fund 60.21

Buddhism underwent a decline in
sixth-century India, and Hinduism
once again became the dominant
religion and the main inspiration for
Indian art. In contrast to the austere
and restrained images fostered by
Buddhist thought, Hindu art is robust
and sensuous, charged with an appre-
ciation of life and its pleasures. This
sculpture from the Deccan region of
southern India represents one of the
seven mother goddesses (*saptamātri-
kās*) of Hindu theology. They are the
shaktis of the great gods—female
personifications of the gods' dynamic
energy. This one may be Brahmani,
the shakti of Brahma, since the duck
incised on the base of the stone under
her right ankle is one of his attributes.
In her left hand she holds a water
vessel containing the primordial sub-
stance of life, in her right hand a mace,
a sign of her power and royal authority.
Large-breasted and voluptuous, she
promises fertility and regeneration.
This energetic combination of the
earthly and the spiritual, the human
and the divine, has always been
fundamental to Hindu art.

Indian (Chola period)
Siva Nataraja
11th century
Bronze
28 in. high
Gift of Mrs. E. C. Gale 29.2

Brahma the creator, Vishnu the preserver, and Siva the destroyer are the most important gods in the Hindu pantheon. To his worshipers, Siva embodies all cosmic activity—creation, destruction, reincarnation, and salvation. As Siva Nataraja, Lord of the Dance, he creates the cadence of the universe. His four long arms, a sign of divinity, are poised in midair. In one hand he holds the flame of destruction, in another, the drum of creation; with his second left hand he points to his raised foot, the refuge of the soul, while with his other right hand he makes the open-palmed gesture of reassurance. Beneath his right foot, he crushes the dwarf Muyalaka, demon of evil and ignorance. Cast bronzes like this were among the great artistic achievements of India's Chola period (850–1310). During religious ceremonies, they were often taken from their temple niches and paraded through the streets. Carried on poles high above the crowd, Siva presided over the festivities, reminding the faithful of the cyclical nature of existence and of the need to do good in this lifetime in order to attain a higher caste in the next.

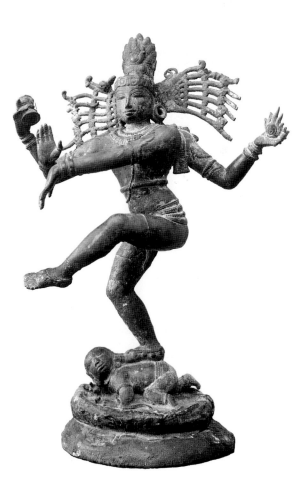

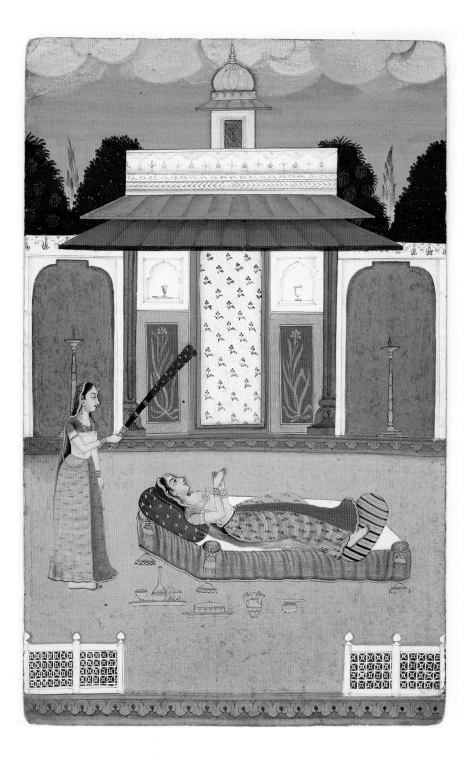

Indian (Bikaner school)
Courtyard Scene
Early 18th century
Color and gold on paper
8¾ × 5⁹/₁₆ in.

The Ethel Morrison Van Derlip Fund
79.17

The Muslim invasions of northern India and the Deccan, which began in the year 1000 and lasted for several centuries, hindered the production of sculpture there but led to a flowering of miniature painting. Persian painters were brought to India, especially in the late sixteenth and early seventeenth centuries, during the reigns of Akbar and his son Jahangir. The influence of the elegant, highly decorative Persian manner on the gentle naturalism of native Indian art resulted in the Mughal court style, which spread to the provinces and for the next three hundred years continued to be shaped by local traditions and Hindu patronage. In the desert state of Bikaner, to the west of Delhi, the Rajput school of painting assimilated the Mughal preference for intricate detail. Rajput painters favored brilliant primary colors and usually depicted subjects from Hindu epics and mythology. This finely drawn miniature, painted in vivid reds, greens, and purples, shows an intimate scene in which a young woman awaits the arrival of her lover. Beneath a bright sky of gilt clouds, she reclines on a couch in an open courtyard while a servant fans her with peacock feathers.

Cambodian (Khmer style)
Head of a Buddha Image
Late 12th century
Sandstone
12 in. high

Bequest of Alfred F. Pillsbury
50.46.222

Of all the regions in Southeast Asia that fell under the spell of Indian art and culture, Cambodia came the closest to developing a sculptural style uniquely its own. Beginning in the ninth and tenth centuries, Cambodian sculpture—whether a giant stone relief of the bodhisattva Lokesvara at Angkor Thom or a small, freestanding bronze of the god Vishnu from Angkor Wat—exhibits certain characteristics that became standard. They can be seen in this sandstone head of the Buddha from Lopburi, with its square face, broad forehead, flat nose, continuous eyebrows, downcast gaze, and smiling lips. With statues such as this, expressing the bliss of nirvana, Cambodian art reached a peak, but it declined after the Khmer rulers were defeated by the Thai in 1431.

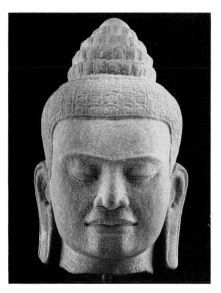

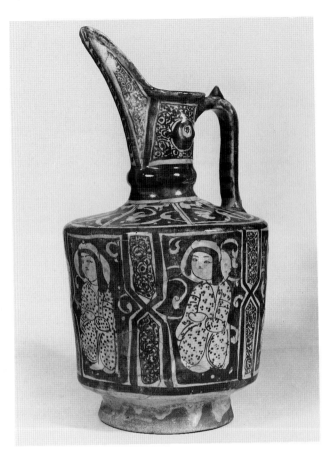

Persian (Kashan ware)
Ewer
13th century
Earthenware with golden luster decor
13 in. high
Bequest of Alfred F. Pillsbury
50.46.437

With Hinduism and Buddhism, Islam
is one of the principal religions of
the Eastern world. Established by the
prophet Muhammad early in the
seventh century, it spread westward
from Arabia to northern Africa and
Spain and eastward to India, China,
and Indonesia. Despite their ethnic and
political differences, Muslims share
a belief in one god, Allah, whose
revealed word is set forth in the Koran.
Islamic art, too—be it a mosque in

Iraq, a carpet from Iran, or a candle-
stick from Egypt—has certain dis-
tinctive features in common, such as
overall surface decoration and the use
of stylized plant motifs called ara-
besques. This Persian water pitcher
has small floral arabesques on the body
and spout and large scrolling vines on
the shoulder and as background to the
kneeling figures. The metallic finish
was achieved by a technique called
luster painting, first used on glass but
adapted to ceramics by Islamic potters
of the ninth century. Compounds of
silver and copper were applied to a
tin-glazed vessel, which was then fired
again. During the second firing, chemi-
cal reactions occurred that produced
a glossy surface resembling metal,
giving the appearance of more expen-
sive objects in gold and bronze.

Egyptian (Mamluk period)
Page from the Koran
Mid-14th century
Ink, color, and gold on paper
$11^{13}/_{16} \times 8^{13}/_{16}$ in.

Bequest of Margaret McMillan Webber in memory of her mother, Katherine Kittredge McMillan 51.37.21

Calligraphy became one of the most highly regarded art forms in the Muslim world. Since Islam forbade as idolatrous the use of human or animal images in a religious context, lettering was widely used to decorate objects of all sorts, from buildings to manuscript illuminations, textiles, ceramics, glassware, and metalwork. The Koran, written in classical Arabic, was copied over and over, with geometrical and floral motifs highlighting the beauty of the writing. This handsome page, composed in black ink in an elegant Thuluth script, consists of the final lines from sura 37 and the heading and opening passages of sura 38. The words "glory" and "God" and the phrase "Glory be to the Lord" are in gold, and the end of each verse is marked by a colored rosette. In contrast to the fluid dark lettering of the text, the heading is painted in white and embellished with red, blue, and gold floral patterns. Delicate rules of black and gold form a border around the page. Books like this were made by several skilled artisans—a calligrapher, an illuminator, and a binder—working at the behest of a wealthy patron.

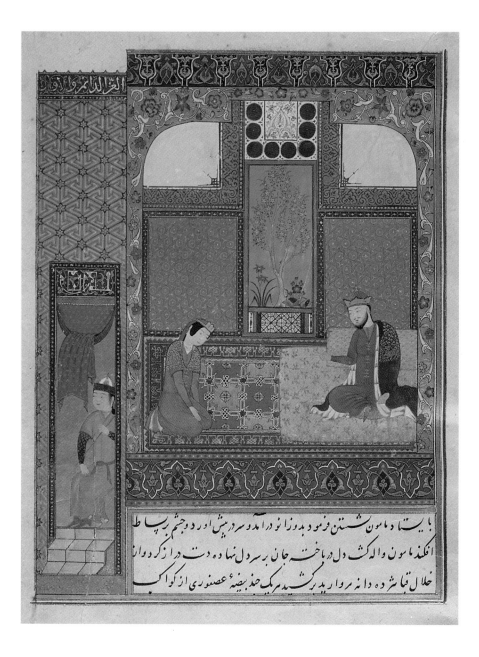

Persian (Herat school)
*A Court Scene from
the "Chahar Maqaleh"*
About 1431
Ink, colors, and gold on paper
5⁷/₁₆ × 4³/₁₆ in.

Bequest of Margaret McMillan Webber
in memory of her mother, Katherine
Kittredge McMillan 51.37.30

Although Islamic teaching prohibited
the figural decoration of religious texts,
secular works were often illustrated
with scenes of people and daily life.
Persian miniatures, in particular,
depict historical events and episodes
from literary epics and romantic tales
with a grace and an attention to detail
rarely equaled. This painting is from a
manuscript commissioned in 1431 by
Baysunghur Mirza, a grandson of the
infamous Mongol conqueror Timur
(Tamburlaine). It was part of a treatise
entitled *Chahar Maqaleh* (Four Dis-
courses), about the attributes desirable
in a Muslim prince and his advisors.
The virtue of forbearance is exempli-
fied in a story about a ninth-century
Abbasid caliph and his bride. The
manuscript leaf shows the young
husband, eager to consummate the
marriage, and his shy wife, entreating
him to be patient. Their sumptuously
appointed room has tiled floors, rich
carpets, gilt wall paintings, and a view
of a flowering garden. Complex
colored patterns fill every inch of the
painted surface — a feature typical of
Islamic art.

The Art of Africa, Oceania,
and the New World

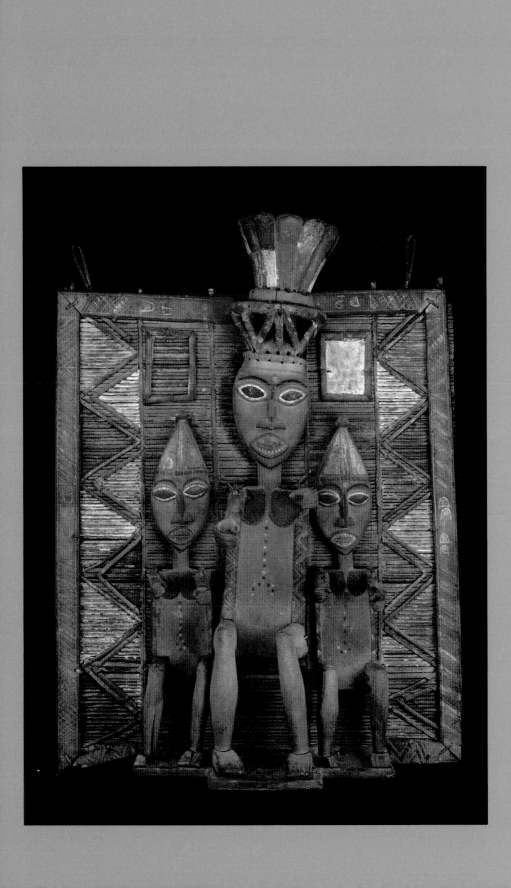

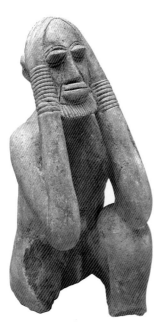

gifts of food helped secure the future of later generations. These practices were common until the late nineteenth century, when the pressures of European colonialism, trade, and missionary work caused them to decline.

African, Mali (Djenné region)
Equestrian Figure
14th–17th century
Wood
28¾ in. high

Gift of the Aimee Mott Butler Charitable Trust, Anne S. Dayton, Mr. and Mrs. Donald C. Dayton, Mr. and Mrs. William N. Driscoll, Clarence G. Frame, and Mr. and Mrs. Clinton Morrison 83.168

African, Mali (Djenné)
Seated Figure
13th–15th century
Terra-cotta
8½ in. high

The Hershey Foundation Fund 78.66

For centuries, Islamic merchants from north of the Sahara traversed West Africa, trading salt, cloth, and copper for Sudanese goods—palm oil, ivory, and especially gold. In fact, until the discovery of the Americas in the late fifteenth century, the ancient kingdom of Ghana was the largest supplier of gold to the Near East and Europe. This clay sculpture dates to a time when the city of Djenné was a thriving intellectual and commercial center. Statuettes, along with vessels containing cooked millet and rice, were buried outside villages, in groves that functioned as memorial parks. Such figurines were probably commemorative offerings honoring a dead ancestor. Since ancestors were revered not only as progenitors of the tribe but also as overseers of the present, venerating them with ceremonies and

Three times the size of the United States, Africa is a vast and diverse continent of deserts, savannas, and forests. Its population, too, is immensely varied, racially, linguistically, and culturally. The peoples of West Africa, inhabiting the lands drained by the Niger and Congo rivers, became well known to Westerners for their masks and religious figures, but the existence of a long tradition of royal art is often overlooked. This statuette from the region of Djenné, in the western Sudan, is one of the oldest extant wooden pieces from sub-Saharan Africa. It may have been carved as an elaborate stopper for a large gourd container, or calabash. It represents a mounted warrior in short pants and skullcap, carrying a bow in his left hand, a sheathed dagger on his left arm, and a cylindrical quiver on his back. Horses were rare in the African empires south of the Sahara, and only kings and their cavalries were allowed to possess them. The small size of this one relative to its rider indicates that the person is of exceptionally high status, probably a royal ancestor of an ancient Malian people.

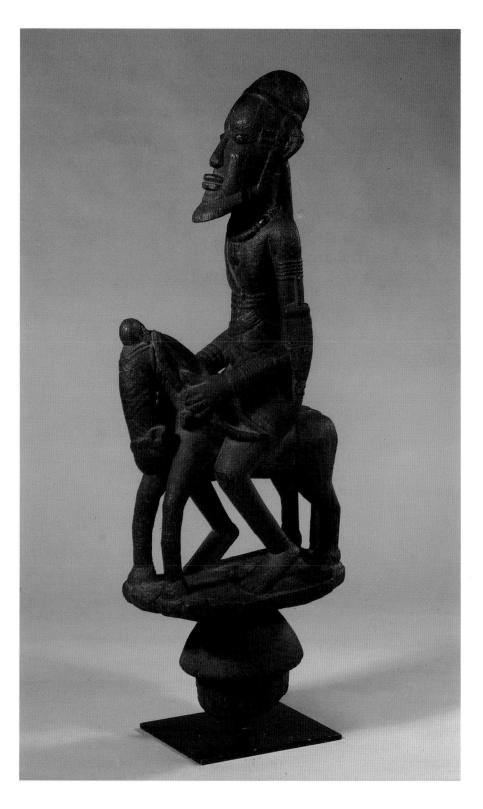

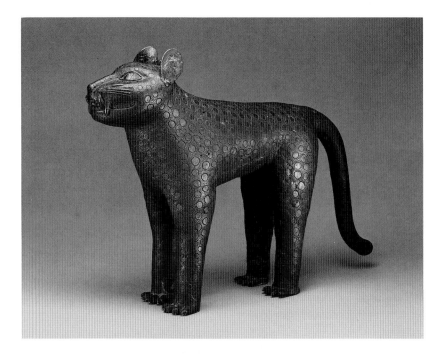

African, Nigeria (Benin)
Leopard
17th century
Bronze
17 in. high
Miscellaneous Works of Art Fund
58.9

In 1485, when the Portuguese first
arrived in western Nigeria, the city
of Benin governed several hundred
villages inhabited by the Bini people.
It was the center of a highly organized
administration headed by the Oba,
a king thought to be the reincarnation
of the original ruler and hence con-
sidered divine. As the supreme politi-
cal, economic, and spiritual leader, the
Oba was involved in countless religious
and state ceremonies that required
costumes, jewelry, and ritual para-
phernalia of all kinds. To supply
such objects, he kept guilds of skilled
carvers and metalworkers at the capital
and forbade them to fashion bronzes

or ivories for anyone outside the royal
household. The museum's bronze
leopard is a product of this court tradi-
tion. Modeled on Islamic prototypes
known to the Bini through trade, it is
an aquamanile, a vessel designed to
hold water for washing the hands, and
can be filled through a hole in the top
of its head and emptied through the
nostrils. It would have stood on the
Oba's ancestral altar, to be used on
ceremonial occasions. Known as a
predator of courage, strength, and
cunning, the leopard became a symbol
of the Oba. Tame leopards, kept at the
palace, always accompanied imperial
processions; leopard skins could be
worn only by the Oba and those
having his permission; and if a hunter
killed a leopard in the field, he had to
report to the nearest village chief and
swear that it was a "leopard of the
bush," not one "of the house." Like
the court art of Benin, the leopard
belonged to the king and signified
his superior lineage.

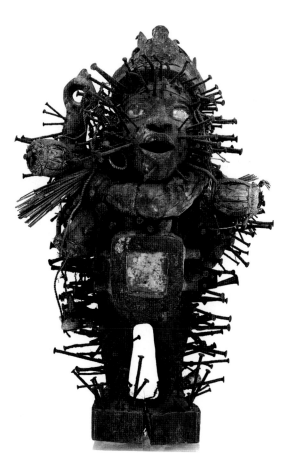

African, Zaire (Kongo)
Nail Figure
19th century
Wood, metal nails and blades
15¾ in. high
The Christina N. and Swan J. Turnblad
Memorial Fund 71.3

An integral part of ceremony and
ritual, African art embodies a tribe's
traditional values and beliefs. Among
the Kongo people, nail figures, or *min-
kondi*, were sacred objects that helped
cure illness, settle disputes, seal agree-
ments, and destroy wrongdoers. Their
power came from magical substances
placed in sealed cavities in their heads
or stomachs. These medicines attracted
spirits that did the bidding of the
figure's owner or client when prodded

into action by a nail or blade driven
into the image. The museum's nail
figure was made in the late nineteenth
century. Its tense, open mouth, a typical
feature of *minkondi*, expresses
the ferocity of the spirit within. It is
covered with nails and other parapher-
nalia—shells, string, pieces of bone,
and extra packages of medicine—which
were added during the course of its
use. The clusters of nails wrapped
together in leaves and raffia cords
were part of a ceremony to stop a
disease or infection, the bound nails
symbolically restraining the cause of
the affliction. The nails that are
entwined with string or wicker may
have been attached during a rite of
reconciliation, tying a person to
a promise or binding an agreement.

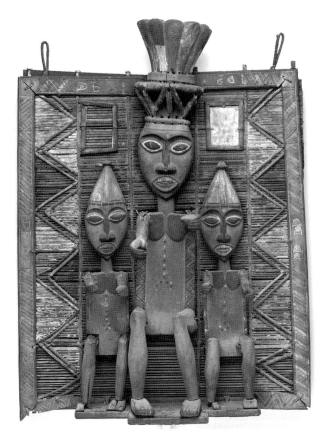

African, Nigeria (Ijaw)
Duein Fobara (Memorial Screen)
19th century
Wood, raffia, and traces of paint
37½ × 28 in.
The John R. Van Derlip Fund 74.22

The Ijaw-speaking people from the swampy deltas of coastal Nigeria believed that their ancestors remained active in community and family affairs. To honor the spirits of their most important citizens and give them a place to reside, the Kalabari Ijaw fabricated elaborate wooden and raffia memorial screens. Such a screen is called a *duein fobara*, or "forehead of the dead." The Institute's was collected in the village of Abonnema early in the twentieth century and was once

owned by the British Museum. Like most such pieces it is dominated by a large central figure, symbolizing the ancestor (probably a chieftain), wearing the headdress of a masquerade society. Next to him sit two of his kinsmen-followers, both smaller because of their inferior status. The identifying objects that they all once held in their outstretched arms—canoe paddles, fly whisks, fans, and machettes—are now missing, as are the small heads that were pegged into the top to represent the numerous dependents this leader once had. The mitered joints and the lettering on the frame attest to a strong European influence, a result of the Kalabari's prosperous slave trade with the Dutch and Portuguese.

African, Nigeria (Yoruba)
King's Crown
19th century
Beads, leather, canvas, and wicker
30 in. high
The Ethel Morrison Van Derlip
Fund 76.29

The Yoruba of western Nigeria consti-
tute one of the largest tribes in Africa.
Prolific and versatile artists, they are
skilled at making masks; cult figures of
wood, bronze, terra-cotta, and iron;
carved houseposts and doors; and
beaded objects and garments. Their
beadwork, in particular, flourished
during the nineteenth and twentieth
centuries, when large quantities of
European "seed beads" (small trade
beads in a multitude of colors) first
became readily available to them. The
use of beaded accessories, however,
was restricted to kings, priests and
priestesses, and herbalist-diviners, and
only kings could enjoy the full range of
beaded regalia: slippers, fans, fly
whisks, footrests, canes, staffs, thrones,
and crowns. This headdress, with its
veil and gathering of birds, is known
as an *adenla* (great crown). A sign of
the king's divinity and authority, it was
worn only for ceremonial occasions.
The vertical scarification markings on
the face at the front of the headgear
identify the ruler's lineage, and the
birds, an age-old reference to super-
natural power, symbolize his ability
to deal with the forces of evil and
darkness. For fear of blindness, the
king could not look at the inside of his
crown with its pouch of magical herbs,
and the layman was protected from
the face of a living god by the heavily
beaded veil.

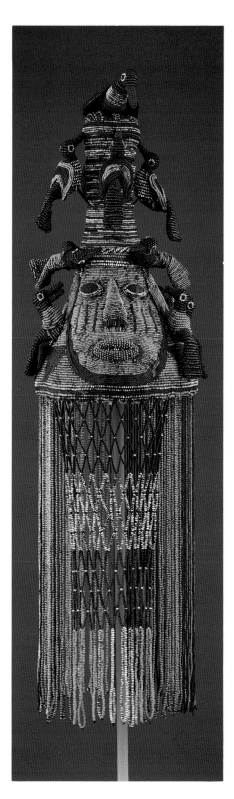

Melanesian, Papua New Guinea
(Astrolabe Bay)
Mask
19th century
Wood
21½ in. high
The Ethel Morrison Van Derlip Fund
78.8

The peoples of northeastern New
Guinea have a legend about an evil
spirit variously called Asa, Ai, Barak,
or Balum. One day, while the villagers
were out tending their gardens, Asa
stole into their houses and devoured
their children. Upon their return, the
men avenged the children's deaths by
burning Asa in his hut, and from his
charred bones grew coconuts and
other plants. This is the spirit personi-
fied by the museum's mask from
Astrolabe Bay. During initiation
ceremonies for boys of the Astrolabe
Bay area, a dancer wearing an Asa
mask and a grass costume would
appear to the sound of music that was
supposed to imitate the spirit's voice.
The "reincarnated" Asa would then
symbolically eat his victims by "biting"
their penises (i.e., circumcising them,
usually with an obsidian blade). This
ritual death was followed by a period
of seclusion, after which the boys
"came back to life" as adult men.

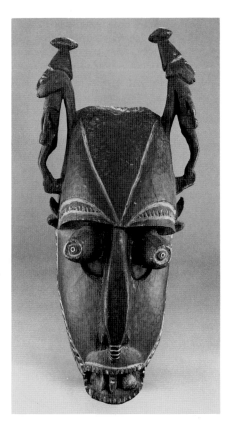

Melanesian, Papua New Guinea
(New Ireland)
Malagan Pole
19th century
Polychromed wood
101 in. high
Gift of the Morse Foundation 68.9.3

Melanesia—the group of South Pacific islands that includes New Guinea, New Caledonia, the Solomons, and Fiji—is one of the three cultural regions of tropical Oceania. This intricately carved and brightly painted column is from the island of New Ireland, in the Bismarck Archipelago. The term *malagan* refers to sculptures like it and also to the elaborate ceremonies staged by the New Irelanders to commemorate their ancestors, both the recently departed and the long dead. *Malagan*s were held months or years after the death of an important clan member. Days of dancing, feasting, singing, and speechmaking culminated in the dramatic unveiling of many large wooden sculptures, which had been hidden in enclosures near the burial grounds. The Institute's *malagan* pole, over eight feet high, is dominated by two large figures: a male crouching on the tail feathers of a frigate bird occupies the upper half, and a female standing on the head of a wild boar fills the lower portion. The birds, boars, fish, and other animals depicted on such poles are related totemic emblems that refer to air, earth, and water. The soft, lightweight wood used for *malagan*s lent itself to detailed carving and openwork, and it decayed quickly when the sculptures were discarded and left to rot after the festivities concluded.

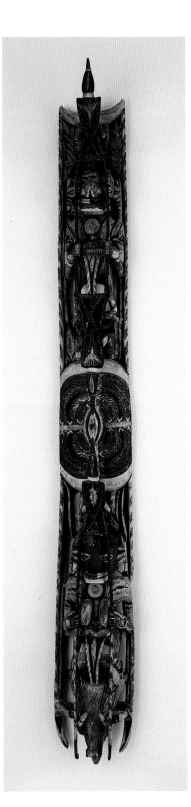

Australian (aboriginal)
Churinga
19th century
Stone with traces of red ocher
10¾ in. high
The Christina N. and Swan J. Turnblad
Memorial Fund 72.16

Although their material culture and
nomadic way of life were extremely
simple, the aborigines of central and
northern Australia had a complex
and esoteric religion. They believed in
countless animate and inanimate ances-
tral beings, or "Dreamings," which in
the distant past (the "Dream Time")
had traveled over the earth, forming
its topography, creatures, and institu-
tions. Myths concerning the ancestors
and their primeval wanderings were
recorded on stone or wood slabs
ranging from a few inches to ten feet
high. Known as *churinga*s, these were
abstract renderings of the myths, often
taking the form of "maps" of pri-
mordial space. Only the initiates of the
group to whom they belonged knew
their meaning. The Institute's stone is
incised on both sides. The concentric
circles at the center can be interpreted
as the place at which the Dreaming
emerged from the ground to begin its
epic journey and to which it finally
returned. During ceremonial dramati-
zations of the ancient times, *churinga*s

were rubbed with grease and ocher
and "read." When not in use, they
were wrapped in cloths and kept
in secret places known only to the
men of the tribe. Women or children
who accidentally saw them were put
to death or blinded.

Mesoamerican, Mexico (Nayarit)
House Group
200 B.C.–A.D. 300
Polychromed terra-cotta
18½ in. high
The John R. Van Derlip Fund 47.2.37

Most surviving pre-Columbian art
comes from grave sites and thus tells
us a good deal about the burial prac-
tices of the ancient peoples who
created it. The native populations at
Nayarit, Jalisco, and Colima, in west-
ern Mexico, placed terra-cotta vessels
and figurines with their dead to ensure
continuity between life on earth and
life after death. Furnishing a tomb
with models of the familiar—men,
women, and children, and even entire
miniature villages—guaranteed that
the afterlife would be much the same
as mortal existence. Among the
tomb figures that have been found are
soldiers, acrobats, ball players, musi-
cians, and scenes of people involved in
daily activities. The museum's house
group, an unusually elaborate Nayarit
work, displays the naturalism and
vitality for which these funerary genre
pieces are known. It consists of a
lavishly painted dwelling inhabited
by eleven figures in various poses—
lounging, eating, embracing, making
tortillas. Because multistoried build-
ings were uncommon in western
Mexico at the time this sculpture was
made, it seems probable that the two
stories represent two levels of reality:
the open, airy world of the living
above and the closed, shadowy realm
of the dead below.

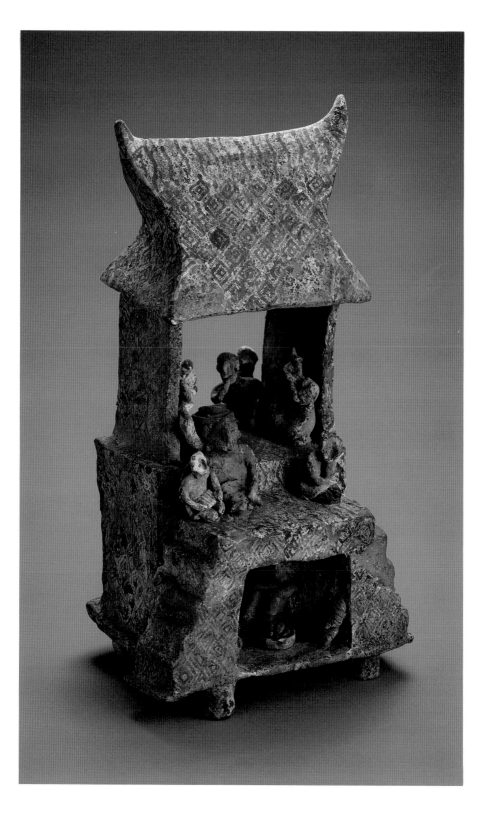

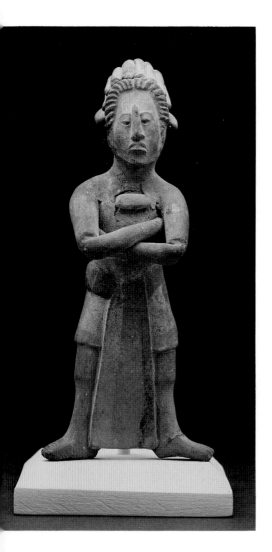

Mesoamerican, Mexico,
Island of Jaina (Maya)
Standing Male Dignitary
8th–9th century
Polychromed clay
7½ in. high
The John R. Van Derlip Fund 47.2.5

The small island of Jaina, in the Gulf
of Mexico off the coast of Campeche,
is the site of the largest known Mayan
necropolis. Between the sixth and
tenth centuries, over twenty thousand
people were buried there in shallow
pits. The corpses were either laid flat
in the ground or, more commonly,
arranged in a squatting or fetal posi-
tion, with the knees drawn up to the
chin. Sometimes they were painted red
with iron oxides, and occasionally a
small jade bead was put in the mouth.
Pottery vessels and small figurines, as
well as jewelry of stone and shell, were
often deposited with the body, and a
heavy ceramic bowl was inverted over
the head to protect it. Infants were
interred in large clay pots with lids.
The Institute's terra-cotta figurine
would have been set on the deceased's
chest or arms. Its ceremonial regalia
indicate that it represents a person of
high rank. Hollow, and perforated on
the back and shoulder, the figure can
be blown like a whistle.

Mesoamerican, Costa Rica
(Chiriqui or Diquis)
Figure of a Man with a Rattle
About 11th–15th century
Cast gold
2⅜ in. high
The Christina N. and Swan J. Turnblad
Memorial Fund 53.2.8

The art of metalworking, known in
Peru since the first millennium B.C., was
not practiced in lower Central America
(Nicaragua, Costa Rica, and Panama)
until about A.D. 500. Peruvian gold-
smiths generally hammered metal into
smooth, thin sheets, but the craftsmen
of Central America preferred casting.
They made a wax model and encased
it in clay, which dried to a hard shell.
Molten metal poured into this clay
mold caused the wax to melt and flow
out built-in vents. After the metal
cooled, the mold was broken, freeing
the object, which would then be
finished with chiseling and hand
polishing. This process was used
to create the museum's small gold
pendant from south central Costa Rica.
Like others of its type, it would have
been suspended from the wearer's neck
by a string inserted through loops
soldered to the back of the ornament.
This exquisite piece of jewelry was
buried in a grave near the town of
Buenos Aires and thus escaped the
ravages of the Spanish conquest.

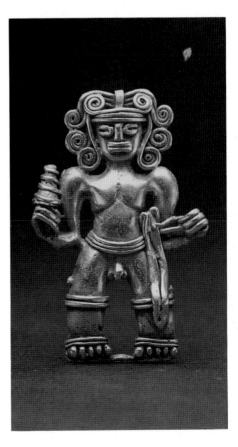

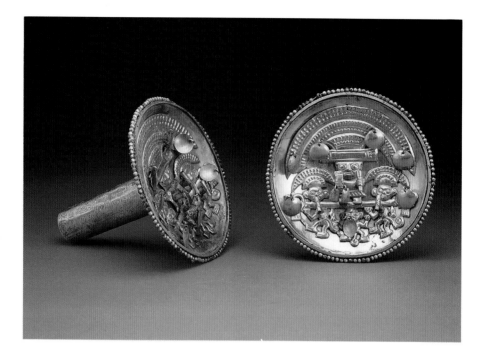

South American, Peru (Chimu)
Earspools
1000–1450
Gold
5 in. long
The William Hood Dunwoody Fund
43.4.1,2

The Spanish conquest of the New World began in the early sixteenth century and with it the systematic plundering of the Americas' wealth of gold and silver. Objects of every kind—temple decorations, ceremonial vessels, imperial treasures, and personal jewelry—were collected by the thousands, melted down, and exported to Europe as bullion stamped with the royal crown of Spain. Almost the only valuable items to escape the conquistadors' greed were those buried with the dead or hidden in secret caches. Ear ornaments were a coveted mark of distinction among the ancient Peruvians. These gold earspools, made by the Chimu people of the northern coastal area, are of a type reserved for kings or priests. Such a personage is shown at the center of each earring. Wearing a bespangled headdress and holding a ritual beaker and bag, he stands on a dais supported by several smaller figures that are part human and part monkey. An engraved frieze of cats and birds winds around the entire length of the cylindrical tubes, or "posts." When in place, the earspools would have been drawn to the back of the wearer's neck and tied together for greater stability.

North American, Canada (Haida)
Shaman's Rattle
19th century
Wood, leather, and haliotis shell
12½ in. long
The Christina N. and Swan J. Turnblad
Memorial Fund 75.55

The Northwest Coast Indians inhab-
ited an area extending about twelve
hundred miles along the Pacific coast
of North America, from Yakutat Bay,
in southeastern Alaska, to northern
Oregon. The rain forests and rivers of
this humid region provided abundant
fish and game, a ready food supply that
enabled the Indians to establish per-
manent settlements without becoming
agriculturalists. They developed a
variety of art forms, from totem poles
and houseposts to decorated chests,
bowls, and canoes. The Institute's
cedar rattle, carved by the Haida of
the Queen Charlotte Islands, British
Columbia, was once the personal
property of a shaman. Because of
their power to cure illness, control the
weather, and protect against witches,
shamans had immense influence, and
their rattles, masks, and other imple-
ments were thought to be super-
naturally potent in themselves. The
museum's rattle is shaped like a raven,
the creator and trickster in Northwest
Coast mythology. The merging forms
of man, frog, and hawk on the bird's
back symbolize shamanic flight.

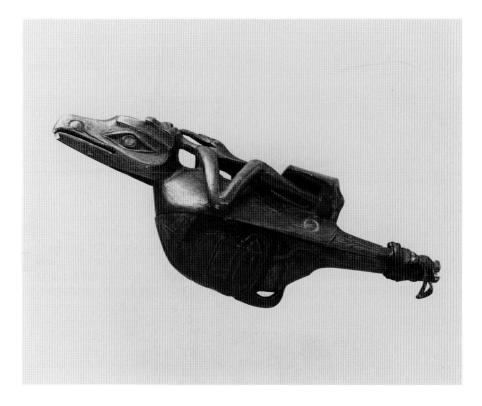

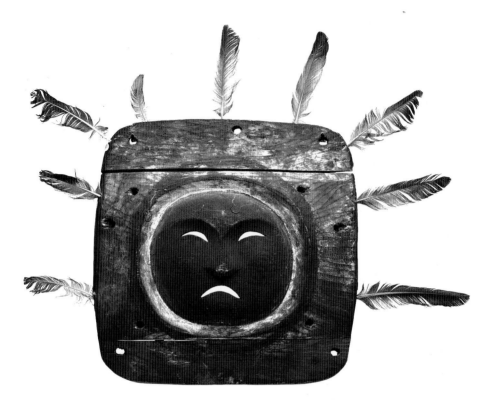

North American, Canada (Inuit)
Mask
19th century
Wood and feathers with traces of paint
13¾ × 17¼ in.
The John R. Van Derlip Fund 81.14

The Inuit (Eskimo) of arctic North America developed a hunting and fishing culture especially suited to the harsh northern climate. The earliest examples of Inuit art, dating to around 300 B.C., are small tools, weapons, and figurines carved from ivory and bone. This spirit mask of driftwood and feathers, collected in the village of Anvik in the late nineteenth century, was made by the Bering Sea Inuit of western Alaska, who lived in the desolate coastal stretches of the Yukon and Kuskokwim river deltas. The Inuit regarded every animal, plant, and inanimate object—caribou, tree, or mountain—as capable of possessing an *inua*, or spirit. The *inua* could assume various guises, or "persons," including that of a human being, as indicated by the features on some of the Inuit ceremonial masks. These spare and elegant pieces were worn by dancers during religious festivals that ensured a tribe's survival by honoring the spirits that provided for its needs. We do not know what creature the museum's mask symbolizes, although the downturned mouth indicates a female spirit. The feathers offer no real clue, since the Inuit did not limit the use of feathers to representations of bird forms.

North American, United States
(Navajo)
Ketoh (Wrist Guard)
About 1930
Cast silver with turquoise
on a leather band
3½ in. high
Bequest of Virginia Doneghy

Although for thousands of years the peoples of the American Southwest have adorned themselves with various sorts of jewelry, they did not learn the art of silversmithing until the middle of the nineteenth century. The Navajo were the first to acquire this skill, adapting the methods of Mexican silversmiths and Euro-American blacksmiths to their own needs. To begin with, they simply hammered the silver into shape and then engraved or stamped it with decorative motifs, but they soon mastered the techniques of soldering and casting, which enabled them to create more elaborate forms. The *ketoh*, or wrist guard, was worn by Indian archers to protect their forearms against the snap of the bowstring. The design of this one is typical of Navajo work—a turquoise in the center, with bars of metal radiating outward to signify the four cardinal directions. The axial symmetry is consistent with the Navajo concept of *hózhǫ́*, or "beauty," which emphasizes the importance of order, harmony, and simplicity in both art and life. Like other traditional cast ornaments, this *ketoh* was made in a sandstone mold that left the jewelry rough and pitted. Days of sanding and polishing were required to give the silver its smooth and lustrous finish.

Index of Artists